CW00921440

THE
JERMYN
STREET
SHIRT

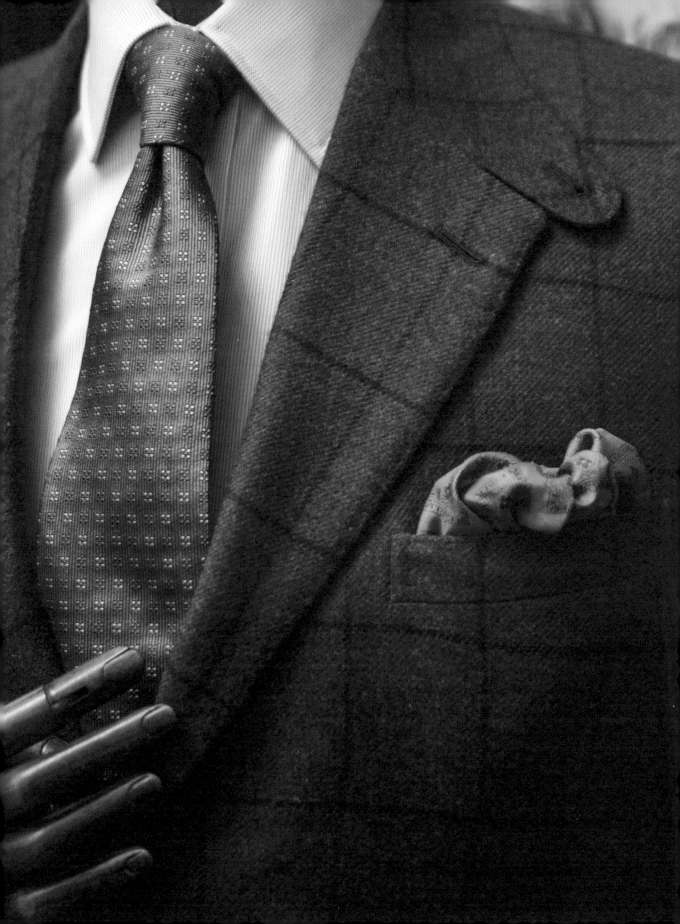

THE JERMYN STREET SHIRT

JONATHAN SOTHCOTT

The
History
Press

For Jeanine – the love of my life and my perfect fit

All original photography by Rikesh Chauhan. All other photography kindly provided by the shirtmakers of Jermyn Street.

First published 2021

The History Press
97 St George's Place, Cheltenham,
Gloucestershire, GL50 3QB
www.thehistorypress.co.uk

British Library Cataloguing in Publication Data.
A catalogue record for this book is available from the British Library.

ISBN 978 0 07509 9417 0

Typesetting and origination by The History Press
Printed in Turkey by IMAK

CONTENTS

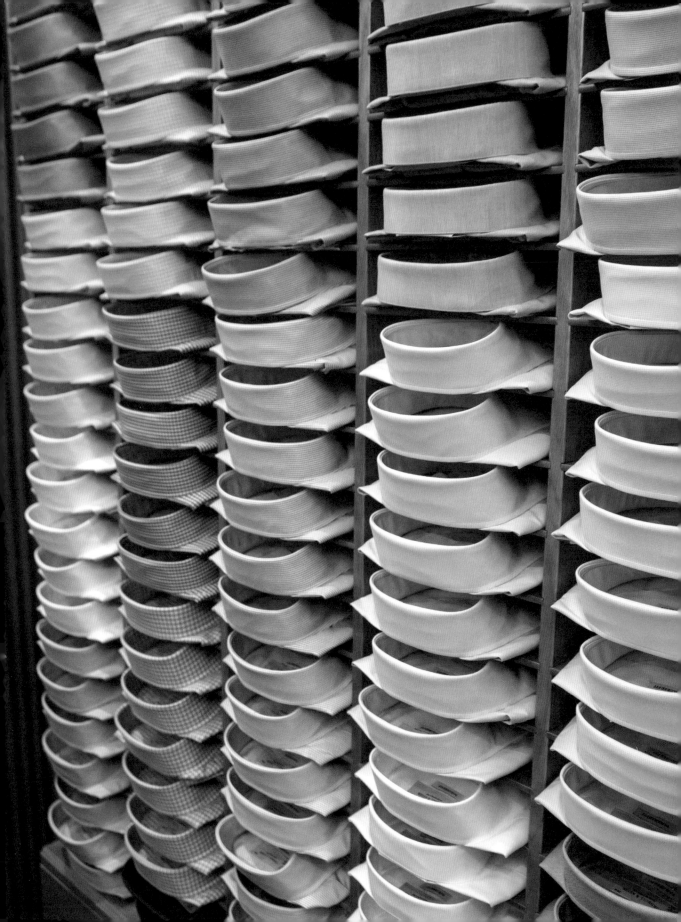

ACKNOWLEDGEMENTS

Many people have fostered my interest in fine menswear over the years, but I'd particularly like to acknowledge three who are sadly no longer with us: the late Sir Roger Moore, not just for endless sartorial inspiration but also for introducing me to my shirtmaker, the late Frank Foster; Frank himself; and my first tailor, the late, much-missed Doug Hayward, who was as much a one-off as any of the beautiful suits he cut with such flair.

My wife Jeanine who not only appreciates my shirts (and remarked on one the first time we met) but washes and irons them too. *That* is true love.

My dear friend Tom Parker Bowles for such kind words in the foreword and for his unflagging support and enthusiasm both for this book and for all that I do.

Tom Chamberlain, not only for writing such an elegant introduction, but also – in his role as editor of *The Rake* magazine – finally giving us sartorialists the men's magazine we've always wanted.

For graciously giving their time to talk to me for the book: Emma Willis, Robert Emmett, Stephen Lachter, Steve Quinn at Turnbull & Asser, Charles Seaton and Carla Bicknell at New & Lingwood, Richard Harvie at Harvie & Hudson, John Butcher and Darren Tiernan at Budd, Nick Wheeler at Charles Tyrwhitt and Steve Miller at Hilditch & Key.

Rikesh Chauhan whose stunning photography captured the elegance of Jermyn Street so effortlessly. Mark Beynon at The History Press for indulging my whim to write a book about shirts and forgiving my flagrant lack of respect for deadlines.

Billy Murray, Geoffrey and Loulou Moore, Adam Stephen Kelly, Jamie and Claire Barber, Ewan Venters, Paul Sandgrove, Terry Haste, Les Haynes, Audie Charles, Peter Brooker, Matt Spaiser, Simon Thompson, David Marlborough and Poppy Charles.

At home, Dylan, Hannah, Grace and Gabriel. And my Mum and Dad for that first Turnbull & Asser shirt.

FOREWORD

TOM PARKER BOWLES

Film producers are not, on the whole, known for their distinctive sartorial style. Sure, Robert Evans worked a particularly louche West Coast look, all cashmere polo necks and black silk shirts. David Heyman wears a well-cut suit. And Alexander Korda was never knowingly underdressed. But the vast majority could be charitably described as, at best, scruffy. At worst, a bloody mess.

Not Jonathan Sothcott. Hell, no. The first time I met him, about ten years back, was at Langan's. I turned up looking, as ever, as if I'd had a fight with a tumble dryer. Jonathan, on the other hand, was clad in an immaculately cut double-breasted blazer (pristine white handkerchief peeping exactly an inch from his breast pocket), grey slacks with a crease so sharp it could slice garlic, bespoke Frank Foster shirt (with the plain white collar, of course), and a pair of gleaming Gucci loafers. This was Jonathan in casual mode.

Since then, and over the course of countless long and invariably merry lunches and dinners, I've never seen him dressed in the same thing twice. Sometimes, the jacket may be fine tweed; at others, a lightweight wool. And as the days get longer, so the pastels emerge, in linen jackets and poplin cotton shirts and the sort of white slacks that I thought only Cary Grant could pull off. He puts as much care, love and attention into his clothing as he does into producing his films.

I'm not sure if he has ever worn a T-shirt or, God forbid, a pair of tracksuit bottoms. And on the few times I've seen him 'dressed down' (two words I don't think he uses much), there's usually some incredibly grand overcoat, or Roger Moore-style blouson jacket. And talking of the late, great Sir Rog, you can see the influence the actor had on Jonathan's dress. His shirts, in particular. They were great friends, and I force him to recount the same old anecdotes, time after time. They never lose their charm.

Anyway, I can't think of a more fitting, knowledgeable or passionate guide to *The Jermyn Street Shirt*. God only knows how many he has, although I'm pretty certain they're hung with colour-coded precision. There's nothing he doesn't know about spread versus cut-away collar, or sea island versus lightweight voile. And don't even get him started on those cuffs. He can talk for days. But in a world where the bespoke shirt is an increasingly rare luxury, Jonathan keeps the flag flying. For British style, craftsmanship and the pure, elegant joy of a proper handmade shirt.

INTRODUCTION

TOM CHAMBERLAIN

The first bespoke shirt I ever had made was a two-fold white cotton shirt from Emma Willis. Like many people I know who have explored this particular bespoke avenue, I felt a sense of overindulgence; that bespeaking a suit can be easily justified, but what lies underneath the suit surely doesn't need it, right? The result converted this particular agnostic into a passionate evangelist on the beneficial effects of bespoke shirts. Since then the journey has taken me through several of the different shirtmakers in Mayfair and St James's who have met the challenge of staying relevant and living up to the expectations created by their own heritage by producing clothing that is not only adaptable to modern needs, but still conjures that intoxicating feeling that someone who has dedicated their life to a particular art has focused their energy on you. It is a precision craft that is more like shoemaking than tailoring, as the end product will have no overlay and the margin for error is effectively zero.

When Jonathan, a friend through being a reader of *The Rake*, asked me to write the introduction to a book on Jermyn Street shirtmakers, there was some confusion. Not that a film producer was writing this book – no, he's an articulate, passionate, knowledgeable author for the subject. The puzzlement was simply that this was a book that has been written before, surely? Sartorial matters are one of the nation's great exports, and Jermyn Street is the beating heart for shirts. But I was wrong. Aside from the in-house books on specific brands, there is a dearth of published books on this street as a whole, with anything already out there so softly grazing the surface that it is instantly forgettable.

It is therefore with great pleasure and privilege that I get to introduce a book that understands how rich and fertile a soil this subject matter is for telling stories. Shirts are, from a common cultural point of view, undoubtedly perceived as occupying a second-fiddle position against the

suit. What this book demonstrates, by getting to grips with the field and its players, is that there is very little to support this prejudice. It elevates not only the esteem of the shirt as a work of art, but also the makers as artisans comparable with tailors, working under the roofs of brands with just as much heritage as any house on Savile Row.

Over the course of the book, as each brand's nuance, heritage and technique is illuminated to you, Sothcott's passion will no doubt leave you in a state of blissful indecision. For when the quality across the board is so high, the most pressing question should be: whom do I go to first?

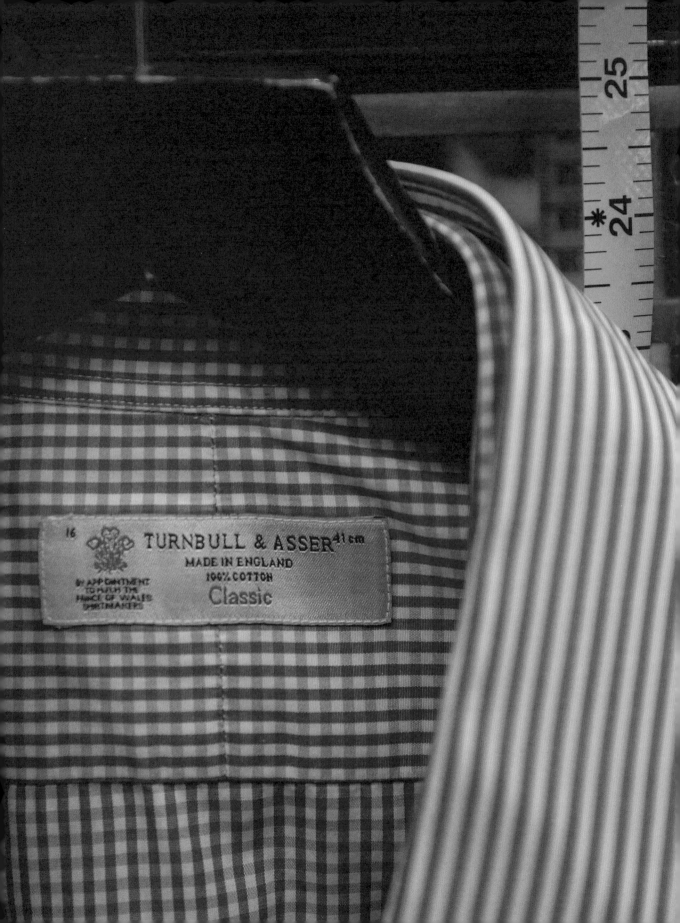

JS ON JERMYN STREET – MY LIFE IN SHIRTS

The prospect of a book – written by me – about fine and bespoke shirts, and more specifically those made on or around Jermyn Street, has largely met with two views from friends. Some have said, 'Fantastic, that's a wonderful idea.' Others have said, 'German what? What do you mean "shirts"? Be spoken to like what?' All have – largely kindly – agreed it is a perfect book for me to write because, despite my somewhat self-propagated public persona as the king of gangster B-movies, the truth is that that's work and something I very much leave at the office.

Like many men of my age (I was born in 1980) my interest in menswear began with James Bond. The old saying that men want to be Bond and women want to be with him is an undoubted truth, but while Bond's suits have been the subject of countless column inches and internet pages, his influence on men's shirts cannot be overlooked. Growing up on the classic Sean Connery and (particularly) Roger Moore films, in my teens I aspired to the classic, understated style on display in these movies, which was jarringly at odds with the loud, often acidic colours, baggy fits and stylistic excesses of 1990s fashion. I never followed fashion or owned a pair of trainers and was doubtless something of an eccentric in my youth. Terms such as 'old head on young shoulders' and 'old before his time' would be bandied about in less than flattering contexts, but nonetheless brands such

as DAKS and Aquascutum were far more appealing to me than Nike or Hugo Boss. In my school sixth form I paraded about in a DAKS double-breasted Prince of Wales check suit with a striped tie and cufflinks while my peers resentfully wore their fathers' discarded work wear, counting down the days until they could get changed into trainers and sweatshirts. At the time, the closest I got to Jermyn Street or Savile Row was the sprawling department stores such as Army & Navy and Alders that dominated large towns. Alders in Croydon, where I regularly found myself, stocked brands such as DAKS for suits and blazers but, like most stores, no comparable shirt brands – there were a lot of soft-collared Van Heusen shirts which, while not without merit, were decidedly cheap and cheerful and certainly weren't comparable in quality to the garments retailers expected them to sit under. It always seemed strange to me that there was still a perception that shirts were largely a complex undergarment and that only the jacket over them mattered.

In 1997 my mother bought me, as a huge indulgence, a blue Bengal striped shirt with a white collar and white double cuffs from the Turnbull & Asser concession in Harrods. It was to lead me on a journey around the shirtmakers of Jermyn Street and beyond over the next two decades. Fine shirts were my first menswear love: they were more affordable than jackets or suits and the plethora of styles and patterns made them an instant focal point for my early wardrobe. There is an old Jermyn Street saying that the suit is the frame and the shirt is the artwork and it is one that has always stuck with me. That first Turnbull & Asser shirt opened my eyes to the fact that there was a whole world beyond the Van Heusen and Savoy Taylors Guild shirts I had aspired to in my teens. The removable stays gave the collar a regal, luxurious feel. The stripes seemed that little bit more defined. The cuffs were full and rich, with plenty of soft, silky material. They felt worthy of cufflinks. It felt like a rite of passage. I had graduated. Fine shirting was not only one of the great institutions – it had its very own Mecca: Jermyn Street. And it was calling to me.

I still remember that crisp, chilly morning heading to Jermyn Street from Green Park tube for the first time, a few months later. Walking past The Ritz Hotel, I was struck by an explosion of colourful menswear in one of its windows – the Angelo Roma boutique, sadly no longer with us. Eventually I made it across St James's and there it was – one long,

beautiful street of shirts, ties and accessories. Another explosion of continental colour was provided by what was then the first menswear store on the street – Italian luxury specialist Vincci, which specialised in plush cashmeres with brass buttons in much the same style as Brioni and indeed Angelo.

Even then, at the risk of cliché it was like stepping back in time (and two decades on, even more so) – there was an air of Grace Brothers about the service in some of the shops, for sure, but not in a bad way. And there were esoteric items in some of the windows which took me by surprise even then – I can still see in my mind a lightweight (and thus entirely fashionable and unfit for purpose) checked Inverness cape in the long-closed Baron of Piccadilly, a garment I have never seen someone wear anywhere except on the silver screen. Baron was a curious place, seemingly trapped in 1979 for three decades, selling a strange mix of excellent tweeds by the likes of Magee offset by a deluge of polyester-rich 'leisure wear' of the sort sported by Brits on cruise ships in situation comedies. The staff were of the personable, no-nonsense school characterised by country department stores for decades and largely of the opinion that everything one tried on was 'just the ticket' – and in some cases they were right. It was no surprise – yet still rather sad – when it closed its doors in 2009. And, of course, I still regret not buying that Inverness cape which I'd never, ever have worn.

One of the things which most stood out on Jermyn Street was its adherence to classicalism, which simply could not be found on the high street. The '90s were the era of the dreaded black business suit paired with matching shirts and ties, and Jermyn Street offered the counterpoint of colour and pattern to this monochromatic monstrosity. Bold stripes in reds and blues, yellows and creams to match browns and tans. Everything was thought out. How you put an outfit together could be rewarding, not just a chore. Then, as now, I always started planning my outfit with the shirt (I suspect for most men it is the suit, or at the very least the jacket) – it is the centre point of a gentleman's ensemble, for while he may take off jacket, tie and even shoes, nobody but his most intimate acquaintances will ever see him without his shirt.

That first day, I came home with a red and white striped shirt with a white collar from Herbie Frogg – another brand lost in the mists of time. Frogg was perhaps the raciest store on the street, located at the

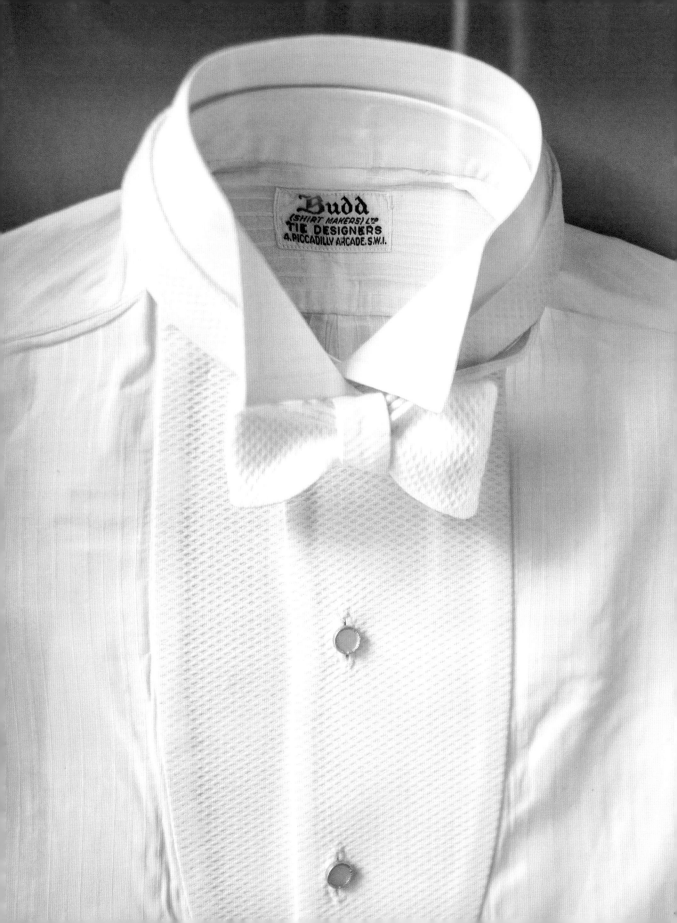

theatre end opposite Rowleys. It housed a curious mix of Italian suits and British shirts in bolder, more modern colours than most of its neighbours and certainly didn't conform to the fashion-backward style that defined the street. But its shirt was, for me, another triumph and, paired with a solid red tie, made me feel like I was ready to take on Wall Street. It is fair to say that, from that day on, Jermyn Street became part of my life and I have been going back ever since.

It is hard not to be intoxicated by Jermyn Street – aside from the bountiful wardrobe shopping, it offers some of the finest cigars (Davidoff), cheese (Paxton & Whitfield, whose wares waft delightfully down the street), books (Waterstones and Hatchards) and restaurants (45 Jermyn Street, Wiltons, Rowleys), and even has a theatre, the delightfully compact Jermyn Street Theatre. In the middle of the street towers Fortnum & Mason, rightfully the world's most revered department store. There really is nowhere like Jermyn Street.

In my early twenties I wrote the film column for an arts and media magazine called *The Grapevine*, published and edited by British screenwriter Michael Armstrong (*House of the Long Shadows*, *Eskimo Nell*) under his Armstrong Arts banner. As part of his burgeoning empire, Michael ran drama classes and staged showcases for his students at the Jermyn Street Theatre. For me, this was the highlight of the job, not because I was particularly enamoured with the acting, but because it was an excuse to spend a day on Jermyn Street. I would often sit next to another legendary British film screenwriter – *Barbarella* scribe Tudor Gates (his real name), who was about as dapper as the industry allowed – and even he was baffled at my interest in collars and cuffs.

It wasn't all great, of course. Like everyone, I was seduced by some of the cheaper options. An outfit called Crichton based in Sackville Street on the other side of Piccadilly made me four shirts for a ludicrously low price which was reflected in the fit, fabric and style – definitely a case of breaking a few eggs to learn how to make an omelette. And to be honest, this is why you have to really think about what you want from a shirt, particularly if you are having one made. Another shop, long since gone, which was in the Piccadilly Arcade, made me a shirt that the elderly proprietor hard-sold me as bespoke but which turned up with a collar so small that my 8-year-old son would have looked silly in it. Unfortunately, as with all luxury goods, shirt making does attract the

odd cowboy, though thankfully less so now that the world is more joined up by the internet.

In the past two decades I like to think I have patronised most of the key players on Jermyn Street, not merely buying shirts but also ties, trousers, jackets, handkerchiefs, coats, scarves and sweaters. Having ended up as a film producer, I dress smartly because I want to and like to, not because of any expectation from my profession – indeed, my dear friend Billy Murray once said to me, 'Jonathan, it's no good you keep coming to set in a suit and tie because nobody believes we are making low budget movies.' It is very rare to meet anyone in my profession who has any interest in fine British menswear. A rare exception is my friend Gary Kemp. I treasure a lunch at that venerable Jermyn Street institution Wilton's with him, followed by a stroll along Jermyn Street and Savile Row.

I suppose that the point of sartorial no return for me was meeting the late, great Doug Hayward. Back in the late 1990s Doug's unassuming and much-missed shop at 95 Mount Street had an atmosphere, a vibe if you like, unlike any other I have ever been to. You will read it was like a private members' club and in essence it was, but it was the antithesis of the stuffy, elitist picture such a description can conjure. I had read that Hayward made the suits for the James Bond films and so, being naïve and curious, I made the journey over Berkley Square, away from what had already become the comfort of Jermyn Street. Mount Street has changed much over the years and is now the home to high-end designers, but two decades ago it was a quiet, elegant street with a delightful pub on one corner, Scott's restaurant in the middle and an intoxicating mix of cigar shops and gun merchants. As I pushed the door open, a loud, old-fashioned bell clanged announcing my arrival and a small, scruffy dog started barking at me. Doug, a great big man with a gentle, relaxed air, was sitting in a big, brown leather armchair opposite a huge sofa, separated by a table heaving with books. A charming, warm lady who I was later to discover was Audie, Doug's right-hand woman, came forward and calmed the dog, Bert, and asked if she could help. Beyond accessories, Hayward sold very little in the way of ready-to-wear, but I left that day with a tie which I still have hanging in my closet, quite besotted with Doug and his easy-going, anecdotal stories.

Doug seemed genuinely interested in why a young man would seek him out, and as our friendship blossomed over the next few

years, his tales of tailoring and showbusiness (for Doug the two were inextricably linked) helped to inform the path I was to take in my life and my interest. We'd sit in the pub and he'd smoke a cigar while I had a Guinness, or we'd lunch in his favourite café Richoux or – if it was a special occasion – Scott's. He came to my birthday party one year at The Arts Club and, despite being the oldest person in the room, he was instantly the centre of attention, quietly sitting in an armchair introducing himself to everyone. The only stipulation Doug made about going out in the evening was that he liked to be home in time for *EastEnders* at 7.30 p.m. – he hated missing it. It was a world away from his glamorous movie star mates and he enjoyed all the misery. Doug came from very humble beginnings and – it was said – was the inspiration for the character Alfie in the film of the same name. He certainly was the inspiration for Harry Pendle, the titular *Tailor of Panama* in John le Carré's best-selling book, which is dedicated to Doug. He was quietly flattered by that. Legend has it that when he first found success in tailoring in the 1960s, his mother couldn't quite believe it, so she put money in a tin under her bed every week for him. Upon her death a sizeable stash was found with a note explaining that it was for Doug, to help him 'when they finally get him'.

Doug was a pragmatist about clothes – he was never, ever anything less than immaculate (Rex Harrison referred to him as 'the Rodin of tweed') and he really did make it seem effortless. He wasn't interested in fancy details or statement patterns; he believed that clothes just needed to make a man look as good as possible. Many of his clients whom I met with him over the years – George Hamilton, Terry O'Neill, A.A. Gill, Hugh Grant, Sir Michael Caine and Tony Bennett – didn't need much help looking good, but all were great ambassadors for that timeless Hayward style. Eventually, as finances allowed, I had a couple of jackets made at Hayward and all were truly stunning. I still have one hanging in my wardrobe. Doug's head cutter was Les Haynes, a charming, dignified man and arguably the best cutter in London. Sadly, Doug became very ill with dementia and a shadow of his former self. It was horrifying to watch him slip away and not be able to recognise old friends he had known for decades. He died on my 28th birthday – I was heartbroken and I still miss him terribly.

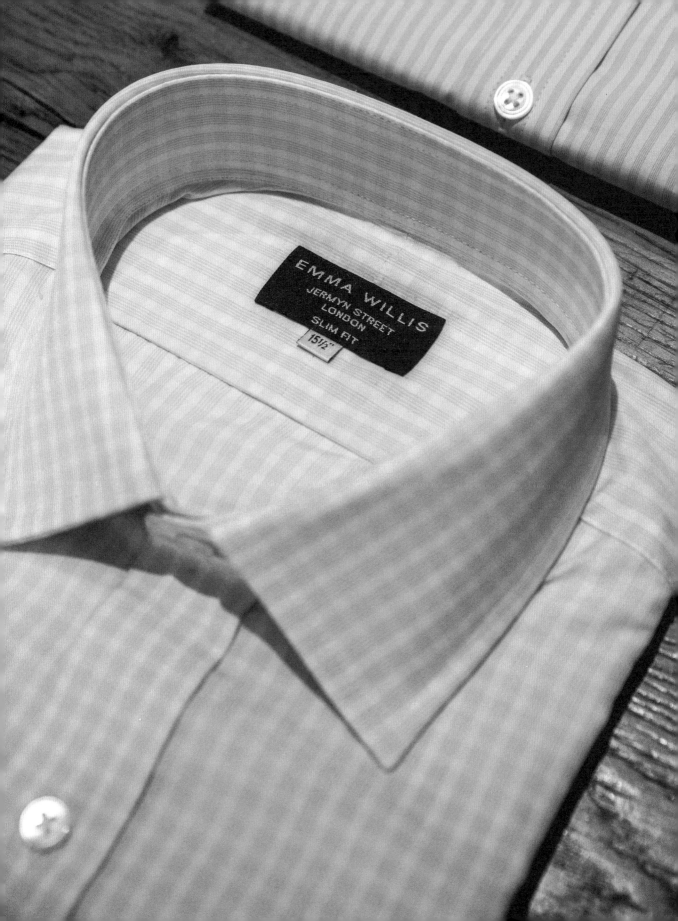

Les Haynes and Audie Charles both moved to Anderson & Shepherd, where Audie now runs the Clifford Street Haberdashery, which is the closest I have seen to a shop capturing that special Hayward ambience. I bumped into Les outside their shop while writing this book and he told me that he is planning to retire, which for me really does mark the end of an era.

I owe a huge amount of thanks to Doug for helping me on my way to writing this book and I like to think that he'd have put a copy on the table in his shop.

It took me a while – like it should everyone – to find my personal style. In my mid-twenties I was fortunate enough to meet and work with my sartorial hero Sir Roger Moore – probably Doug Hayward's most famous customer – and asked him where he got his shirts from, which I noticed still sported the high, wide collars from his James Bond days. 'You have to go to Frank Foster,' he said, and kindly made the introduction (in those days one had to be introduced by an existing client, in much the same way as joining a private members' club). Frank (and his wife Mary and their daughter Sam) eventually became a good friend, and although Frank is no longer with us they still make my shirts to this day. Like Hayward, Frank Foster is a special experience – there is no shop and nothing is sold ready to wear. The premises is a basement in Pall Mall stacked to the rafters with thousands of rolls of fabric, some nearly 100 years old. Over the years, I have flirted with flamboyant shirts made by Angelo Galasso (or, as it was, Interno8), Brioni and Stefano Ricci in Rome, Swedish shirts by Eton and Irish shirts by Smyth & Gibson, but I have always returned to London and Jermyn Street.

One of my personal preferences has become shirts with button cuffs, either single or in the Bondian 'cocktail' style. To my eye they are more appealing and focus the attention on the quality of the shirt's craftsmanship rather than on jewellery adorning it. Some would say they are more informal and they may be right, but the joy of shirts – particularly bespoke shirts – is that the devil is in the detail. I always go for a longer shirt in a classic fit with a wide spread collar with a high band – being a bigger chap, it elongates my neck and slims my face. As much as I would like to sport an extreme cutaway collar, I learned the hard way that the style simply does not suit me. I have also learned that linen is not my friend, either as a shirting or for trousers or jackets, so

I give that a wide berth. I'm also a great fan of shirts with contrasting collars and cuffs, a look I know many consider to be somewhat nouveaux riche or at least a little ostentatious. But that's the point about personal style – you have to find your own.

Since I first made my pilgrimage to Jermyn Street, the rise of the internet and particularly the advent of Instagram have made interest in shirtmakers a shared passion, rather than a lonely one, and as men have taken their grooming and appearance more seriously, wearing a good shirt has become an acceptable everyday staple rather than the confine of the dandy.

The internet is bursting at the seams with blogs, essays and forums full of enthusiastic sartorialists looking to share their passion and wisdom. Most shirtmakers and tailors now have public-facing websites with substantial accounts of their histories. On YouTube you will find vlogs, unboxings and even tutorials on how a bespoke shirt is made. Even though the world is less well dressed than it was, it is far easier for those who wish to dress well to feel part of a community. Instagram is perhaps the greatest hub of information, as being such a visual medium it allows enthusiasts simply to spend their days looking at shirts.

Although many men still don't see beyond that simple staple of the white cotton (or, worse, synthetic) shirt for work, things are changing and fabric, pattern and cut are slowly becoming staples of the modern man's mindset. As formal dressing slowly transcends from a necessary uniformity to an aspirational choice, the artisans of Jermyn Street have become more relevant than ever before. Some – led by Emma Willis and Budd – have embraced the changes and made their online presence as elegant as their premises. Others are less keen on the age of information through some concern that the knowledge shoppers can now easily glean somehow makes their job harder.

A new James Bond film always reawakens interest in the British menswear market and – despite its well-publicised delays and difficulties – *No Time to Die* will be no different. While I – and many others – may grumble about some of Daniel Craig's sartorial preferences, we can at least all enjoy the fact that he has remained faithful to Fleming's character by wearing a suit, shirt and tie. It would, of course, be more gratifying if they were made by Jermyn Street or Savile Row artisans, but who knows what the future may hold? Most of the people I met while

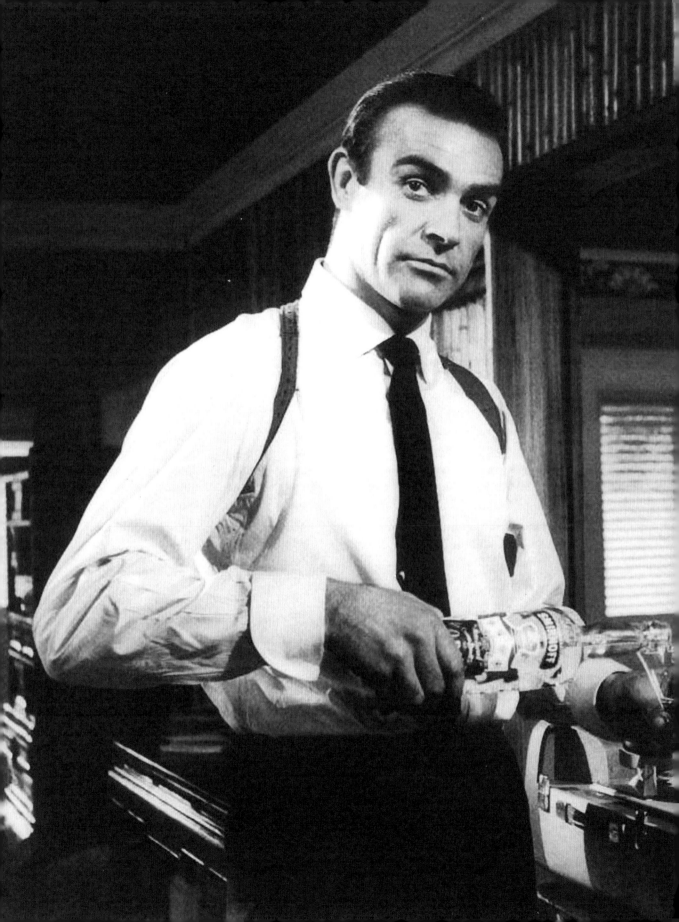

writing this book made it clear that they would rather make shirts for James Bond than anyone else, which is testament to the suited hero's enduring appeal. Tom Ford, of course, announced that they had dressed Bond in the movie just before the release was delayed by six months, but it seems unlikely that this will have any impact on the associated sales – the prized pieces that Bond wears on screen are as coveted as luxury watches and sell out incredibly quickly.

While writing this book I was surprised to hear two of the most respected Jermyn Street doyens tell me that they think the necktie has a limited shelf life as a staple of British menswear and will ultimately join the wide-brimmed hat and the cravat as a dandyish, niche item. I hope very much that this will not be the case, but a few years ago I found myself in Harrods casting around for a tie to wear to an unplanned evening function and was shocked to discover that it no longer had a tie department. In the last decade, ties have become so skinny that it can't be long before they disappear altogether, perhaps literally. The City of London, once defined by bowler hats, furled umbrellas and bold pinstripes, is now the playground of the open-neck shirt and the ghastly slim-fit suit. Some of the Jermyn Street legends have had to move with the times and offer similarly pared-down shirts with softer collars to be worn without a tie. The times really are changing. What has not changed, however, is the sense of joy I derive from a stroll down Jermyn Street, London's finest shopping street for men. The landscape may have changed and some of the stores may have fallen by the wayside, but it remains the last bastion of menswear for Englishmen, a cornucopia of style and taste and the bulwark of traditional style values. This book is an unashamed celebration of the street, its residents and its style, and I hope that it will act as a companion to your Jermyn Street journey, whether it is already a comfortable habit or a new quest upon which you are just setting out.

Opposite: Image © Rex Features

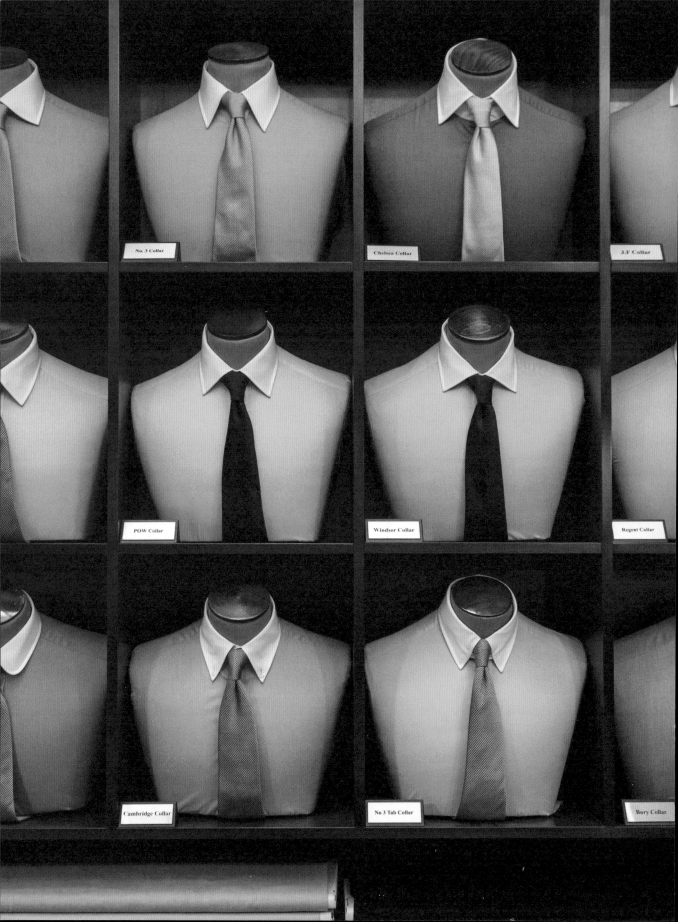

THE ENGLISH SHIRT

The DNA of the modern shirt dates back to the fifth millennium BC when woven fabrics were first invented and formed the basis of a simple tunic-style garment with sleeves, worn under outer clothing. Since then it has evolved quite spectacularly into one of the most popular of all garments, although the advent of casual clothing in the 1960s and 1970s has seen it remain largely unchanged for the last 50 years, save for the vagaries of fashion.

There are essentially three types of English shirt, all of which are popular on Jermyn Street and far beyond.

FORMAL SHIRT

The formal shirt, or business shirt, is a fitted garment designed to be worn under a jacket and (albeit less so these days) with a tie. It has a stiff, shaped collar usually supported by detachable stiffeners, long sleeves and cuffs which are fastened by buttons or cufflinks. A formal shirt can be worn with a suit, blazer or on its own, and despite being referred to as formal, anywhere except upon formal occasions (black tie, white tie, etc.).

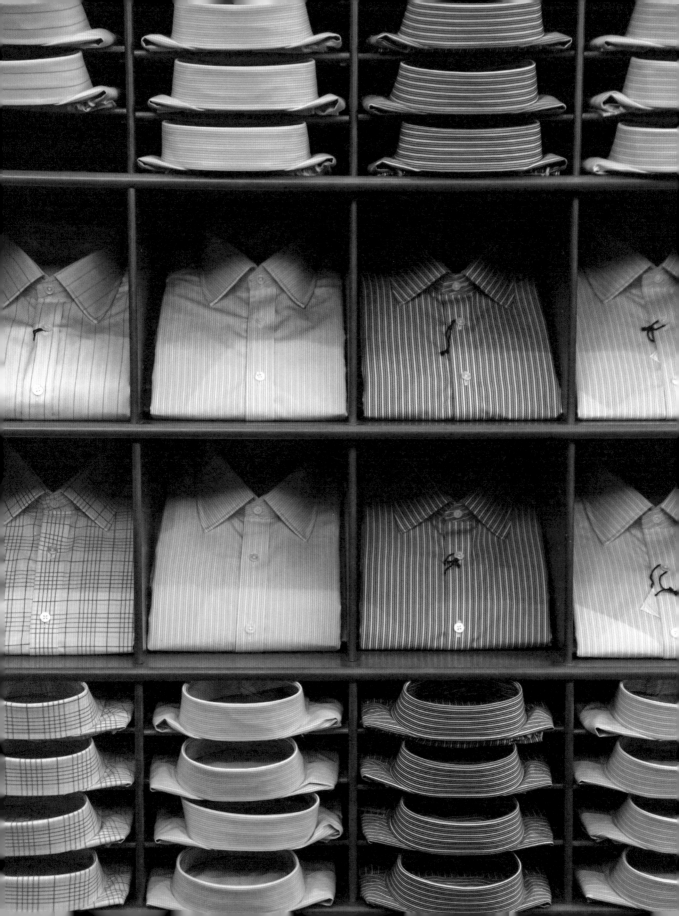

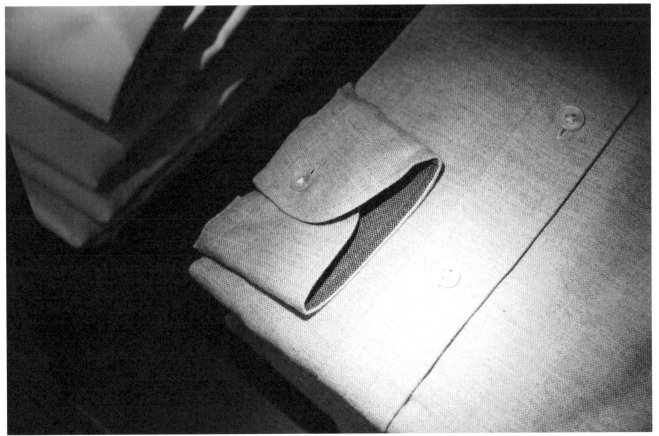

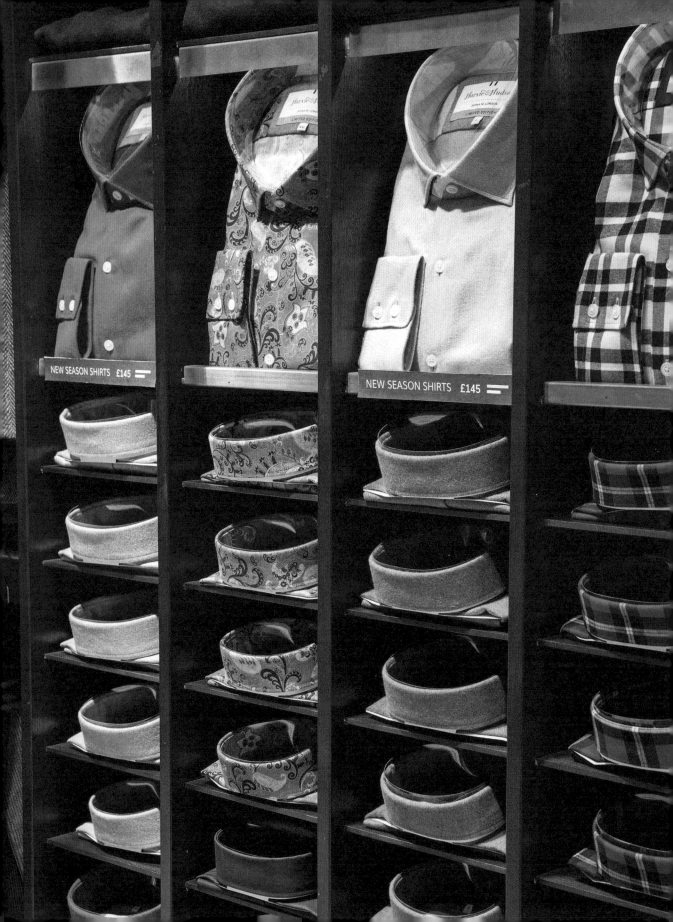

NEW SEASON SHIRTS £145

NEW SEASON SHIRTS £145

CASUAL SHIRT

A shirt can, of course, be rendered casual by its pattern and fabric as well as by its design, but generally speaking the informality is defined by either a soft collar (one not designed to support a necktie) or short sleeves. While a short-sleeved shirt may be worn with a stiffer collar, it should never be worn under a jacket or with a tie – to do so is to commit an unforgivable sartorial sin. Although in America it is considered acceptable to wear a button-down collar such as those made by Brookes Brothers or Ralph Lauren with a tie, in England we see it as a casual option. The casual shirt has button cuffs.

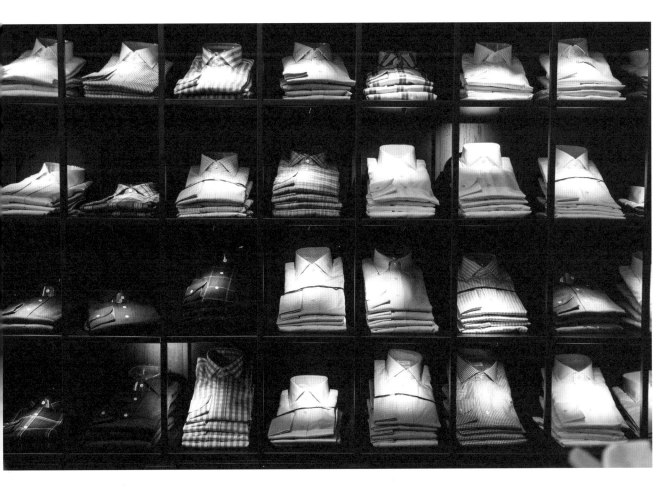

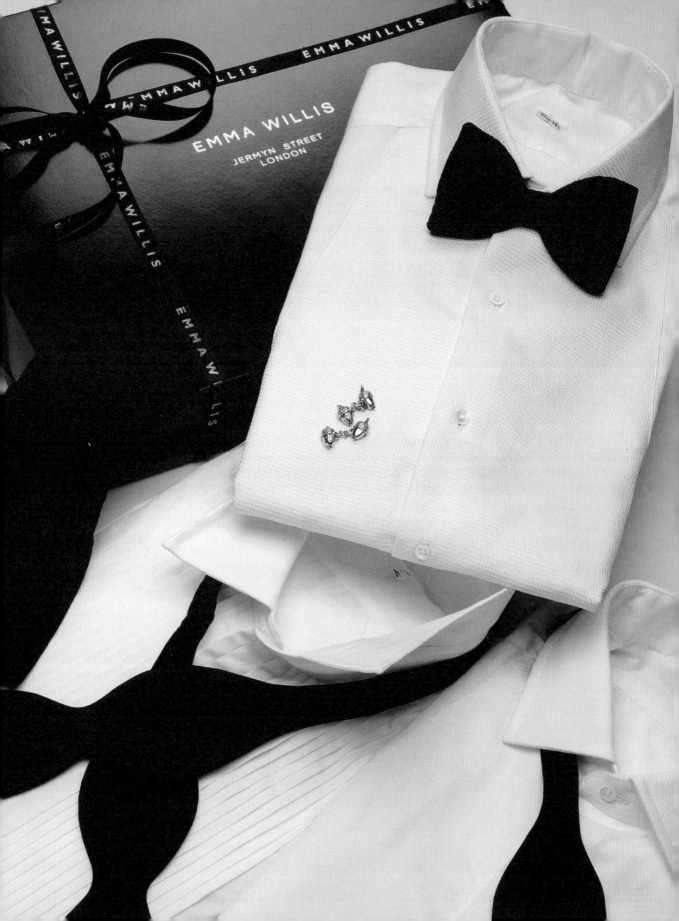

EVENING SHIRT

An evening shirt is the most formal of all – designed to be worn with a black or white bow tie, which you really should learn to tie for yourself. Pre-tied ties are available, of course, but if you can tie shoelaces, you can manage a bow tie. The evening shirt should really be white, although pale blue is acceptable under a midnight blue dinner suit. The evening shirt usually has a fancy front (which can be anything from pleats to full-blown ruffles), fastened with dress studs rather than the usual buttons. A dress shirt traditionally has double cuffs, which are fastened with cuff links.

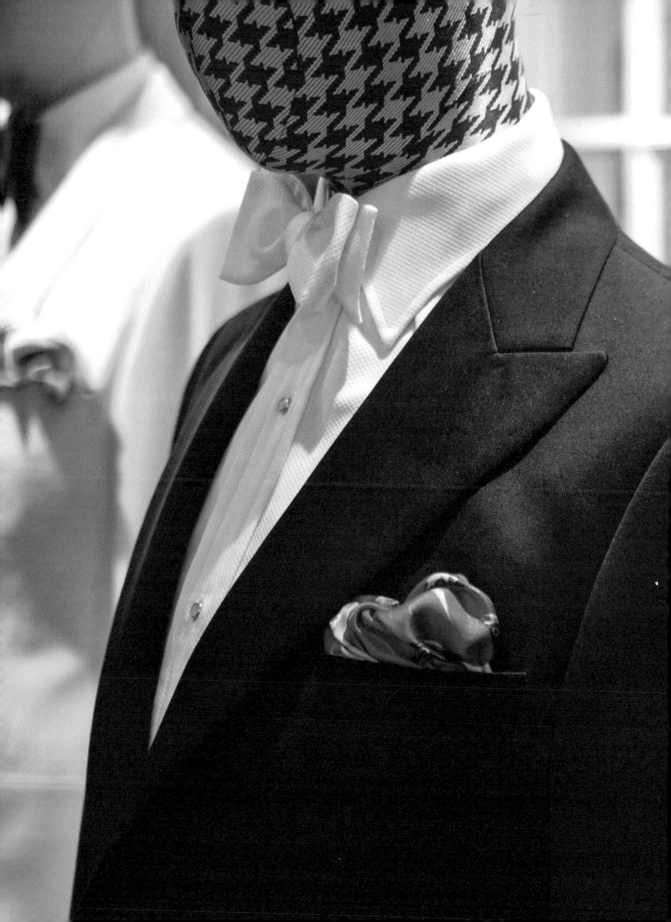

FABRICS

The standard material from which shirts are made is, of course, cotton. Cotton is a fuzzy fibre of almost pure cellulose which grows in a boll (a protective shell) around the seeds of the cotton plant, a common shrub found in the Americas, Africa, Egypt and India. The cotton is spun into a yarn and used to make a smooth, breathable textile.

Cotton has been a staple of our clothing as far back as the fifth millennium BC. In ancient times it was a luxurious material due to the complexity of making it by hand, but the invention of the cotton gin (essentially a cotton engine) around AD 500 opened it up to mass production. These early gins, which were handheld, were invented on the Indian subcontinent. The modern mechanical cotton gin was invented by American Eli Whitney in 1793 and patented the following year.

Britain's Industrial Revolution provided a significant boost to the cotton industry as textiles became the country's biggest export and the period saw the invention of such key manufacturing paraphernalia as the spinning jenny and the flyer and bobbin system. Much of the British Empire's cotton came from India in the days of the colonies.

Today, many people get hung up on a cotton's thread count signifying its quality. The thread count is the threads per inch (TPI) in the fabric. These numbers can range from 50 to the 330. Your shirtmaker will have many options to offer you, but this is not something to use as a deciding factor in how you choose your shirts and can be an easy distraction. The cloth you wear your shirt in should be one you enjoy wearing, not a numbers system, and the mill, ply and quality of cotton will be more decisive factors in the quality of the shirting.

As noted, you will also hear reference to ply construction – whether it be single ply or two ply. Two-ply fabrics have two yarns spun into one to make a single thread, in order to mitigate general wear-and-tear

factors such as piling. Shirts with a thread count over 100 will normally be made with a two-ply construction. Three-ply fabrics do exist but are very rare.

It may seem obvious but it is probably worth noting that you should never buy shirts made from synthetics such as polyester – not only do they not breathe or wear well, but no shirt of quality will ever be made in anything but a natural fabric. The golden rule of gentlemanly dressing is that if it hasn't seen beast or field, avoid it!

POPLIN

Poplin is the blue-chip fabric for fine shirts – a durable, lightweight cotton which looks and wears beautifully. The name derives from 'papelaine' or 'papelino', a fabric made in a mill that was located in the former French papal town of Avignon. Poplin has a lightly ribbed texture and a tightly closed weave, and is made from 100 per cent cotton.

In America, broadcloth is a very similar and popular alternative to poplin, the fundamental difference being that poplins can have different-weight yarns in the warp and weft, while broadcloths have a symmetrical construction.

TWILL

Twill is one of the most distinctive cottons, characterised by its pattern of diagonal, parallel ribs. The effect is achieved by passing a weft thread over the warp thread(s) and then under two or more warp threads and so on, with an offset between the rows creating the diagonal pattern. Twills drape well and hold their shape, but if overworn (particularly in the inner collar) they can rub and wear out, appearing distressed.

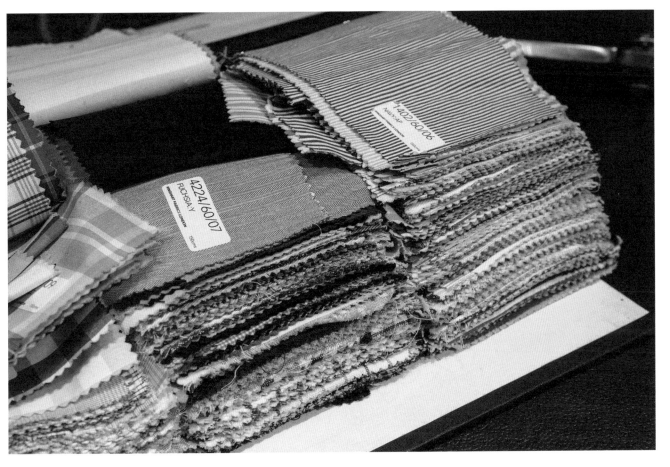

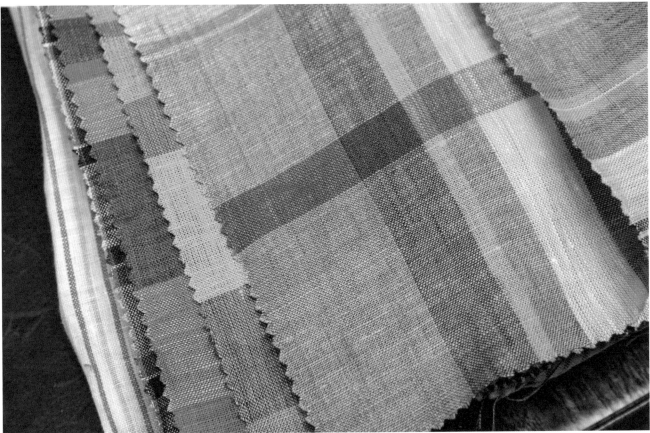

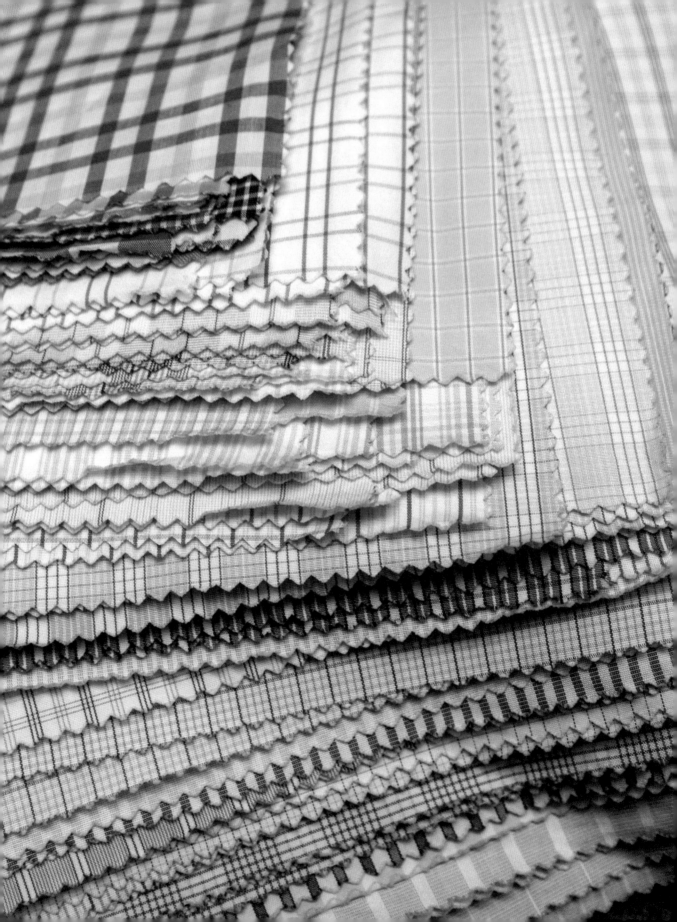

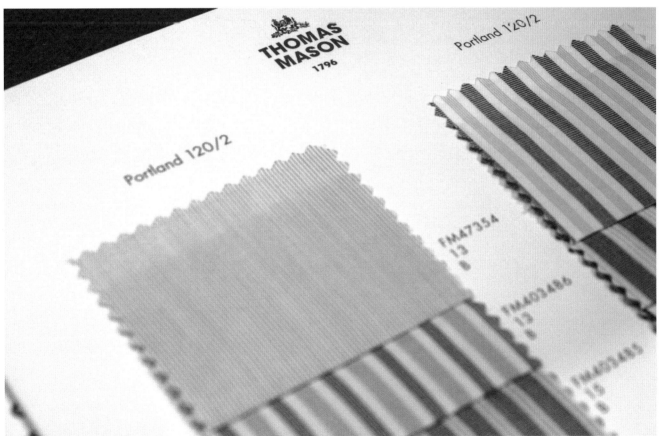

OXFORD AND PINPOINT

Cotton Oxford and cotton pinpoint are soft, durable fabrics with a slight texture to the touch. Oxfords have a basketweave construction and are more casual, as on a formal shirt they have a tendency to look a little faded, particularly in bolder patterns and colours. Pinpoints are made up from a small dot or pin effect and are dressier and more formal.

SEA ISLAND COTTON

Regarded by many as the rarest and most luxurious (and expensive) of all cottons, Sea Island cotton is incredibly exclusive, accounting for just 0.004 per cent of the world's cotton supplies.

The *Gossypium barbadense* plant, from which Sea Island cotton is derived, is of South American origin, dating back thousands of years. It has been grown in the West Indies since the fifteenth century, but it was not until 1786 that it was grown in the part of the world from which it takes its popular name: namely, Georgia in North America. It is said that it was a Briton – Francis Levett – who first planted it there, though he had no opportunity to reap what he sowed as the American Revolution forced him out of his Georgia mansion.

The British aristocracy popularised this most luxurious of cottons, which has not only the most beautiful sheen but also the boldest, longest-lasting colours – Queen Victoria even had her handkerchiefs made from it. However, the Sea Island boom was halted in the early part of the twentieth century when a huge infestation of weevils (an insect which eats cotton plants) decimated the cotton belt stretching from Mexico to the Eastern Seaboard.

Today, Sea Island cotton comes predominantly from the Caribbean – Jamaica, Antigua and Barnados – where it is hand-picked in small quantities. You will find that many shirtmakers offer shirts described as 'Sea Island quality' and, while these may be lovely fabrics, you owe it to yourself to try a shirt in the definitive article: it really is something special.

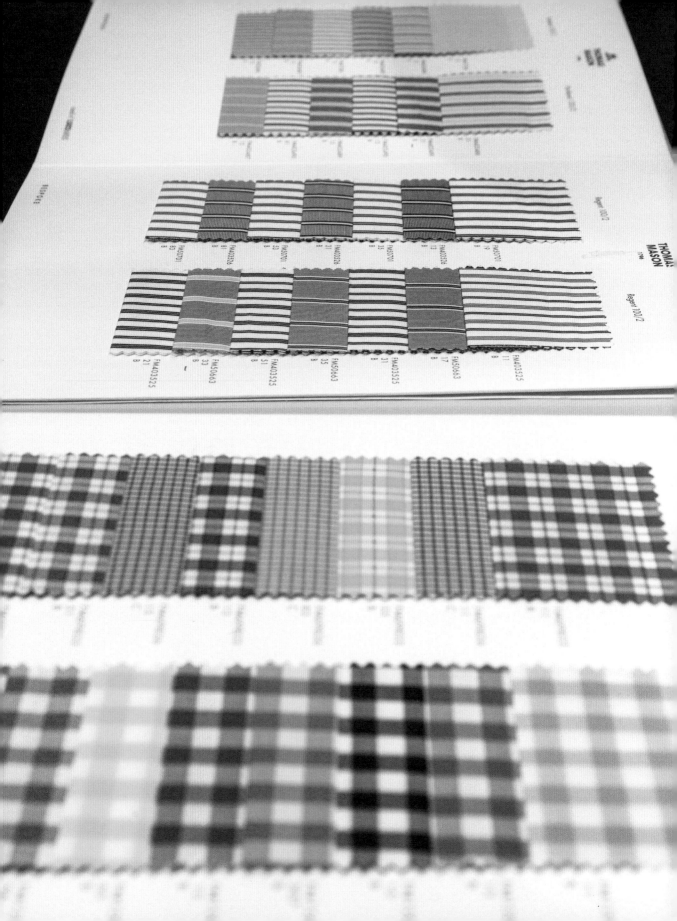

VOILE

Voile – from the French for 'veil', as it was often used for making wedding veils – is one of the most luxurious but also divisive shirtings, as it is very transparent and if worn as a shirt front it will display pretty much every detail of the wearer's torso – and if you have a hairy chest, some of the hairs will poke through the fabric! However, in hot climates it allows a jacket (and even a tie) to be worn when other fabrics would not. If you wish to wear shirts made of voile, you will need to be bold as well as elegant. Voile has a particularly soft hand which feels lovely to wear – certainly as luxurious as silk, but without that fabric's propensity to overheat.

Voile is best known as the fabric of choice for evening shirts, when a non-transparent fabric is usually used for the shirt front (or bib) and the cuffs. However, a shirt will look magnificent when made entirely of voile.

A voile shirt, particularly without a jacket and tie, is a bold statement for a man to make, but once you've worn one, particularly in warmer climates, it can be hard to go back to regular cotton.

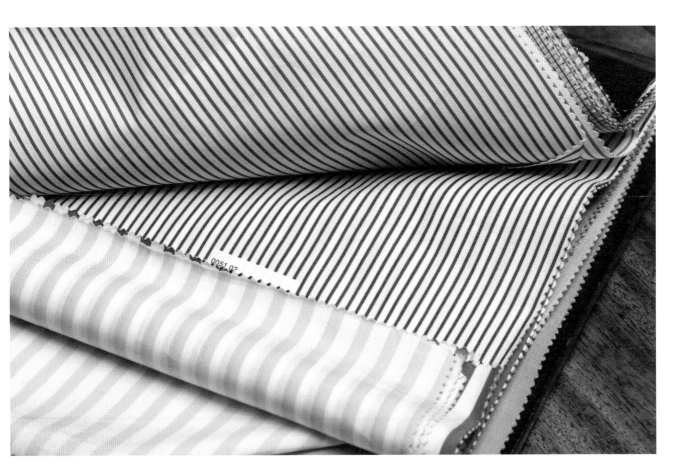

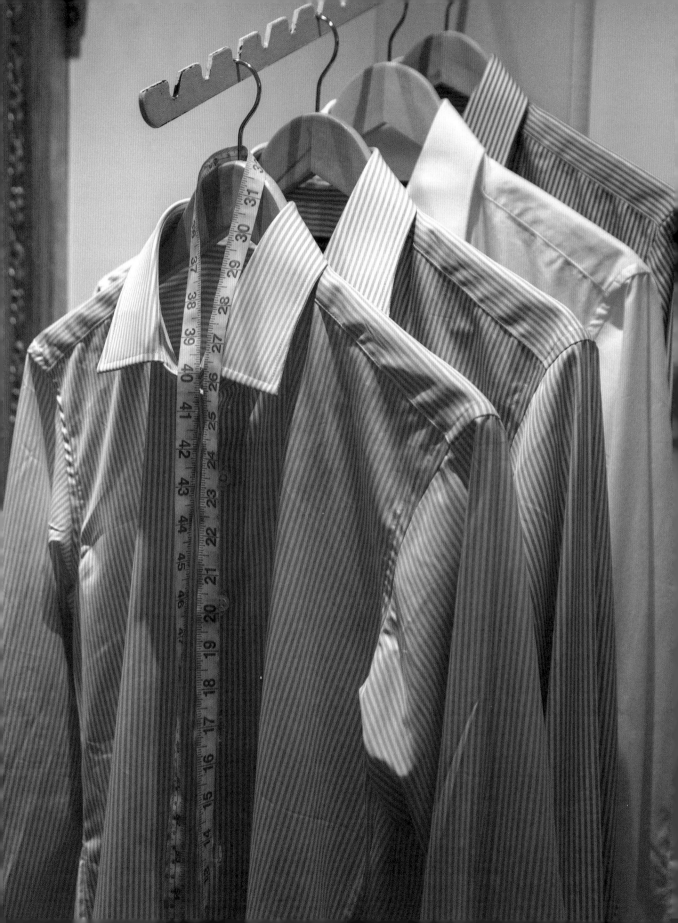

ZEPHYR OR BATISTE

Zephyr or batiste is a supremely lightweight alternative to poplin for cool summer shirts without the sheerness associated with voile.

SILK

Seen by many as the ultimate in decadent luxury, silk shirts are not as popular on Jermyn Street as they once were, having become a fixture in high-end fashion rather than tailoring.

Silk is, of course, a natural fibre but its origins are even more bizarre than those of cotton. The protein fibre of silk is produced by the larvae of the mulberry silk worm (*Bombyx mori*) to form cocoons in which they pupate into moths. Silk was initially developed in ancient China some 8,500 years ago (perhaps longer) for the sole use of the emperor. Eventually its use spread throughout China, which for many years kept its cultivation a secret, with anyone caught smuggling silk worms from the country executed. Eventually, of course, the secret travelled – as legend would have it via a Chinese princess sent to marry a foreign prince, who smuggled cocoons in her spectacular hair – and silk became a global sensation, with major travel routes between Europe and Asia becoming known as the Silk Road.

Silk, being natural, is very breathable, so perfect for casual summer shirts, but it also wears warm, so although popular for fancy evening shirts, it isn't particularly suitable for everyday business shirts, certainly not in warm climates. There are also silk/cotton blends available which make up beautiful shirts, particularly in stripes.

Silk shirts should always be professionally dry cleaned after wear, which only adds to their delightful impracticality.

ROYAL OXFORD AND PANAMA

Royal Oxford cotton is a more luxurious alternative to the regular Oxford weave, while Panama is a thicker, heavier variant. Both fabrics have a basketweave texture which gives them a distinctive, luxurious sheen, and are woven using two-ply yarns to make them last longer. Both are strong choices in basic core colours such as blue, pink and white where something more than just a plain poplin is required. Both fabrics are a little heavy for hot weather and the summer months.

HERRINGBONE AND DOBBY

Herringbone and dobby are members of the twill family. Herringbone is one of the staple weaves in menswear, appearing in coats, suits, ties, scarves and just about everything else. The weave bears a passing resemblance to the skeleton of a fish, hence the somewhat incongruous name. The direction of the twill is reversed in order to produce these 'herringbones' or the textured pattern of dobbies. From a distance both fabrics can appear plain with a slight sheen and they only reveal their true lustre at close range.

As these fabrics are somewhat heavier than many of their counterparts, they are ideal for cooler climates and winter months. Herringbone is also one of the most water-resistant cottons, so should you find yourself regularly caught in a downpour, it is probably your best bet. More practically, these fabrics are easier to iron and quicker to dry, but like all twills you will need to be aware of the collars rubbing where they touch your neck, particularly if you have stubble or a thick beard.

SEERSUCKER

A beautiful warm-weather fabric for casual shirts, seersucker is instantly recognisable by its distinctive puckered appearance, which is created during the finishing of the fabric, once it has been woven, to make the air flow easier when being worn. The most iconic seersucker

is blue and white stripes, but it comes in many other colours and is a particularly attractive alternative to linen in summer.

PIQUÉ AND MARCELLA

Piqué is a weave most often used for the front of dress shirts. The dobby pattern makes that plainest and most formal white shirt a little more interesting. Marcella is a type of piqué characterised by a unique waffle effect. It is a stiff, heavy fabric and should really only form the front of a dress shirt – one shirtmaker described a shirt made entirely of marcella as being akin to wearing a suit of armour.

Piqué was developed in Lancashire by weaving double cloth with an enclosed cording weft, initially for imitations of corded Provençal quilts from Marseilles, but by the middle of the twentieth century it had become a staple of men's formal wear.

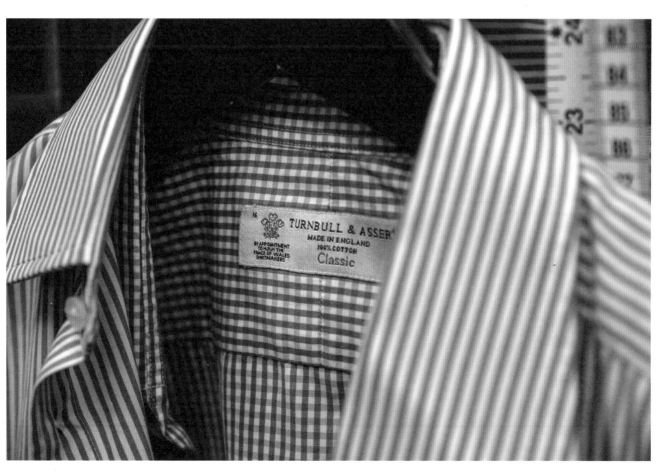

LINEN

Linen is a natural fabric created from the fibres of the flax plant and has been a clothing staple since 8,000 BC. It is uniquely woven to allow more airflow than other fabrics, which is why it is such a popular choice in warm climates. It is perhaps the most breathable of fabrics and if you wear it in the sun you are unlikely to sweat – but it is conversely the wrong choice if you're going to spend your evening somewhere with serious air conditioning. Linen is regularly branded as the ultimate summer fabric.

Linen is the most divisive of shirtings – largely unsuitable for shirting as a part of any formal outfit, it is loved and loathed in equal measure by sartorialists. Its advocates adore the look of *sprezzatura* ('studied carelessness' in Italian) that it gives, while its detractors call it crumpled and scruffy. It does, of course, wrinkle very easily and can very quickly look like yesterday's dirty shirt within an hour of wearing. But if you like that look then you like it. There are also two schools of thought on how it feels next to the skin – personally I have always found it scratchy, but many adore it.

There are many linen blends available, the most popular being a cotton blend (which rather defeats the object of linen being a cotton substitute), but perhaps the best is a mix of linen and bamboo. A linen/bamboo blend wears softer than pure linen, and with bamboo being sustainable it is a pleasing way to dress well and help the planet at the same time.

BRUSHED AND WOOL COTTONS

Another member of the twill family, brushed cotton is literally a fabric that has been brushed to raise the fibres, giving that soft, warm feeling. The chunkier yarns used are far heavier and warmer than regular cotton, so brushed cotton is one of the very best choices for casual and sporting wear in the winter months, particularly in robust tattersall checks. Some mills add a percentage of wool (or even cashmere) to shirts like this for an extra layer of luxurious insulation.

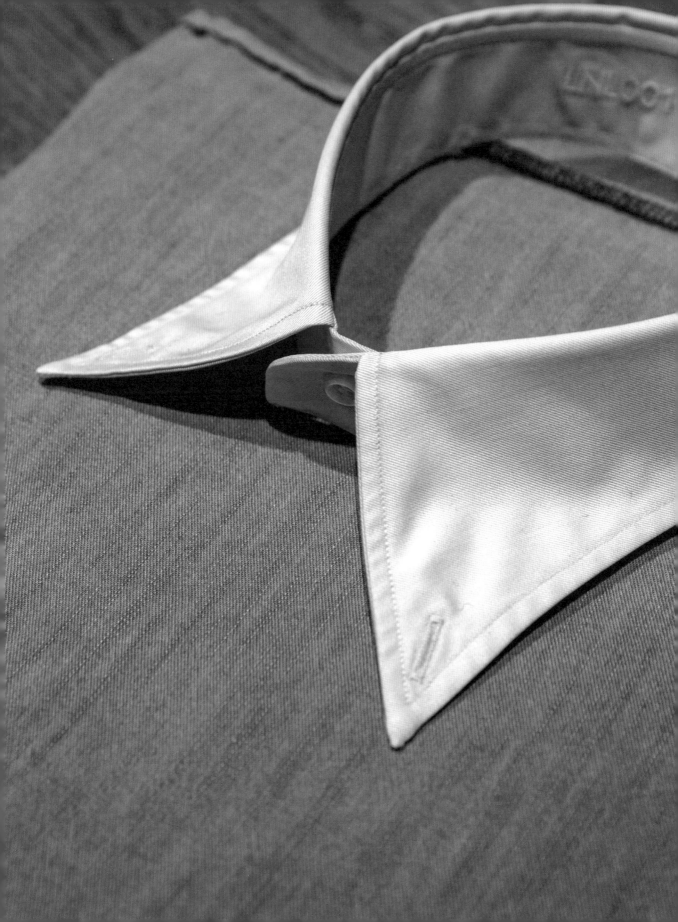

COLLARS

After the fabric and colour, the collar is usually the most striking component of a shirt, and in some ways the most important as it frames the face of the person wearing it. A shirt collar is made from two pieces – literally the top and bottom, which are either 'fused' or sewn together. Between the two pieces is an interlining, which is what gives the collar its shape. A fused collar is one where the interlining is heated and glued together using a fusing machine, which gives an initially stiff effect. A sewn collar with what is called a floating interlining is usually considered the hallmark of a quality shirt. Fused collars simply do not keep their shape as well or last as long as sewn collars. On the other hand, they are much cheaper to produce and this is reflected in the retail price.

There are many different styles of collar and an infinite amount of tiny variations thereof, but here we examine the key types that most shirtmakers offer.

SPREAD COLLAR

One of the most classic collar styles, the spread collar is the template for the majority of modern collars. The 'spread' is the width (usually 4–6in) between the collar points. The style works well with or without a tie.

POINT COLLAR

The point collar has less distance between the collar points, which 'point' down. It suits slimmer ties and can be worn open neck. The consensus is that this style has a slimming effect and flatters those with shorter necks

and/or rounder faces. It can look a little less luxurious than the spread collar but is every bit as smart.

CUTAWAY COLLAR

A true statement collar and a menswear staple since the 1930s, the cutaway is defined by the distance between the collar points being far wider than on other styles. The name comes from the dramatic way the collar 'cuts away' from the wearer's face. Although it is both formal and striking, the style only really works with a tie with a very thick knot, otherwise it can look a little incomplete. Consequently, it is sometimes referred to as the 'Windsor collar', given its propensity to accommodate sumptuous Windsor knots.

CLUB COLLAR

Popularised as the collar of choice for pupils at Eton School (to differentiate them immediately from other students), this distinctive collar is characterised by rounded collar points, giving it a uniquely old-fashioned but not eccentric look. It is essentially a modified spread or point collar and looks particularly striking in white with a contrasting body. The name comes from the exclusive 'club' its original wearers considered themselves part of.

BAND OR NEHRU COLLAR

Not a particularly popular style for British shirts, the band collar is a stylistic leftover from the days when collars were detachable and has largely become a fun casual option in recent times. The mandarin, or Nehru, variation is a more rigid, formal version, but if you wear it with a jacket you will look eccentric at best (and there's nothing wrong with eccentricity!).

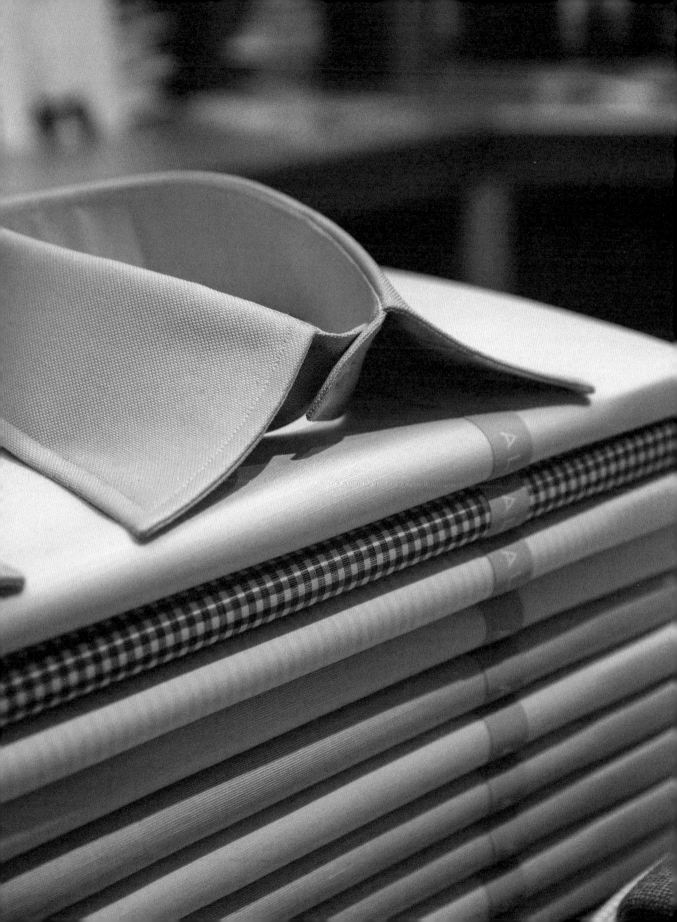

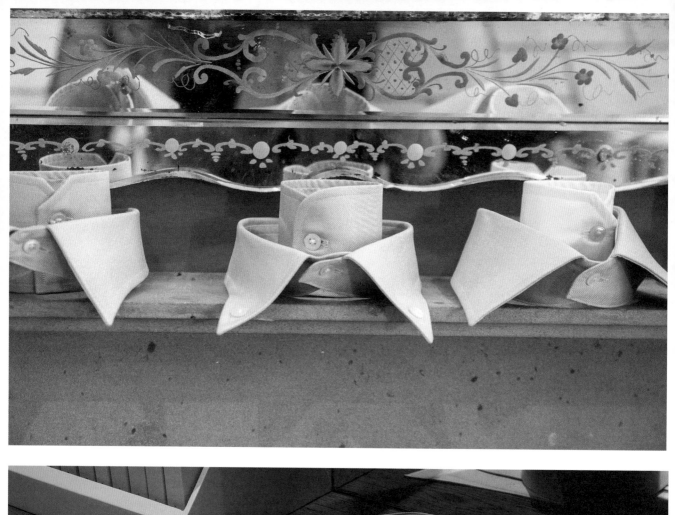
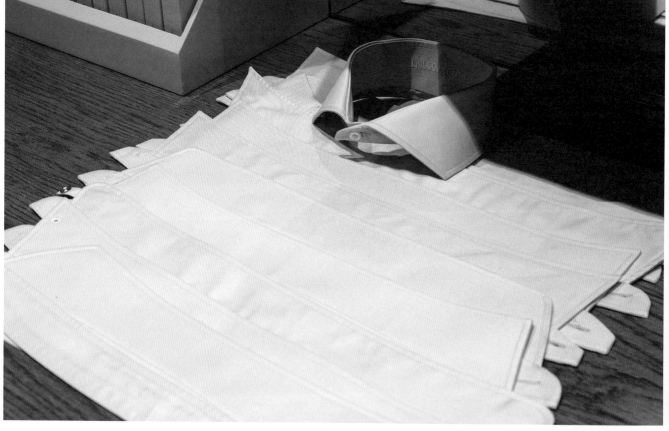

WING COLLAR

A controversial option for formal evening wear – and which can only be worn with a bow tie – the wing or wingtip collar takes its name from its decorative fold-out collar points which look like birds' wings (or, in all honesty, those on a paper aeroplane). Given that the point of black tie is uniformity, it can be seen as ostentatious or at best a little affected.

TAB COLLAR

The tab collar – popularised in American '80s culture but British in origin – is a great look, if a little fussy. It features a small button with two flaps which pull the collar together around the tie, making the tie knot more pronounced. It is a decadent, sophisticated style which connoisseurs appreciate, albeit a little fiddly. This style can only be worn with a tie.

There is, of course, a more complex version, often referred to as a 'pin collar', in which the band of material is replaced with a removable metal bar. The bar functions in exactly the same way as the fabric tab, highlighting the tie knot. It's a beautiful, elegant look but not the easiest to pull off.

CAMP COLLAR

The leisure shirt collar of choice, the camp collar is completely unfused and unlined so is often seen on casual holiday wear such as Hawaiian shirts. It does not suit a tie or jacket and isn't really an option for the City. Sean Connery got it absolutely right in the Bahamas in *Thunderball*.

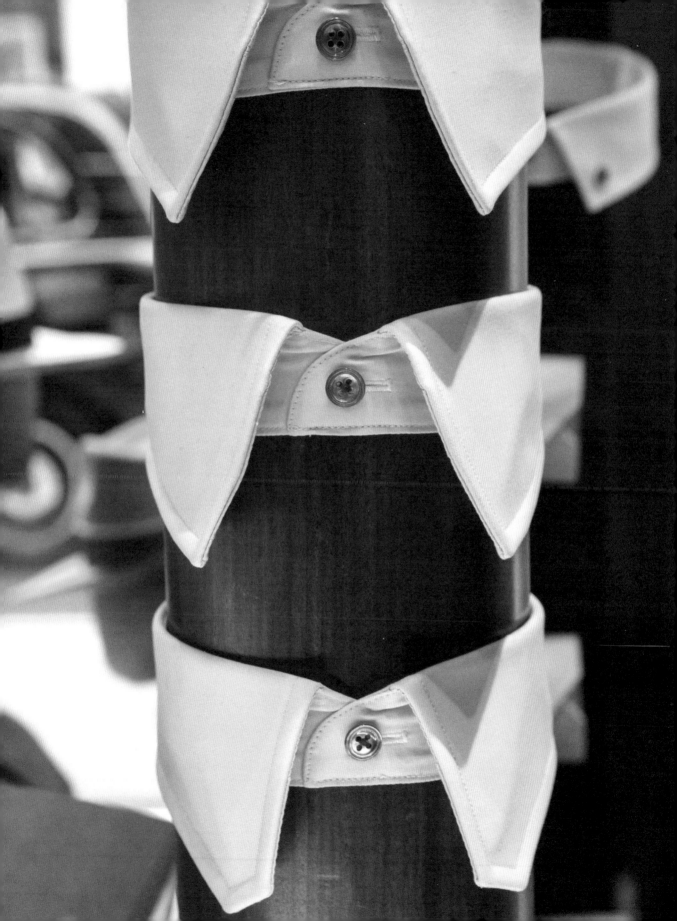

COLLAR STAYS

Collar stays or collar bones are the removable plastic (or mother-of-pearl) 'stiffeners' that keep a formal collar looking stiff and robust and sitting properly against the collar bone. They fit neatly into a pocket sewn into the underneath of the collar point and should be removed for washing and ironing shirts. The stays come in different lengths and fits according to the maker's collar style.

Some ready-to-wear shirts come with sewn-in (often flimsy) collar stays and in most cases this should be avoided as they rarely sit right and can leave an imprint when the collar is ironed.

More casual shirts, such as button-downs, tab collars and many linen shirts and formal wing collars, are not made to support collar stays, but the majority of Jermyn Street shirts are.

Although it is unusual, should you wish to see smart Jermyn Street shirts worn without collar stays, watch *Diamonds Are Forever*, in which – unlike his five previous 007 movies – Sean Connery eschews them, giving his shirts a softer, more relaxed look, even with his three-piece suits. The film came at a transitional period in menswear, before the elephantine collars which came to define the '70s look took hold, and reflects the largely American setting of the film. The look was pulled off far more effectively by Cary Grant in *North By North West*.

One thing I would avoid at all costs are the sets of metal collar stays which some of the Jermyn Street shops (and other luxury goods stores) sell as gifting items. Not only are they unnecessarily expensive but they can actually harm your shirt collar – they are heavier than the collar is designed to hold and in extreme cases they can damage and push through the fabric. If you want to add a touch more ostentation to your shirt, invest in a more luxurious cloth rather than these monstrosities.

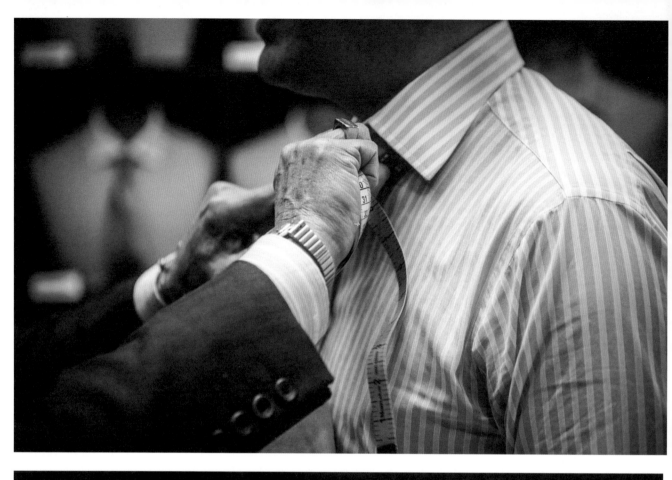

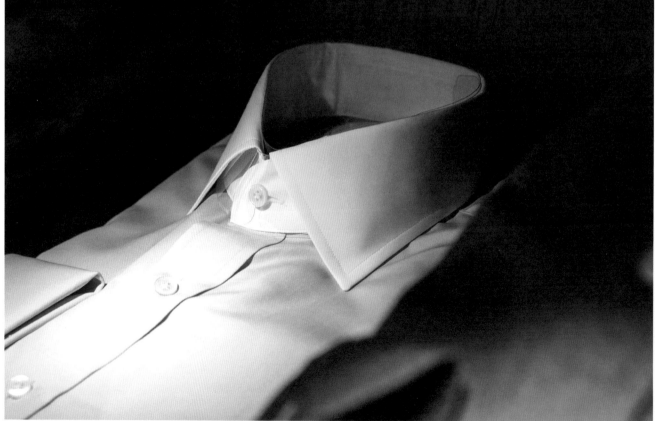

CUFFS

As shirts were originally designed as undergarments to keep expensive suiting from contact with the body, they were made without cuffs, and for many years wearing shirt sleeves in public was viewed as a flagrant etiquette failure. In the early 1500s, tiny ruffles – the genesis of cuffs – began to adorn the ends of shirt sleeves. These, of course, evolved and became more structured to the point where men would put ribbons through or around them to keep their sleeves in place. So the perception that cufflink shirts are somehow 'original' or historically correct is a fallacy. Indeed, that great dandy Louis XIV had one eye-watering dress set of 104 diamond buttons and 48 diamond studs but still tied his sleeves with ribbons.

When studs and buttons were combined to form the precursor of what we now know as the cufflink is lost in the mists of time. The earliest reference to cufflinks is believed to be in a 1788 edition of the *Birmingham Gazette*. It was not until the Industrial Revolution – and thus the mass manufacturing of metal goods – that cufflinks became readily available (and affordable) to the masses.

There is no right or wrong in wearing double cuffs or button cuffs with a suit; it is entirely a matter of personal preference. Double cuffs should, however, be worn with evening wear.

DOUBLE CUFFS

The double cuff, link cuff or French cuff is a long cuff that folds over and is fastened by external links via two holes in either side of the cuff. It can have rounded or squared edges.

Although the cuff designed to be worn with cufflinks is often referred to as the 'French cuff', it is definitely a British invention, and the French appellation was not given until the style reached America.

In Victorian and Edwardian times, cuffs (like collars) were both stiff and detachable and the stiffness was achieved by starching. These starched cuffs would be too stiff to accommodate a traditional button without breaking it, so metal cufflinks became more popular amongst the middle and upper classes. The first double cuffs had six holes rather than the now standard four in order that, if the shirt was worn two days running, it could be rolled back a bit to obscure any grime left around the cufflink holes. Similarly, detachable cuffs could be reversed for a second day's wear if deemed grimy. It is to be hoped that the modern gentleman would not wear the same shirt two days in a row.

There are also single-link cuffs, which are essentially a large single cuff designed to be worn with cufflinks, but these are simply not as appealing as double cuffs and much like the hybrid cuff are neither really one thing nor another.

SINGLE CUFFS

The most popular cuff style, the single or button cuff, is a little less formal and arguably less prestigious than the double cuff, not only because the lack of jewellery makes it plainer but because by using less fabric it should – in theory – be cheaper. This is certainly why it is the style favoured by most high-street fashion brands.

The single cuff is a smaller cuff shaped like a barrel (hence it is often referred to as 'barrel cuff') and attached via a simple button (or buttons), much like the front of a shirt. It usually features a single button, two buttons or – particularly from Turnbull & Asser – three buttons. The edges of the cuff are usually mitred or rounded. Mitred can appear slightly more formal.

Some retailers sell an adjustable button cuff with two buttons for a tighter or looser fitting. Although this style, which is more popular in America than Britain, is not visually unappealing, it is unnecessary if your shirt cuffs fit you well.

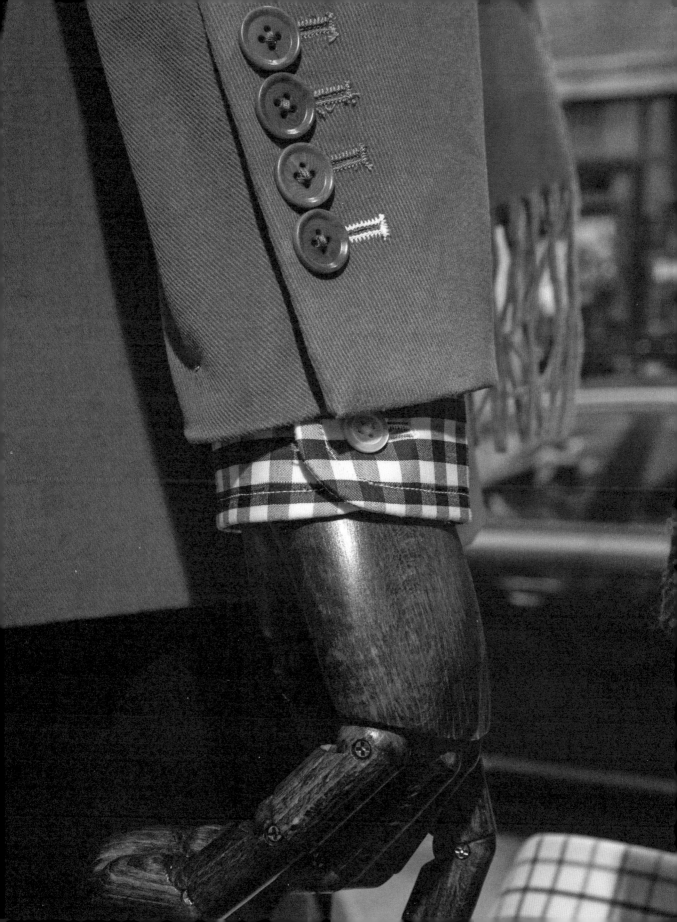

COCKTAIL CUFFS

The cocktail cuff – also known as the Portofino cuff, turnback cuff, casino cuff, Neapolitan cuff or James Bond cuff (and, yes, upon occasion, the penis cuff owing to its phallic curves) – has as many claims of credit for its invention as it does names. Both Turnbull & Asser and Frank Foster claim to have made it first, and both were certainly proponents of it in the 1960s (on David Niven, Sean Connery and Roger Moore), but in truth its origins likely date back to the 1930s, when a common complaint in London bars was about the loud clanging that metal cufflinks made against marble counters when worn by well-oiled drinkers.

The cocktail cuff is similar in structure to the double cuff, except it is fastened with two buttons (or, upon occasion, one) rather than by detachable links. It has a uniquely streamlined elegance and, unlike its simple button and link counterparts, has never achieved mainstream popularity, so still has a certain novelty. As such, it is perhaps the most satisfying of all cuff styles since it is functional, aesthetically pleasing and that little bit different.

Sean Connery popularised the cuff on film as Bond, while Roger Moore did so on television in *The Saint* (and later *The Persuaders*). Moore wore a unique button-down (or button-back) cocktail cuff in both shows, designed by Frank Foster to stop the cuffs catching inelegantly on the jacket during action scenes. *The Persuaders* was, of course, as much about peacockery as it was about solving crimes and Moore wears some truly beautiful shirts with cocktail cuffs throughout the series. Connery later wore similar button-down cocktail cuffs in the 'rogue' Bond film *Never Say Never Again*. The button-down cocktail cuff is perhaps the most striking of all, but with four buttons excluding the gauntlet, don't expect to undo it in a hurry.

COCKTAIL CUFFS ON SCREEN

The story goes that clubbable, former military man Terrence Young, who directed *Dr No*, fashioned Bond's on-screen appearance on his own, taking Connery to his tailor Anthony Sinclair and his shirtmaker

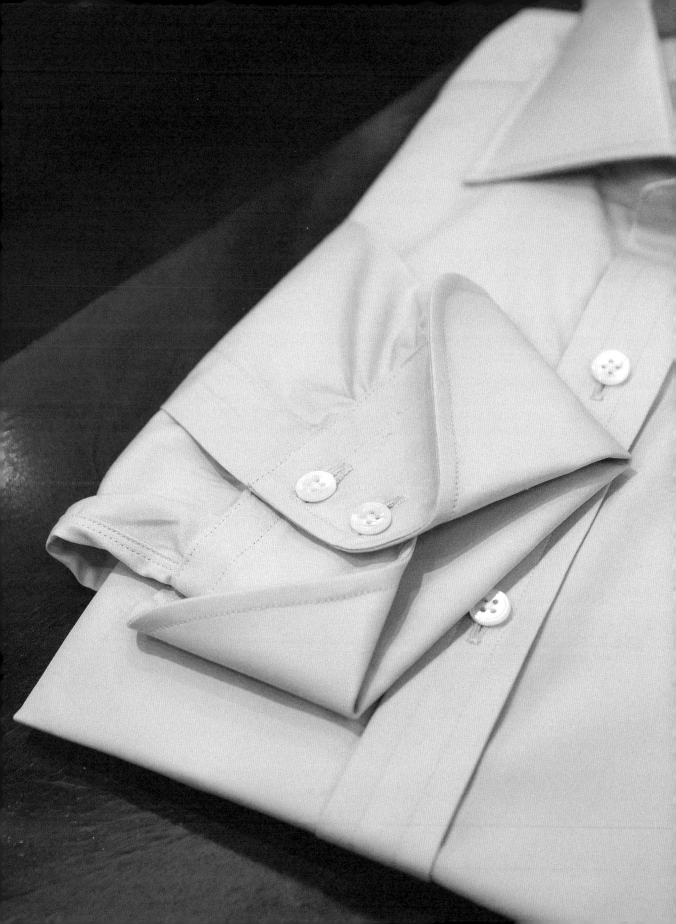

Turnbull & Asser. Young wore cocktail cuffs and thus so would Bond. There was no precedent for cuff styles in Ian Fleming's books; we know only that the literary Bond wore shirts of Sea Island cotton from an unnamed Jermyn Street maker.

Sean Connery wore cocktail cuffs as James Bond in *Dr No*, *From Russia with Love*, *Thunderball*, *You Only Live Twice*, *Diamonds Are Forever* and *Never Say Never Again*. For reasons that are lost in the mists of time – although probably simply because Guy Hamilton replaced Terrence Young in the director's chair, Connery's shirts were made elsewhere for *Goldfinger* and he wore cufflinks.

When George Lazenby took over, director Peter Hunt took him to his own tailor, Dimi Major in Fulham, in order to give him that 'similar but different' look which formed the ethos of the film. Frank Foster made Lazenby's shirts, which were fastened with cufflinks.

Roger Moore, having made the cocktail cuff very much his own on the small screen and in his private life, wore them in *Live and Let Die*, *The Man with the Golden Gun* and *Moonraker*. When Doug Hayward started making Moore's suits as Bond from *For Your Eyes Only* onwards, he was keen to establish a more minimalist look for Bond without fashionable flourishes, so the cuff style changed to regular button cuffs. Moore was inarguably the best dressed of the Bond actors off screen and had the most input in the character's wardrobe, but after the excesses of *Moonraker* a more muted style was certainly appropriate.

For the next two decades, Bond's love affair with cocktail cuffs floundered as first Timothy Dalton and then, surprisingly, Pierce Brosnan opted for other styles.

Starting in *Spectre*, Daniel Craig has worn Tom Ford cocktail cuffs both as James Bond and in his private life, and while a number of high-end designers have adopted the trend it is unlikely ever to become a high-street staple as menswear becomes successively less formal. Mayfair shirtmaker Oscar Udeshi was so influenced by Bond that he named his shirt styles after the 007 actors, calling his cocktail cuff shirts The Connery.

Away from James Bond, the cocktail cuff shirt has been worn by Don Adam in *Get Smart*, Martin Landau in *Mission Impossible* and Dick Van Dyke in *The Dick Van Dyke Show*. Rogue Bond Peter Sellers wore cufflink shirts in the first big-screen *Casino Royale* but sported cocktail cuffs in *What's New Pussycat?*

If you've not tried a shirt with this style of cuff, I cannot recommend it highly enough, and if you are placing a bespoke order in Jermyn Street, make sure at least one of your shirts has these cuffs.

HYBRID CUFF

The hybrid cuff is a single cuff that has an option to be worn either with its attached button or with cufflinks. This is a somewhat unimaginative cuff usually found on high-street shirts and one largely to be avoided. If you want somewhere between cufflinks and button cuffs, opt for a cocktail cuff instead.

TAB CUFF

The tab cuff (or 'Lapidus cuff', per Frank Foster after French designer Ted Lapidus, whom he cited as its inventor) is essentially a particularly outré button cuff with a decorative tab extension (essentially a flap with a button hole). Although this style is perhaps best known as the choice of Robert De Niro's Sam Rothstein in *Casino*, it was also seen on James Bond's shirts in *The Spy Who Loved Me* and *Moonraker* (including on an evening shirt, a particularly 1970s flourish). It is sporty rather than formal and better worn with more casual outfits.

There is a version with a small buckle-like piece of fabric that the flap slides into before buttoning, which is elegant if a little busy.

WATCH CUFF

Legend has it that Fiat boss Giana Agneli had an allergy to metal on his skin, so took to wearing his watch over the (single) cuff of his shirt. In response, shirtmaker Angelo Galasso, then working under the Interno8 label, invented his eye-catching but decidedly unsubtle 'Polso Orologio'

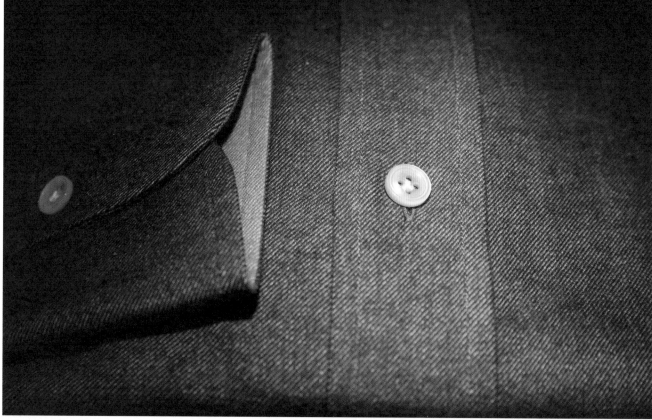

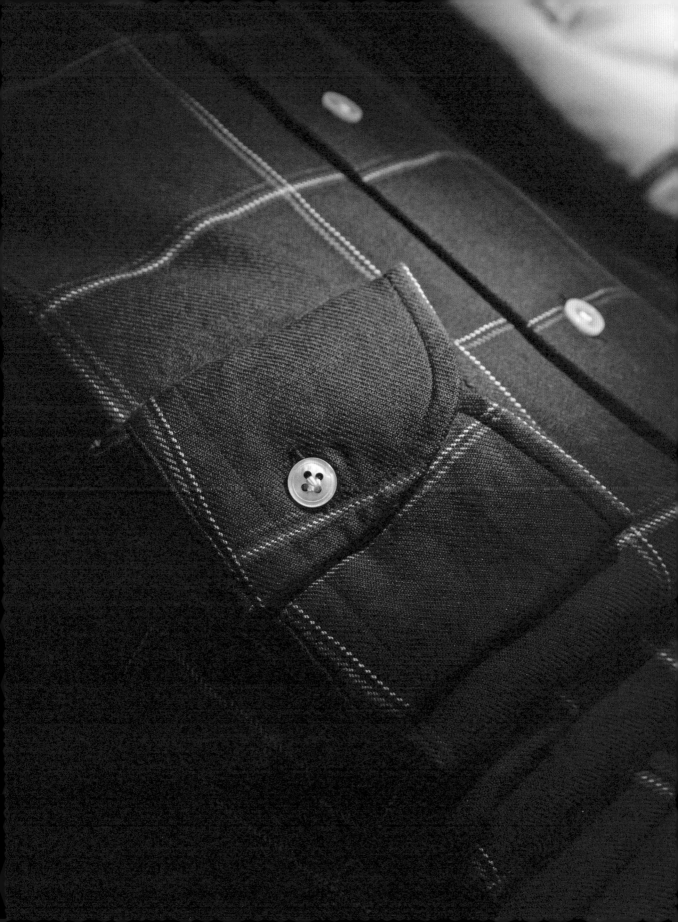

– literally 'watch cuff' – shirt: essentially an oversized cocktail cuff, structured to act as a barrier between watch and wrist with a portion cut away to display the watch's face. Popularised by Sir Roger Moore's restaurateur son Geoffrey, one of the brand's ambassadors, it has become a striking favourite amongst celebrities usually keen to show off their hefty timepieces rather than protect their skin. Any shirtmaker on Jermyn Street could make this cuff – or something similar – for you easily enough. Whether they will *want* to is another matter. Galasso's extravagant shirts (and suits, shoes and casual wear) are definitely polarising, but his innovation as a shirtmaker is undeniable. More subtle and yet more striking than the watch cuff is his double collar shirt, which can come with a doubled cuff (essentially a dummy end piece, so it looks like one cuff on top of another) – but don't be tempted to wear two ties if you venture into this particular sartorial space. Galasso's shirts command a price point as big as his collars, starting at over £500.

SURGEON'S CUFFS

A true dandy might still have his shirts made with what are called surgeon's cuffs. These can be any of the styles above but are made as separates, which are attached to the shirt sleeves with buttons and can be washed separately or replaced with alternative cuffs in a contrasting fabric. They are called surgeon's cuffs because of the historic practice surgeons have of taking them off before performing messy operations.

Cufflinks – much like watches – are a very personal and subjective choice, and whether you wish to show off huge jewelled examples or simple discrete steel links is entirely up to you. What should always be avoided (and is thankfully less commonplace than it was a few years ago) is the lazy trend for silk (or, invariably, elastic) knots as an unimaginative alternative. Although invented by Charvet, the most prestigious of French shirtmakers, in 1904, the look has lost any sheen it might once have had and should remain the exclusive domain of the third-rate estate agent, matched with an electric blue suit and brown plastic shoes. If you don't wish to wear cufflinks, buy button cuff or cocktail cuff shirts.

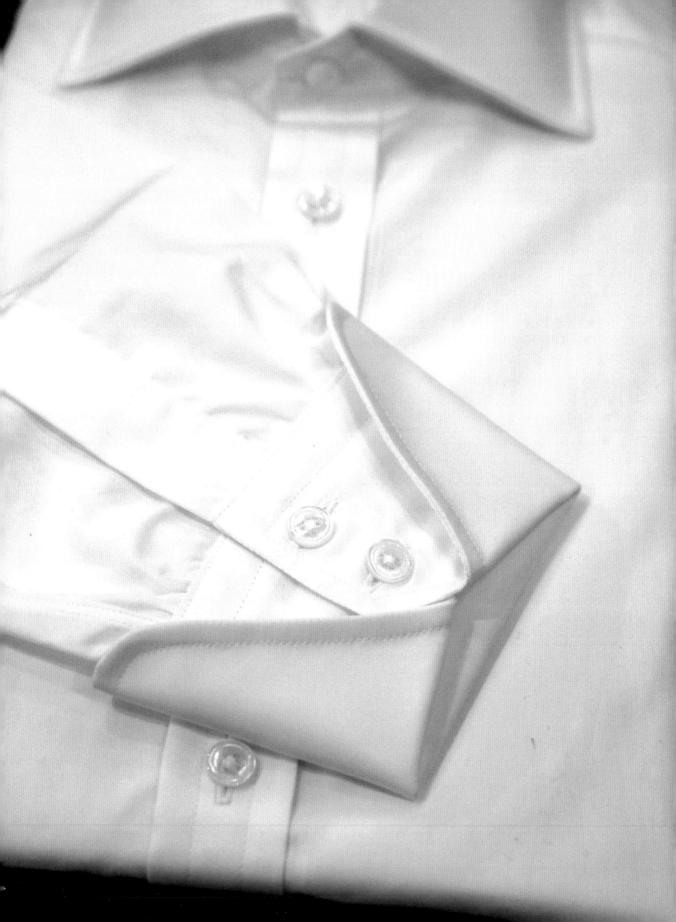

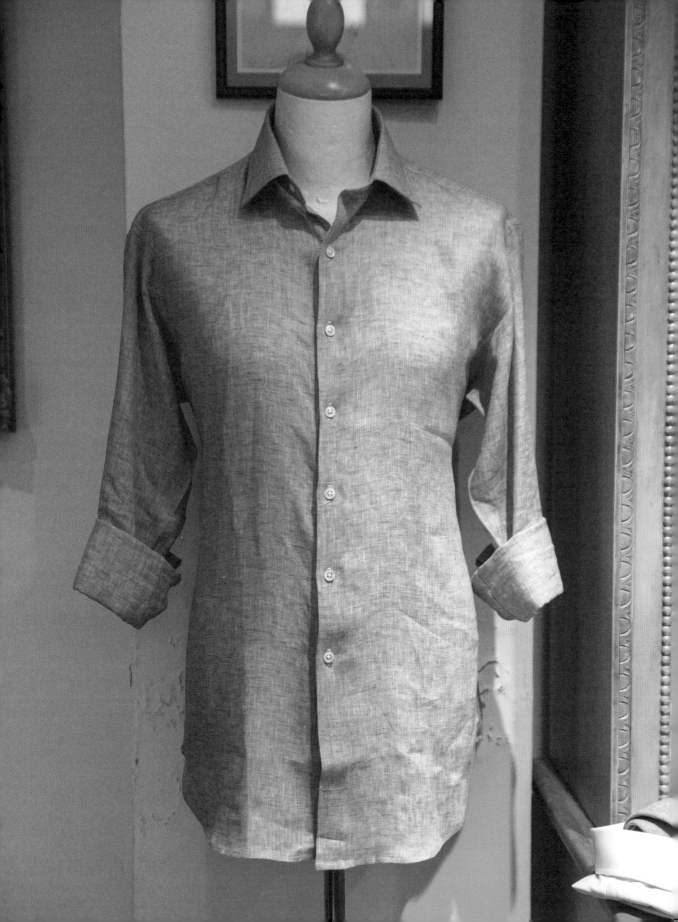

SHIRT FRONTS, SLEEVES AND POCKETS

In many cases the front of your shirt will be obscured by your jacket and tie, but both will, upon occasion, come off and there are a number of style options with which to present your buttons.

PLACKET

A placket is the external double layer of fabric in the centre of a shirt which houses the buttons and buttonholes. It strengthens the garment (reinforcing as it does the most-used part, from buttoning and unbuttoning) as well as making it more visually appealing without a tie. Most quality ready-to-wear shirts come with a placket, but it is entirely up to you whether you choose to have a shirt made with one.

PLAIN FRONT (AKA FRENCH PLACKET)

A more subtle, minimalist variation has the material of the shirt folded towards the underside, giving the same protection as a traditional placket but with a cleaner line to the eye. Enthusiasts will tell you that it is neater, but it is entirely a matter of preference.

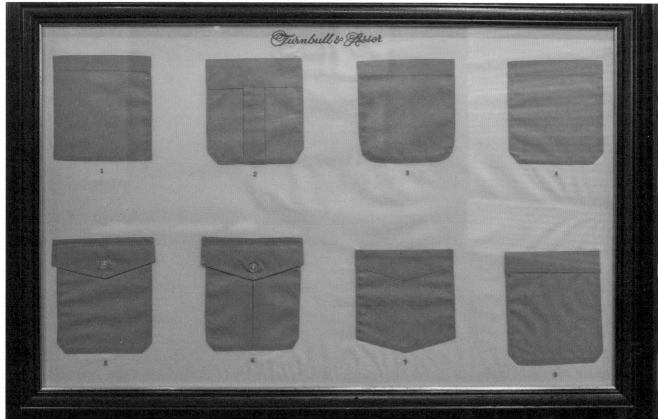

FLY FRONT

The fly front (seen also on coats) refers to a placket where the buttons are actually concealed by an extra layer of cotton like a flap. This gives the shirt a completely clean, uncluttered look and is particularly popular on evening shirts, making dress studs unnecessary.

SLEEVES

The golden rule of shirt sleeves on anything except casual shirts is that they should be long. Short sleeves have no place on a formal shirt and should never be worn with a jacket or tie. Half the joy of shirts is a strong cuff, so don't even think about denying yourself this pleasure. It is important to get your sleeve length right, but how much cuff you show is entirely up to you – 2cm is about right traditionally: remember, discretion is the better part of valour in this case and you will show off more cuff when you extend or fold your arms. If shirt sleeves are too long, they will make your jacket look short, and if you aren't wearing a jacket, you will look like you are wearing your father's shirt, which is not a look to aspire to.

POCKETS

The breast pocket is something of an anachronistic style choice since it really serves no functional purpose and should be exclusively the domain of the casual shirt. Breast pockets on business shirts are a sign of cheap ready-to-wear manufacture and should be avoided at all costs. If you love it, have a safari shirt made and wear it untucked instead of a jacket, though you'll find bespoke shirtmakers are often reticent to make this magnificent style as a lot more work goes into it than traditional shirts – if you can convince one to embark on making such a shirt, jump at the opportunity. Every man should have at least one in his wardrobe.

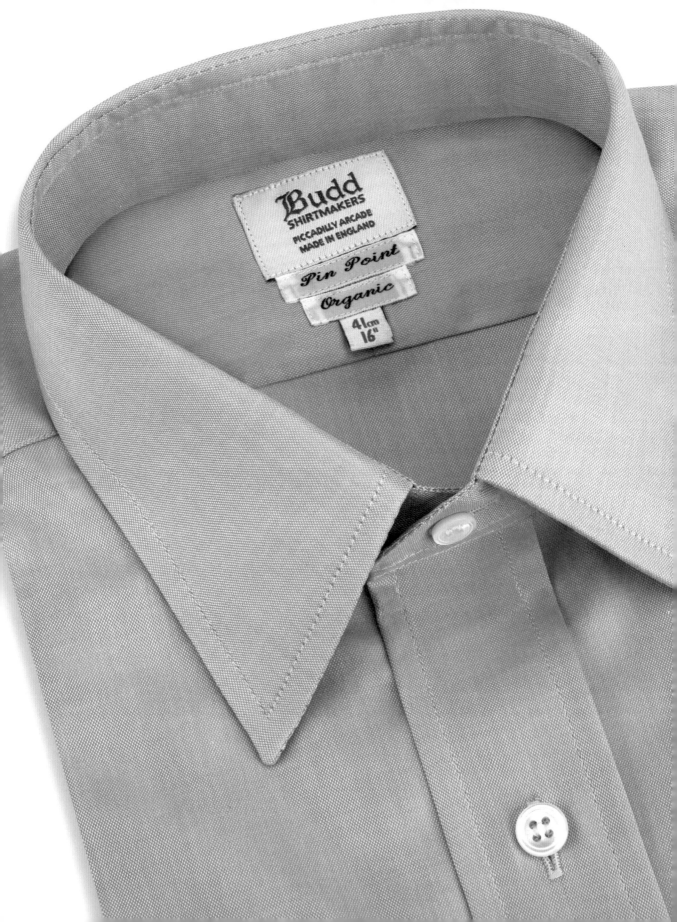

Budd
SHIRTMAKERS
PICCADILLY ARCADE
MADE IN ENGLAND

Pin Point

Organic

41cm
16"

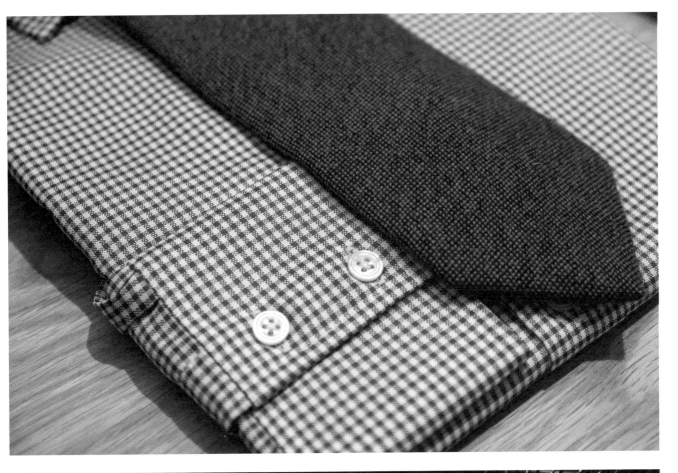

THE DEVIL IS IN THE DETAIL – DOS AND DON'TS!

The joy of bespoke shirts in particular is that you can have anything – well, almost anything – that you wish done to them. Your shirtmaker will do his best to give you advice, so that your shirts will be stylish and classic for many years, but there are certain choices only you can make.

One of the great anachronisms of shirt making is that panel of fabric behind the collar and across the shoulders which is known as the yoke. This comes in two forms: a one-piece yoke, which as the name implies is made from a single piece of fabric; and a 'split yoke', which is split down the middle. The original purpose of the split yoke was to give a little stretch to a shirt across the shoulders to accommodate movement. As a split yoke uses more fabric and takes more time and effort to make, it is generally regarded as superior, and often marketed as such, but as nobody is likely to see this part of your shirt it is very much on an 'if you know, you know' basis.

Monogramming, the practice of having one's initials embroidered on a garment, is divisive to say the least. The practice began when most shirts were white so that they could be told apart when sent to be laundered en masse. Today it is very much a personal choice but, I would venture, best left behind with writing one's name inside school uniforms. It is particularly ghastly on the shirt cuff, flashed around for all to see. If you must do it, limit yourself to plain white cotton or linen handkerchiefs which nobody else needs to see.

Much as Frank Sinatra can be regarded as much a style icon now as in his sartorial heyday, one of his flourishes which is probably best left in the past – for reasons of both dignity and practicality – is the strange buttoning of his shirts with a flap of fabric on the back hem over the posterior. If anyone could make such an unusual look work, it would, of course, have been Ol' Blue Eyes, but the result today is more adult baby than Hollywood legend.

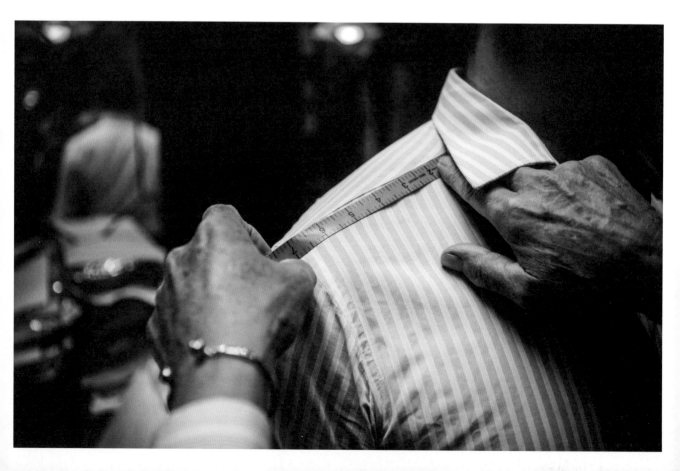

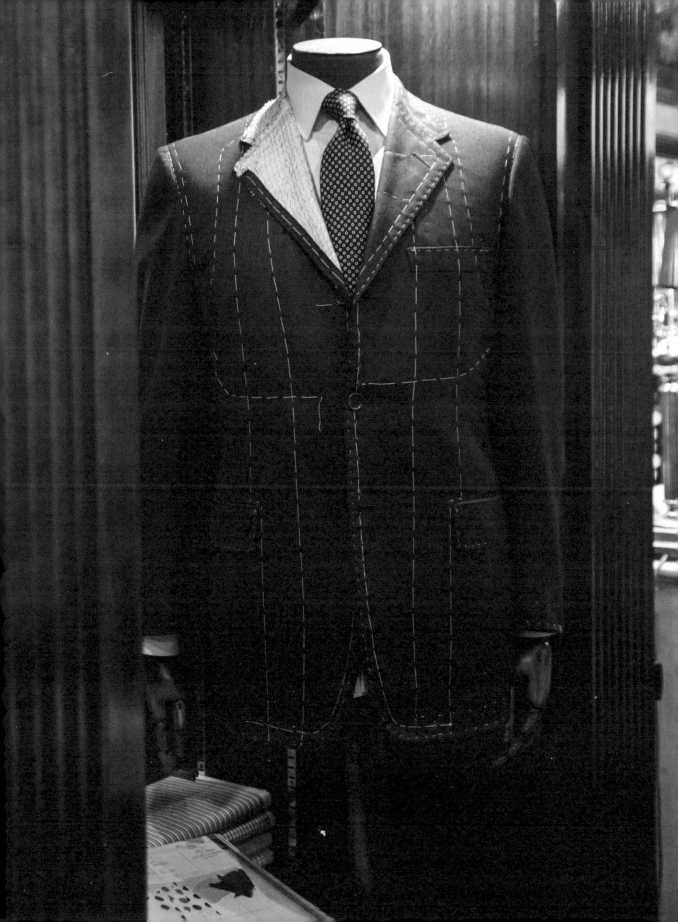

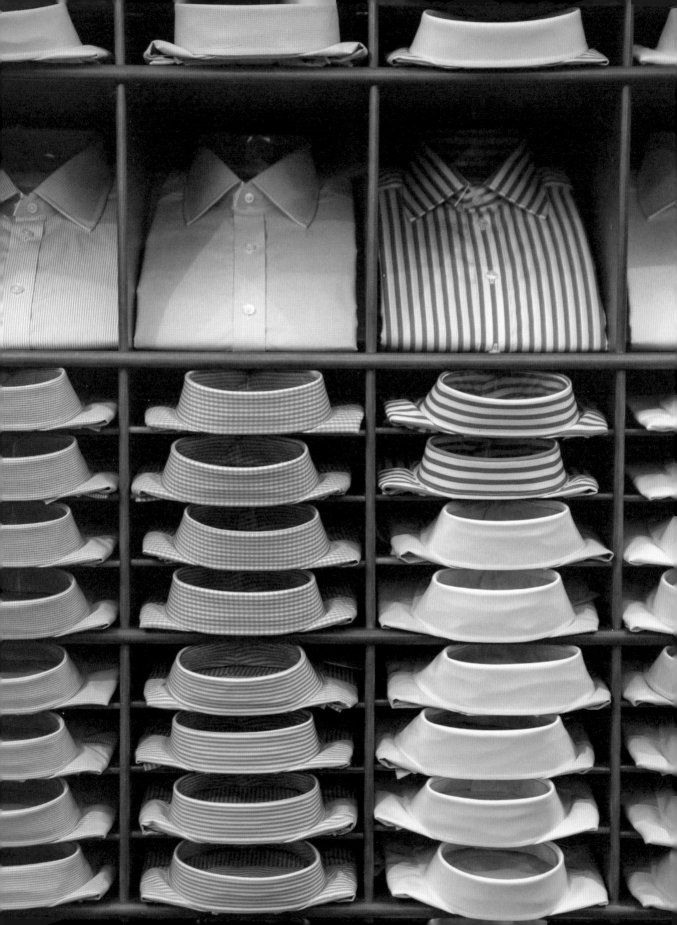

CARING FOR YOUR SHIRTS

I f you look after good-quality shirts, they will last you a long time, particularly if you have the collars and cuffs replaced should they fray (a very real hazard with certain fabrics, particularly herringbones). A decent shirt, and certainly a bespoke shirt, should easily last a decade.

HOW MANY SHIRTS DO YOU NEED?

The answer is, of course, as many as you want, but in practical terms, a strong capsule wardrobe would be ten business shirts and six casual shirts. If you have a business shirt for every work day, you can give them every other week off so that they do not wear too much. Of course, as Jermyn Street aficionados know only too well, necessity is never the end when it comes to shirts.

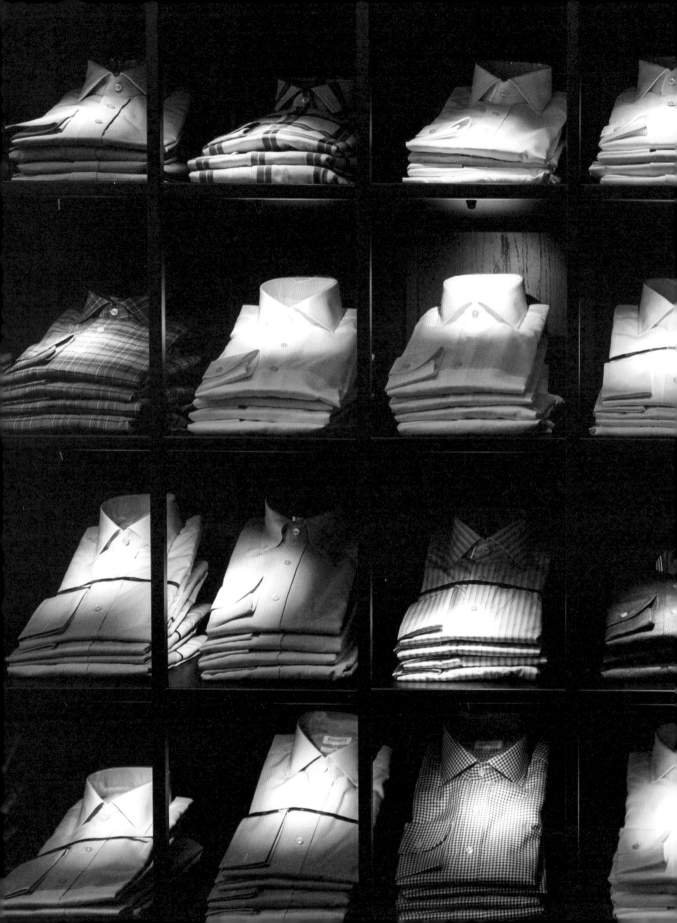

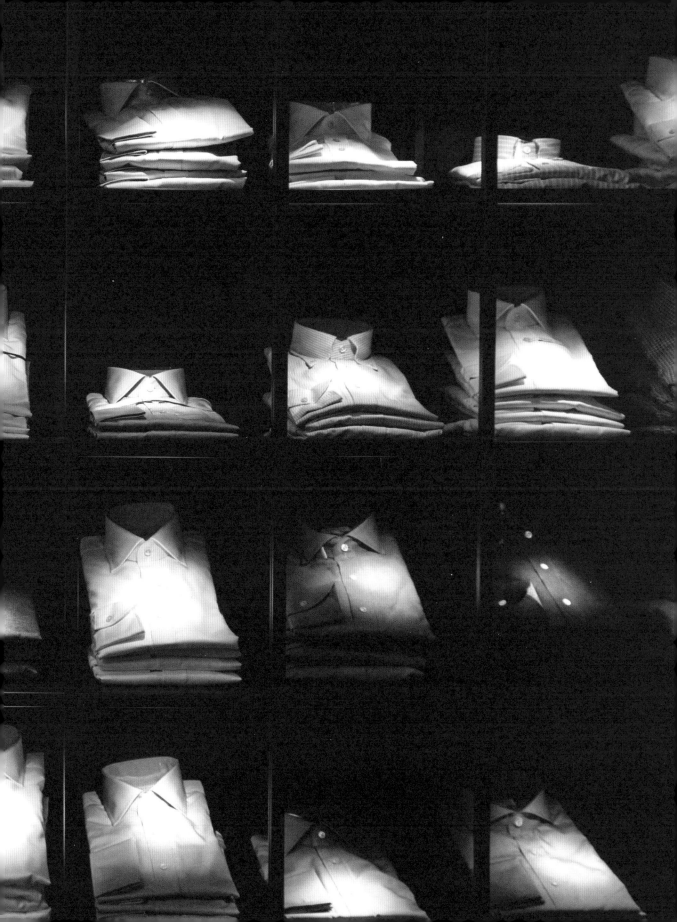

HOW TO FOLD A SHIRT

1. As soon as the shirt is ironed, hang it on a hanger to cool off for approximately thirty minutes. Put the collar stiffeners in (if needed) and button or fold back the cuffs.
2. After half an hour, button up all of the buttons (including the collar one) and lay the shirt on your ironing board front side down.
3. Fold one half of the shirt over.
4. Fold the sleeve of the folded half down.
5. Fold the other half over, so that they meet in the centre.
6. Fold the second sleeve in and down so that the shirt has a long rectangular shape, approximately the same width as when you bought it in a packet.
7. Fold the body of the shirt almost in half (twice if the shirt is a long one), in order that the bottom of the shirt body touches the bottom of the back of the collar.
8. Turn the shirt over and modestly pat yourself on the back.

STORAGE

Whether you hang your clean shirts or keep them folded can be a matter of space as much as any other practical reasoning – shirts hung in a wardrobe will often emerge with squashed collars and have to be rooted through to find the right ones. Personally I keep mine folded, much as they come when new in a packet; if they have been well ironed they will usually hold their shape and just unfold neatly, ready to wear. Of course, some fabrics will withstand folding better than others, so you may need to try both and see which works best for you.

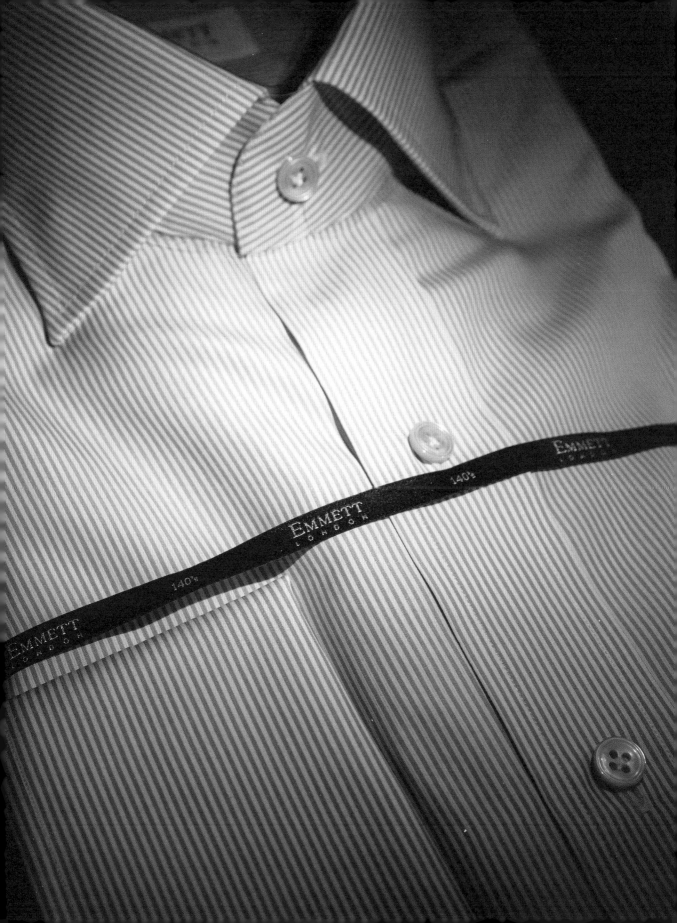

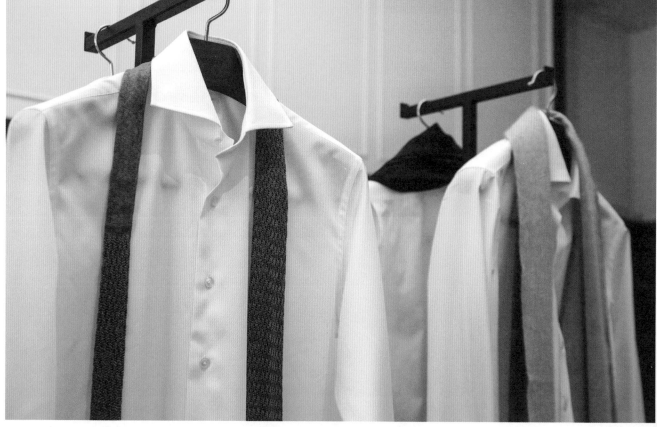

WASHING AND LAUNDERING

While one hopes that it goes without saying, it is worth noting that a good shirt should be washed and ironed every time it is worn.

Professional dry cleaners are, on the whole, best avoided – there's nothing they can do for a shirt that you can't do yourself, and delicate fabrics have an unfortunate propensity for coming home squashed and crushed, and pearl buttons cracked, chipped or in some cases shattered (some high-end dry cleaners will wrap the buttons in tin foil but really those huge washing machines are just best avoided). Generally speaking, the same applies to suits and jackets, except when they are actually stained. I would recommend washing your shirts at 40°C and using a simple household detergent. Fabric softener should not damage your shirts. After washing, hang your shirts on wooden hangers to air dry, in order to keep their shape as much as possible.

IRONING

Ironing is, of course, the least attractive aspect of owning a collection of beautiful shirts, but the effort put in reaps huge style rewards and a creased shirt really is the sartorial equivalent of bad breath or dandruff.

It is important to iron your shirts slightly damp (but not wet), after hanging them up from washing – it makes them more pliable and does not give them time to have unwanted creases set in.

You will need a steam iron, which should be kept clean to avoid staining. Take the shirt off the hanger and lay it on the ironing board.

1. Begin with the collar, which you will need to spray with steam while ironing. This is the most important part of your shirt, so pay special care to getting any creases out. It might sound obvious but remember to iron both sides.
2. Next the cuffs, again with steam – each in turn, again remembering to iron both sides. Do not iron over buttons as this will damage them.

3. After the cuffs, iron the sleeves in turn, ensuring that the fold is at the seam – pull the fabric gently at one end to ensure the sleeves are crisp and smooth.

4. The challenge of the front is the placket – iron it with steam, carefully going around the buttons with the pointy end of the iron. Once the placket is ironed, iron one side of the front, which is comparatively easy.

5. Iron the rest of the shirt by turning it – so after the first half of the front, turn it around to the corresponding back, iron the back of the shirt and then finally the un-ironed part of the front. This circular motion will ensure the shirt is as crisp as possible.

6. Put the collar stiffeners in. Hang the shirt on a wooden hanger and button it up at the front. Button up the cuffs of button cuff shirts but leave those of double cuff shirts hanging undone.

TRAVELLING

You are always better taking shirts folded rather than hanging – suit bags, whether those you get when you buy a jacket or the more robust designer ones, will always leave your shirt looking somewhat the worse for wear. Folded shirts can be packed neatly one on top of the other (with ties rolled up inside the collar) in a suitcase or overnight bag. If you're not keeping toiletries in a sealed bag, ensure that the shirts are wrapped in polythene or something similar.

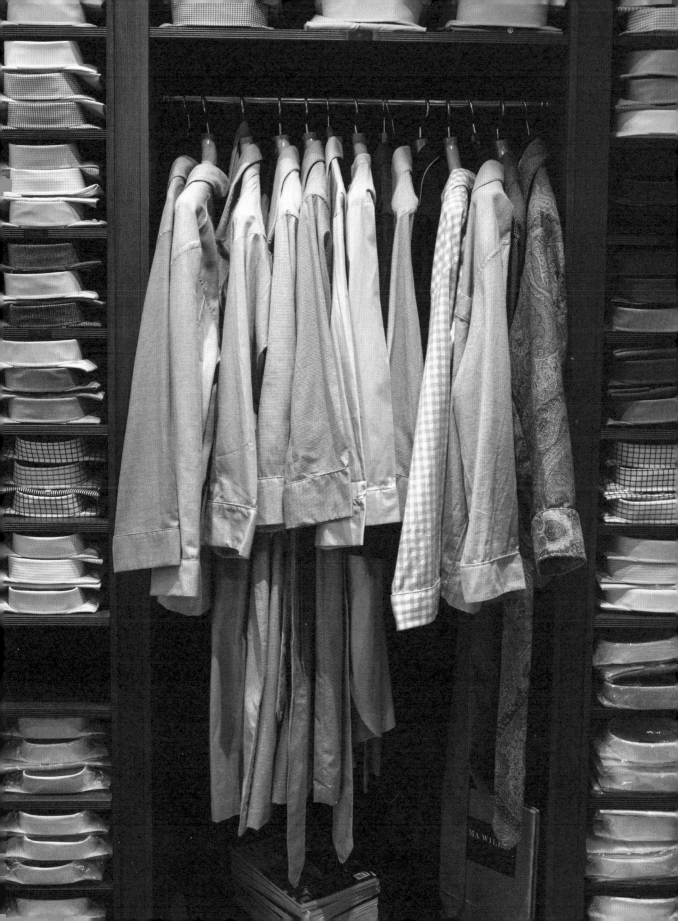

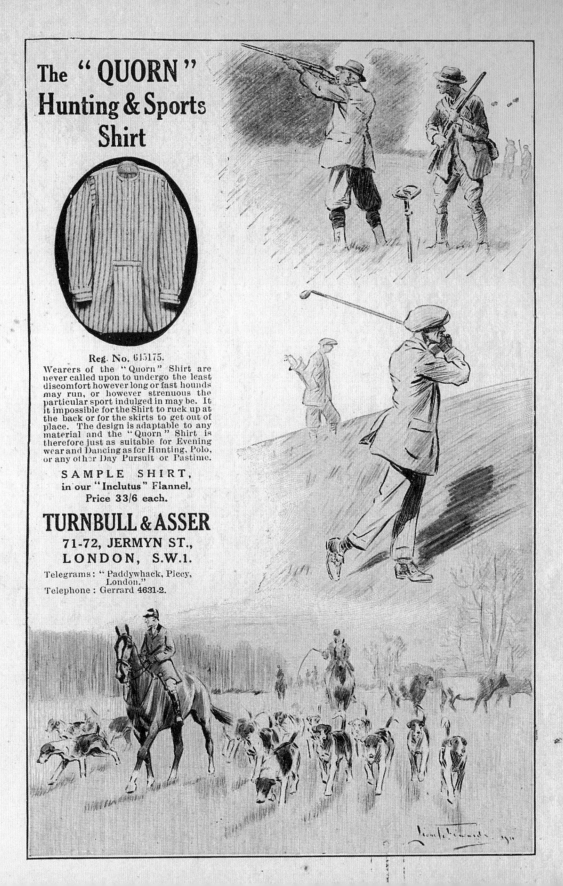

THE HISTORY OF JERMYN STREET

LIFE AND TIMES OF HENRY JERMYN

Jermyn Street (pronounced, for the avoidance of doubt, 'Jer-min', not 'Jer-main' or 'Jer-man') takes its name from Henry Jermyn, the 1st Earl of St Albans, who is regarded as the architect and creator of what we now know as London's West End. Indeed, the *Survey of London* (volume 29) refers to him as the 'Father of the West End'.

Jermyn was a notable Stuart courtier and politician, an ardent royalist and a prolific Member of Parliament whose seats included such diverse constituencies as Bodmin, Liverpool, Corfe Castle and Bury St Edmunds. As a royalist he was a close confidant and adviser to Charles I and his consort Henrietta Maria of France – indeed, it is often suggested that he and Henrietta were lovers and even that he was the real father of Charles II. Either way, Jermyn spoke French fluently and this undoubtedly held sway with Henrietta.

Influenced by his wife, Charles I bestowed power and status on Jermyn, but timing was against him as the king's conflict with Parliament became a crisis. He was made Baron Jermyn on 6 September 1643, allegedly so that if he were to fall into the hands of Parliamentarian plotters, he would be beheaded as an aristocrat rather than suffering the far more horrific hanging, drawing and quartering to which the proletariat were sentenced. Jermyn sought to cow Parliament with the military, but his plan backfired and he was forced into exile in France. Henrietta joined him in France and together they built a mighty army and sailed back to England – through the

most treacherous of storms – to wage war on the parliamentary forces. Henrietta became pregnant once more in 1644 and the pair returned again to France, where they set up a power base at the Louvre in Paris.

While Cromwell ruled England, Jermyn plotted relentlessly to restore Charles to the throne and was the architect of what is known as the 'Second Civil War'.

In 1660 Jermyn was made Earl of St Albans and after the Restoration was made Lord Chamberlain. His power at court was reduced significantly owing to his rivalry with the chancellor, Edward Hyde, however, so he refocused his energies on building a lasting peace between England and France, a cause which would dominate much of the rest of his life. Amongst his triumphs were the marriage of Charles II and Catherine of Braganza (daughter of the King of Portugal, a key French ally), which delivered Bombay to England, paving the way for the British Empire in India. Jermyn's greatest political achievement was perhaps the Secret Treaty of Dover in 1670, from which came the Anglo-French Grand Design.

Before that, however, Jermyn had obtained a grant of land in London to the north of St James's Palace. Jermyn built St James's Square and the neighbouring streets, as well as St Albans market, the site of which would later become Waterloo Place and Regent Street. At the time, the 'Little Town' – an exclusive, expensive development – was known as St James's Field and comprised fourteen opulent townhouses and four whole streets for noble families and those popular at court to live in.

Jermyn Street (known originally as 'Jarman Streete' and occasionally 'German Street') was built around 1664 and was first listed in the rate books of St Martin's in 1167 when it was home to fifty-seven properties. It was originally planned as part of the 'Little Town' that Jermyn conceived as centred on St James's Square. The focal point of the street, St James's Church, which was designed and built by Sir Christopher Wren, afforded a rare opportunity to have the space to build a church exactly as he envisaged it without the forced compromise dictated by London's constant overcrowding. The foundation stone was laid on 3 April 1676. The site was offered to the church by the Earl of St Albans prior to 1674, but as his grant of land was only a leasehold, it could not be consecrated for use. The freehold was finally granted some ten years later and the church was finally consecrated in 1684.

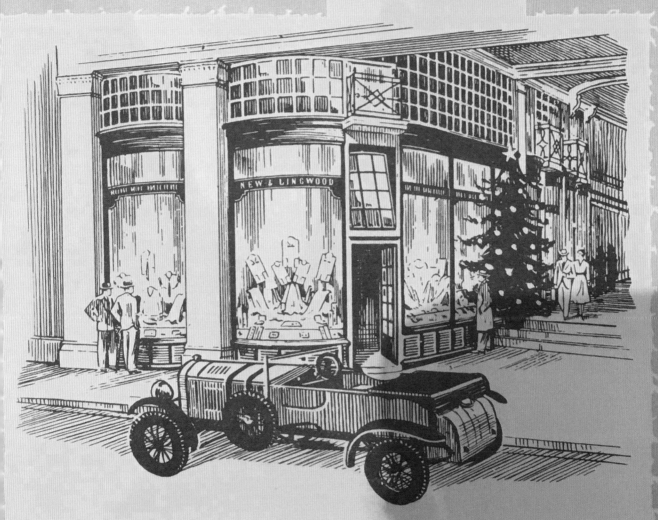

NEW & LINGWOOD

FLOREAT ETONA

CHRISTMAS GREETINGS 1966

COMMERCIAL HUB

The first shop to open on the street was a modest grocer and corner shop by the name of Fortnum & Mason, which opened its doors in 1707 and set the benchmark for the quality of the stores that would follow. In 1705 Hugh Mason had opened a small store in St James's market and when he met William Fortnum – an enterprising footman in Queen Anne's household, who had an abundance of surplus royal candle wax to sell – they teamed up to create perhaps Britain's most iconic shop.

Over the years, Jermyn Street has had a number of famous – and infamous – residents, including Sir Walter Scott, Isaac Newton, the poet Thomas Gray, the highwayman William Plunkett and the self-styled 'most evil man in the world', black magician Alesteir Crowley. Indeed, during the Second World War, Crowley was summoned to the Cavendish Hotel by an intelligence officer named Ian Fleming, who asked him if he could lure Rudolf Hess to Britain via a magic spell. The plan, which was nothing if not imaginative, was swiftly nixed by Winston Churchill.

Gradually, Jermyn Street turned from a residential into a commercial district as galleries, restaurants and shops sprang up and menswear soon became its focus. The hub of the industry was undoubtedly the stunning menswear department store Simpsons of Piccadilly. In 1935 the former site of the Geological Museum was sold at auction on a 99-year building lease and Alexander Simpson's £11,000 bid was the winning one. Simpson – whose S Simpson and DAKS trousers ranges were market leaders in ready-to-wear men's clothing – wanted premises to serve two purposes: to be near enough to Savile Row to attract bespoke customers looking for less expensive ready-made garments, and to take on the existing retail juggernaut Austin Reed. Simpson hired Joseph Emberton as his architect – Emberton had designed the Austin Reed building. Sadly, Alexander Simpson died from leukaemia in 1937, just a year on from the store's opening.

The completed building, characterised by large bands of Portland Stone and one whole side of glass windows, became a retail icon for many years, before the DAKS Simpson Group was acquired by the Japanese outfit Sankyo Seiko Co. in 1991, which sold it to the Waterstones bookshop chain. It remains the flagship Waterstones store to this day as well as being the largest bookshop in London.

Simpsons was famous as the inspiration for the popular BBC sitcom *Are You Being Served?* Writer Jeremy Lloyd was employed there as a junior assistant in the early 1950s (along with a pre-stardom Christopher Lee) and gave his colleagues comedic immortality two decades later. The DAKS brand, of course, flourished, growing beyond trousers into a full-blown collection with a distinctive house check comparable to Burberry or Aquascutum. The brand still maintains a presence in the area with its flagship store now located on Bond Street, just the other side of Piccadilly.

The Second World War saw much of Jermyn Street and the surrounding area badly damaged by Nazi bombing. In 1940 a bomb fell in the churchyard of St James's Church, destroying the rectory and the vestry, while incendiary bombs wiped out the spire and most of the roof. The church took seven years to rebuild and was rededicated in 1954.

Another building that looms large on Jermyn Street is the Cavendish Hotel, which is located opposite Fortnum & Mason. Although the current building dates back to the mid-1960s when it was rebuilt after the Second World War, the Cavendish itself goes back to the early 1800s when it was opened as Miller's Hotel. It was renamed the Cavendish in 1836 and was already popular when it was bought by Rosa Lewis and her husband Excelsior in 1902. Rosa put her husband and his sister Laura in charge of running the hotel, but unfortunately they ran it into the ground – by 1904 it was in huge debt and Excelsior was drinking heavily. Rosa, a strong-minded, intelligent woman whose work as a cook had found royal favour, took over herself and eventually divorced her husband. She turned the four separate buildings that comprised the hotel into one and made it a hub for the aristocracy, with King Edward VII and the Duke of Windsor becoming patrons. Rosa Lewis's time running the hotel in this period became the inspiration for the popular BBC drama series *The Duchess of Duke Street* in the 1970s.

When the 1960s trend for casual wear and fashion made Carnaby Street the epicentre of the menswear revolution, Jermyn Street was quick to adapt. While Savile Row, with its bolts of fabric and tape measure window displays, seemed a world away from flower power and undoubtedly suffered accordingly, Jermyn Street readily embraced the bright shirts and bold fashions pioneered by its Soho neighbours while never entirely eschewing its muted classicism. When flared trousers

and jacket lapels just couldn't get any wider, the Carnaby Street bubble burst but Jermyn Street was left standing.

When suit-centric power-dressing became the 'look' of the 1980s, Jermyn Street easily adapted again, with its white collar and cuff shirts offering that perfect Gordon Gecko look for when greed was considered good.

In December 1969 impresarios Johnny Gold Bill Ofner and Oscar Lerman opened the legendary Tramp, perhaps London's most famous celebrity nightclub, on Jermyn Street. Its forerunner, Dolly's – very much a trial run – had been at number 57, but Tramp opened at number 40 and remains there, discreetly nestled next to Fortnum & Mason. The club was named after Charlie Chaplin, cinema's 'Little Tramp', and the club would go on to play host to virtually every other major movie star for the next four decades, as well as musicians, politicians and royalty, becoming known as London's favourite place to misbehave. Joan Collins (whose sister Jackie married Oscar Lerman), Peter Sellers, Ringo Starr and Liza Minnelli all chose Tramp for their wedding receptions. Michael Caine turned up one night to tell Johnny Gold he was flying to Brazil the next day because he'd fallen in love with a Brazilian model in a commercial, only to be told by Gold – London's smoothest host – that she in fact lived around the corner. Today she is Lady Shakira Caine. Gold eventually sold the club in 2003 and retired to the West Indies, but it remains a celebrity hotspot attracting the likes of Rihanna, Drake and David Beckham.

The 1990s brought a more salubrious establishment to Jermyn Street – Hey Jo (later Abracadabra) was a bar fronted by pink-suited Dave West, a businessman and something of a character in the Peter Stringfellow mould who had made a fortune importing dubious wines in the previous decade. West's clientele was decidedly less well-heeled than that of his neighbour Tramp – in 2006 fugitive Russian spy Alexander Litvinenko received one of the ultimately fatal doses of polonium-210 with which he was assassinated. West himself was tragically stabbed to death by his own son in 2014 at his home in Ormond Yard, just off the street.

Another '90s addition to the street was the Jermyn Street Theatre, which staged its first play in August 1994. Since then the intimate basement space has established itself as one of London's best off West End theatres, attracting a plethora of talent. Like almost everything on Jermyn Street, it is both quirky and rewarding.

BEAU BRUMMELL

In 2002 a statue of Beau Brummell was erected at the bespoke end of Jermyn Street, outside the Piccadilly Arcade and casting his shadow over a triumvirate of Jermyn Street royalty – New & Lingwood, Turnbull & Asser and Hilditch & Key. Brummell, of course, was the famous gambling dandy who became a favourite of the Prince Regent in the early nineteenth century. Considered by some to have been the first celebrity, he set the fashion agenda in his day and effectively invented the trouser as we know it today. The statue, by sculptor Irena Sedlecka, has a brass plaque engraved:

Beau Brumell
1778–1840

'To be truly elegant one should not be noticed'
George 'Beau' Brummell's connections with Court, clubs and tailoring embody the spirit of St James's past and present.

Unveiled by HRH Princess Michael of Kent
on 5 November 2002

Today, during the summer months, Jermyn Street is transformed into an extravagant al fresco cat walk for London Fashion Week Men's, which is truly a spectacle to behold as the dapper regular shoppers vie and jostle with the fashionistas for pavement space.

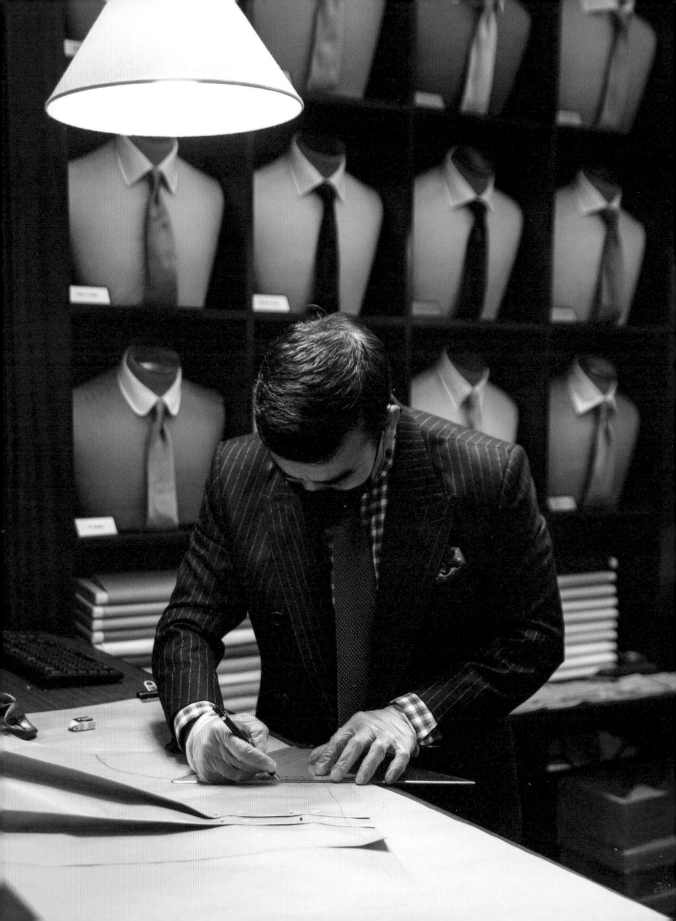

THE BESPOKE
PROCESS

A 'bespoke shirt' is one that is designed and made exclusively for you to your exact specifications. The word 'bespoke' harks back to the early days of Savile Row when a tailor would refer to a length of cloth purchased by a customer as 'spoken for'. It is a unique process and quite different from what is referred to as 'made to measure' or 'stock special', when a shirtmaker takes an existing pattern or block and tweaks it to suit a customer. These options should not be dismissed out of hand, but today the full bespoke process is so easy (and the price difference generally so small) that they are rarely worth bothering with.

A ready-to-wear shirt is sized solely upon the circumference of the wearer's neck, and the body shape, sleeve length and everything else are based on a manufacturer's idea of average proportions. This is why many people find a shirt brand that 'fits' and eschew buying same-sized shirts by different makers as all have different ideas on fit. For those lucky enough to be that 'right' size, buying shirts off the peg is simple, but for the rest of us it is a pain. At some point, if you care about your appearance, you will probably consider bespoke as a solution to these problems. Although it may seem that bespoke shirts are better quality – and in many cases they are – if you can find your ideal shirt off the peg and it fits you well, there is another reason beyond fit and style to have something made for you – for the experience.

While every shirtmaker has their own subtleties and nuances, the true bespoke process is largely the same amongst the artisans of Jermyn Street. Whom you pick to make shirts for you is an entirely personal choice – it may be that they made your father's shirts, those you admired a friend wearing or one you have seen in a magazine or a movie. Don't

expect any snobbery – bespoke shirtmakers love people who wish to bespeak shirts and you will receive a warm welcome wherever you choose to go. Jermyn Street has never been snooty and today more than ever it is an inviting, beguiling place, filled with skilled shirtmakers keen to ply their trade.

While there are high-end, ready-to-wear shirt shops which offer an incredibly luxurious experience, be it Charvet in Paris, practically anywhere in Rome or Stefano Ricci in London (and elsewhere), there is nothing quite like a bespoke shirt from one of the Jermyn Street legends – it is a global gold standard and its wearer is immediately imbued with a sense of history and heritage as well as style.

Most of the shirtmakers require an initial order of four bespoke shirts (in some cases it used to be six), so you will be looking to spend £1,000 on your first go, but thereafter they will make them one at a time for you (if you have the self-discipline only to order one!). The initial order is to justify the time spent creating the unique paper pattern and set-up costs of the order and, one suspects, to foster a relationship which – if all goes well – is likely to last a lifetime.

It is worth noting that without taking into account the measuring, fitting and pattern cutting, a bespoke shirt takes some six hours to make, whereas a ready-to-wear one which is not handmade takes less than twenty minutes in some cases. As such, your money goes a long way, and compared to international prices for similar-quality shirts, Jermyn Street prices are decidedly modest – a shirt off the rack in Stefano Ricci can easily cost £600.

The shirtmaker will ask you about yourself – your job, how active you are, where you live, what type of watch you wear (if it's a big one, the appropriate cuff will need to accommodate it) etc., in order to have a basic understanding of the type of shirt you want and how and where you are going to wear it. Never be afraid to take in (or have on your phone) photographs of shirts that you like and would like replicated, but remember that shirtmakers are artisans rather than magicians, and cannot make you look like George Clooney if you don't give them the basic raw material (you!) to work with.

After you've explained what you're after, the tape measure will come out, which is a totally non-invasive process (there is no 'Carry On'-style, inside-leg awkwardness, although truth be told this isn't the case when

having a pair of trousers made either) and takes just a few minutes. The shirtmaker will write down a complex series of measurements (between eight and thirty-five depending on who is measuring you and their style), which will be used to create your unique paper pattern.

A bespoke shirt pattern is a deceptively nondescript-looking sight to behold – a series of shapes cut in brown paper and annotated in pen or pencil, usually kept in an envelope. Much like with a bespoke suit pattern, it can be altered or even remade should you lose or gain a significant amount of weight.

The pattern and order details are then added to the shirtmaker's records and your order details will be despatched to the work rooms (usually outside of London) where the seamstresses will begin to assemble the shirts.

Most shirtmakers allow for shrinkage in the cloth when they take your measurements, but whenever going slightly off-piste with any unusual fabric it is always worth asking if the shirt will shrink when you wash it.

When placing your first bespoke order, it is probably best to pick four (or more!) very classic shirts that you will wear often. That peppermint-striped silk might be tantalising but will you actually wear it more than three times in a year? Although you might think 'I can get a white shirt off the peg', it is the staple of a man's wardrobe for a reason and you really will notice the difference if you have one made for you. A sensible first order would be a plain white, a sky blue, a cream (or ecru) and either a classic stripe (blue Bengal) or check (blue gingham). If you want that distinctive Jermyn Street look, perhaps choose a bolder stripe or a striped shirt with contrasting collar and cuffs in white (this is a distinctly polarising look – I happen to love it, but many think it looks incomplete). Once you have selected your fabric and all the details, you pay and leave your details with the shirtmaker who will call or email you when your first shirt is ready for a fitting (usually four to six weeks later).

In the past, some shirtmakers would create a 'baste shirt' or test shirt for your first order in muslin, which could be easily altered or even ripped apart and then destroyed. These days, matters are expedited by making one first shirt as the test. The fitting with this shirt is fun and takes ten to twenty minutes – it is still very much a work in progress

but allows your shirtmaker to gauge fit, length and style and make any alterations necessary (don't be alarmed if they rip off an arm – this is the one stage of the process which has a hint of the dramatic).

It is very unusual that a good shirtmaker will require a second fitting and usually you will get a call to collect your initial order a further four to six weeks after the fitting. This has always been my favourite part of the process – seeing and holding a garment that you not only wanted to wear but also helped create to your specifications. And if you find yourself peeking at them in their bag on the way home, nobody will blame you.

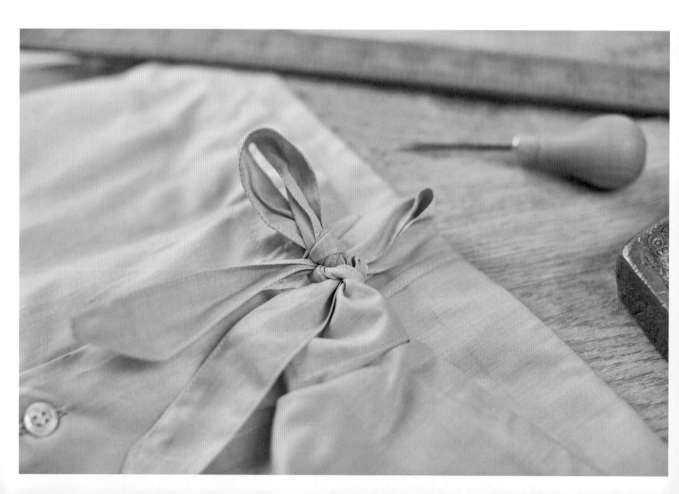

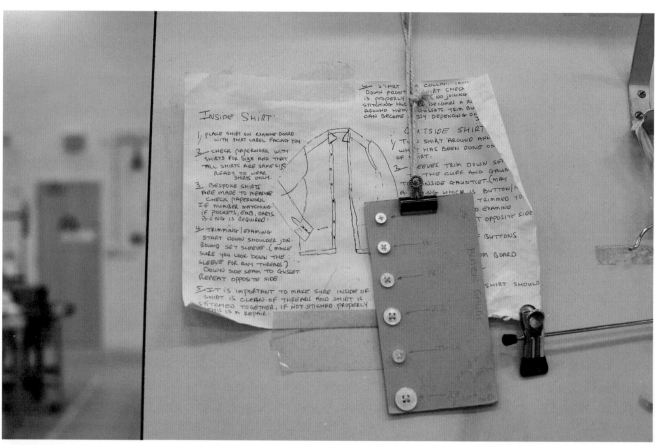

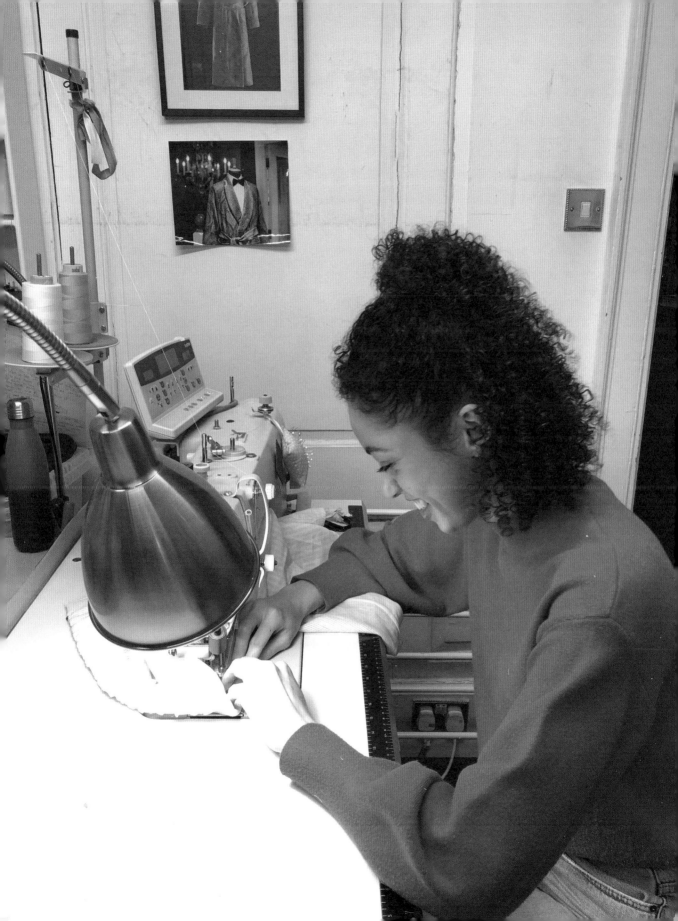

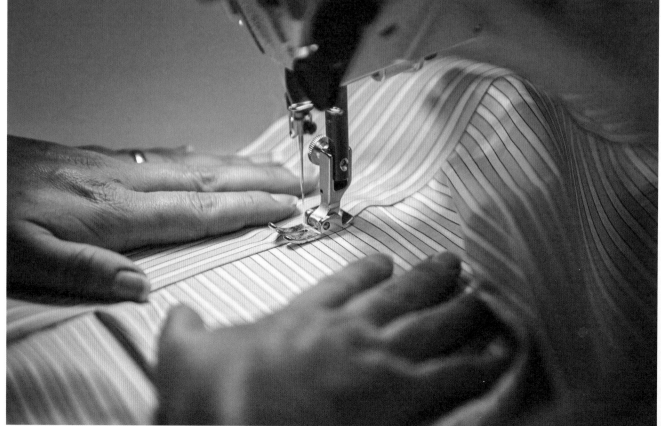

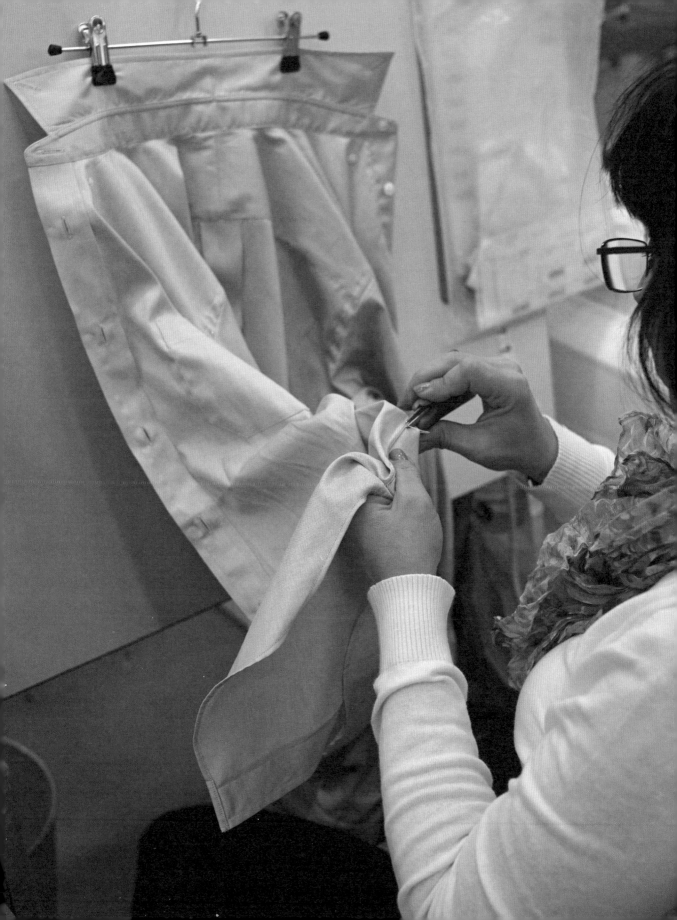

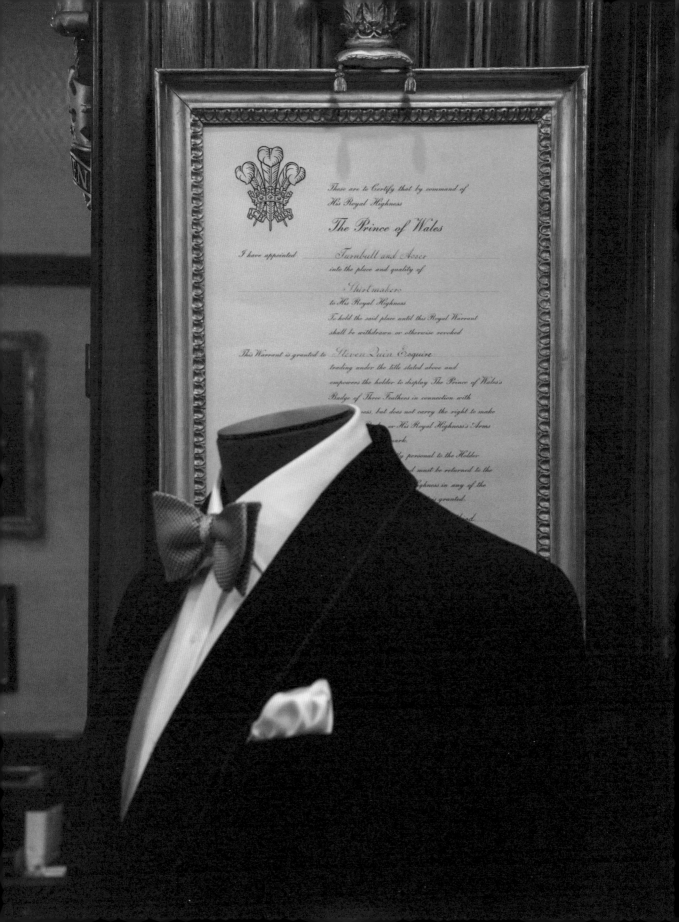

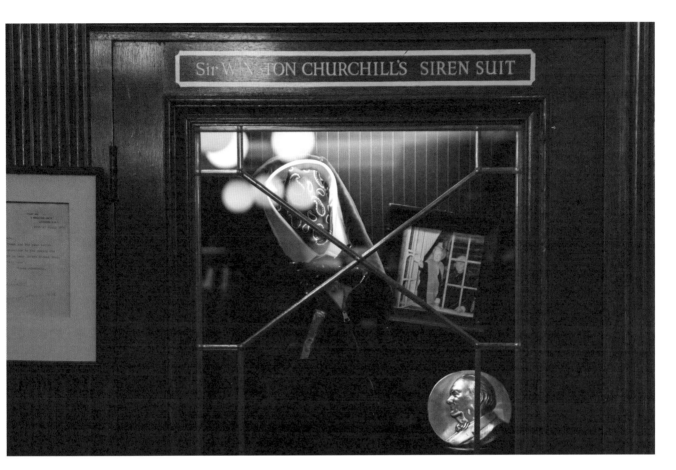

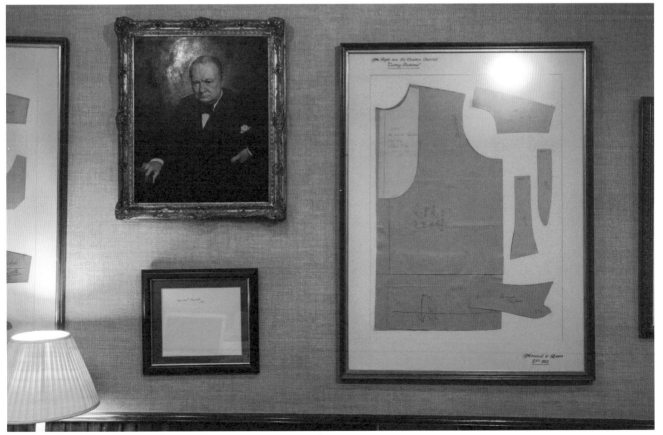

THE SHIRTMAKERS OF JERMYN STREET

At the time of writing tthere are some dozen shirtmakers on Jermyn Street, but since the 2020 pandemic this number is fluctuating as retail casualties take their toll. In this chapter we meet them each in turn, focusing on those who offer the true bespoke experience in order to differentiate them from those who just sell ready-made shirts.

There are some on Jermyn Street who deprecate the rise of low-cost, cheaply made, ready-to-wear shirts, marketed garishly in '4 for the price of 1' promotions (one shirtmaker told me, 'The thing about Jermyn Street is that half of it is on sale and half of it isn't'), but the truth is that for the young or novice customer these are sensible entry-level shirts and a good first step on your Jermyn Street journey, as you learn to create your own style, deciding what you like to wear and what suits you. They are certainly a cut above most of the shirts you would spend twice as much money on in a department store outside of London. One downside, however, is that as more and more of these shops open, not just on Jermyn Street but all over London, it is easy for their customers to lose that unique sense of style to which we all aspire.

It is true that there is no real comparison between those brands who sell handmade shirts and their cheaper competitors – the materials are vastly better, they are usually made in the EU or the UK, and generally speaking they have more flair, but to adapt is to survive and some of the very best-known names on Jermyn Street have had to do so by embracing the low-price model. Many of the great Jermyn Street characters today started out working in these stores and their history is usually as rich as anyone else's.

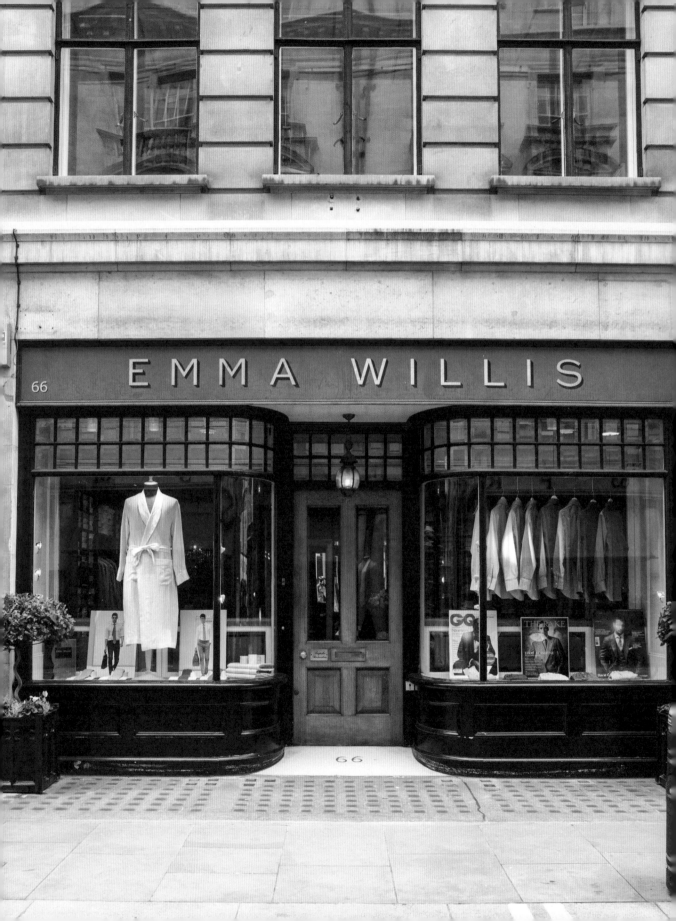

EMMA WILLIS

The first shirtmaker at the St James's end of the street is also the most unique and progressive it has to offer. Emma Willis, the eponymous founder and owner, is the only female shirtmaker on Jermyn Street and one of the very best. Elegant and decidedly chic, Emma is the perfect combination of classic style and modern élan, and her luxurious shirts reflect that.

In keeping with her unique identity, Emma's opulent store is also quite unlike any other on Jermyn Street. More akin to a lavish Parisian haute couture boutique than a shirt shop, it is a cornucopia of pale pastel shirts, ties and accessories, curated by Emma and her (all-female) team.

Although the store is one of Jermyn Street's newer residents, Emma Willis has been in the business of selling shirts for three decades. After graduating from University College London's Slade School of Fine Art, she took a job via an advert in the *Evening Standard* selling clothes door

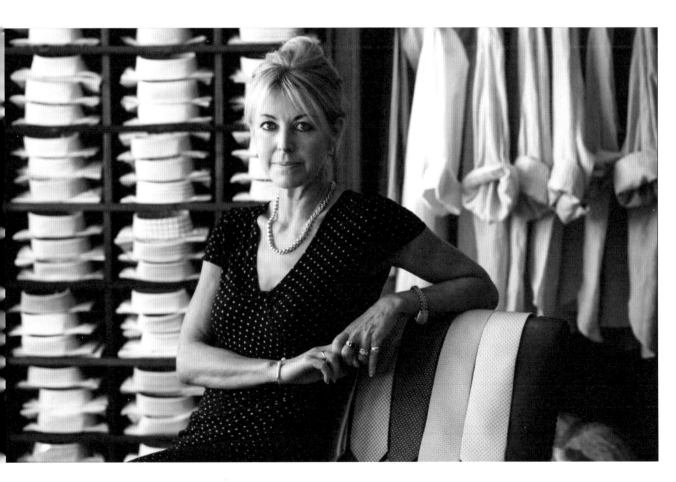

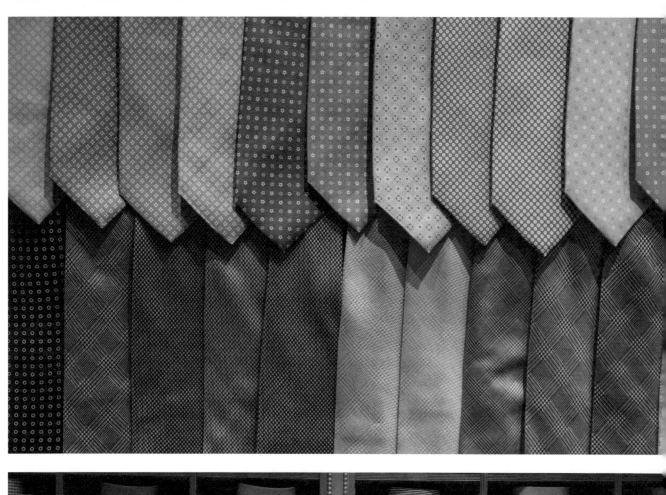

to door while pursuing her twin dreams of becoming a singer-songwriter and portrait painter. Of these wares the only ones she actually liked were the men's shirts, which had a solid and reliable customer base, so she decided to sell these, by appointment, in the City of London. Arriving before the markets opened at stockbroker Kitcat & Aitken, Emma would sell 100 shirts by 8 a.m. and her clients recommended her to the point where she was doing well enough to 'be creative in the arts', where her passion lay.

One of her customers, one of the founders of Guinness Mahon, which owned the shirt wholesaler Hamlet Shirts, located in what is now the luxurious Ham Yard Hotel off Piccadilly Circus, brought Emma in to handle direct selling of his shirts. They cooked up a Jermyn Street-sounding brand – Legge & Pritchard – restructured the business and Emma approached Turnbull & Asser to handle the physical manufacture of the shirts under their 'Jermyn Street Shirt Makers' auspices. The shirts were ready-to-wear only but had sleeve-length options. Emma had six girls selling Legge & Pritchard shirts around London, and the results clearly demonstrated the benefits of female-led sales to an exclusively male client base. Emma's next move was to Turnbull & Asser, which she approached for a job two years later – they initially offered her one at their French factory but during the interview a call from said factory put her bluffed mastery of the French language to the test and she was politely pointed towards James Drew, which was Turnbull's ladies shop in the Burlington Arcade. At James Drew, Emma got to design a few pieces and also learned where to source the best fabrics from – in her view, Alumo and Drakes.

A year later Emma set up Emma Willis Handmade Shirts from her flat in Fulham and by appointment. The shirts were made by Raynor & Sturgess. By 1999, with three young children, Emma found herself increasingly travelling to New York and Paris as a result of the UK recession. 'Jermyn Street had a lot of Old Money which didn't like spending it,' she opines. 'There was definitely a downturn during the Blair era. Things are more pro-UK now which is great.' She had built up an enviable client list at major financial institutions such as Credit Suisse and Goldman Sachs, but decided it was time to put down significant roots in London and in her mind the only destination for luxury shirt shopping was, of course, Jermyn Street.

There was a store for rent at what she rightly calls 'the bespoke end of Jermyn Street', so Emma wrote to her five best shirt customers asking if they were interested in backing her next move. US banker Bill Tyne, for whom she'd made shirts for a decade, agreed to bankroll the venture and remains a valued but hands-off partner to this day. The store opened in 2000 to a mixture of delight and trepidation on the most traditionally male of shopping streets. As the UK came out of recession, a plethora of hedge funds opened offices in Mayfair and St James, and Jermyn Street became a destination for luxury goods as much as everyday wear. Emma's shop perfectly rode this trend.

Emma designed her shop with her friend, the shoe designer Penelope Chilvers, to reflect an 'English drawing room' feel – chandeliers, stone floors, real antiques and a striking staircase certainly give it this appearance, but it also has a continental, feminine feeling to it. In the store's early days an Italian gentleman came in to ask how a woman could possibly know how to make men's shirts. He remains a customer to this day. So too does a man whose initial reaction was *conversely* that, if Emma is the only woman making men's shirts, she *must* be good. Although it may seem a natural fit for Emma to focus on women's shirts too, she runs a discrete bespoke business from her St James's shop but designs seasonal online collections for Net a Porter and Matchesfashion.com and is frequently featured in *Vogue*, very much inspired by the Jermyn Street shirt.

The Emma Willis house collar was inspired by a shirt of her husband Richard's from the now closed Cole's – a shirt shop in the City, which still exists online as W.H. Taylor Shirtmakers. It's a moderate cutaway collar she describes as 'the perfect collar which I loved 30 years ago and is still the perfect collar to my eye today!' Less a proponent of the bold stripe and contrasting collar looks favoured by many of the high-end Jermyn Street stores, Emma arguably offers a better selection of linen and other more casual shirts than anyone else on the street. Over the years Emma has honed her house style to have a slightly softer collar, which looks as good open necked as with a tie. There can be no doubt that her style is more continental than most English shirtmakers, and as with the best of the Jermyn Street makers, one of her shirts is unmistakable to the discerning eye. The predominant colour patterns are pale, pastel blues and pinks in soft, subtle patterns.

As well as feminising the bespoke end of Jermyn Street, Emma Willis has undoubtedly modernised it too. Not only was she the first London shirtmaker to offer a made-to-measure service online (with the customer supplying their own measurements), but her sales background (or 'hardcore selling', as she calls it) meant that she not only embraced but also set the agenda for marketing luxury men's shirts in the modern age. Partnerships with H. Huntsman on Savile Row, Mr Porter, Matchesfashion Men, *The Rake* and *Gentleman's Journal* as well as shelf space in Bond Street department store Fenwick have pushed her brand to a whole new audience of appreciative, well-dressed men.

Emma also realised early on the importance of having ambassadors for her brand in the public eye. With no towering historical client list full of Hollywood glamour to exploit, she has focused on modern celebrities – Benedict Cumberbatch, Colin Firth, Dermot O'Leary, President Obama and particularly David Gandy have all become 'great ambassadors' for her brand. 'Today men are inspired by authentic craftsmanship again,' says Emma, 'and this appreciation has given value to beautifully made things and made them very fashionable again.' HRH The Prince of Wales, inspired by Emma's contribution to British manufacturing and her charity Style for Soldiers, invited her to Clarence House in 2015 for a bespoke shirt appointment and she has been making his shirts ever since. In February 2020, HRH visited her Gloucester factory, Bearland House, which she has since purchased and is renovating, to thank Emma and her staff 'not only for the beautiful shirts and boxer shorts you make' but for all they do for the care of those affected by the trauma of war.

Ready-to-wear shirts in poplin start at £200, rising to £310 for soyella and £350 for Sea Island cottons. Linen shirts are £240, while warmer casuals – the cotton/cashmere blend known as 'cashmerello' come in at £310. An evening shirt costs £350 in cotton or £330 in silk.

The made-to-measure service offered via the website costs between £260 and £410 but, as innovative as it is, if you get the chance to enjoy the personal full bespoke experience, you really should. Full bespoke prices range from £330 to £470.

Emma moved out of London to Gloucestershire and decided that she needed her shirt production based there rather than having it outsourced. She founded her premises in Bearland House, a stunning

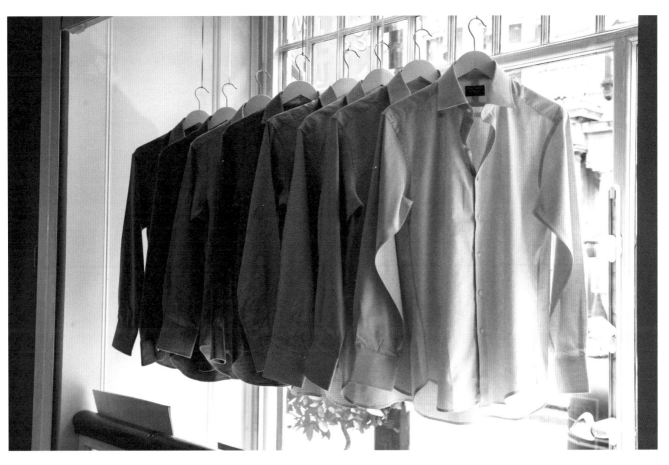

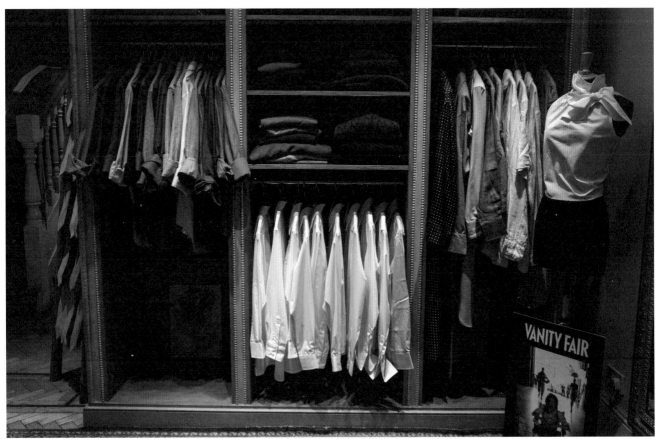

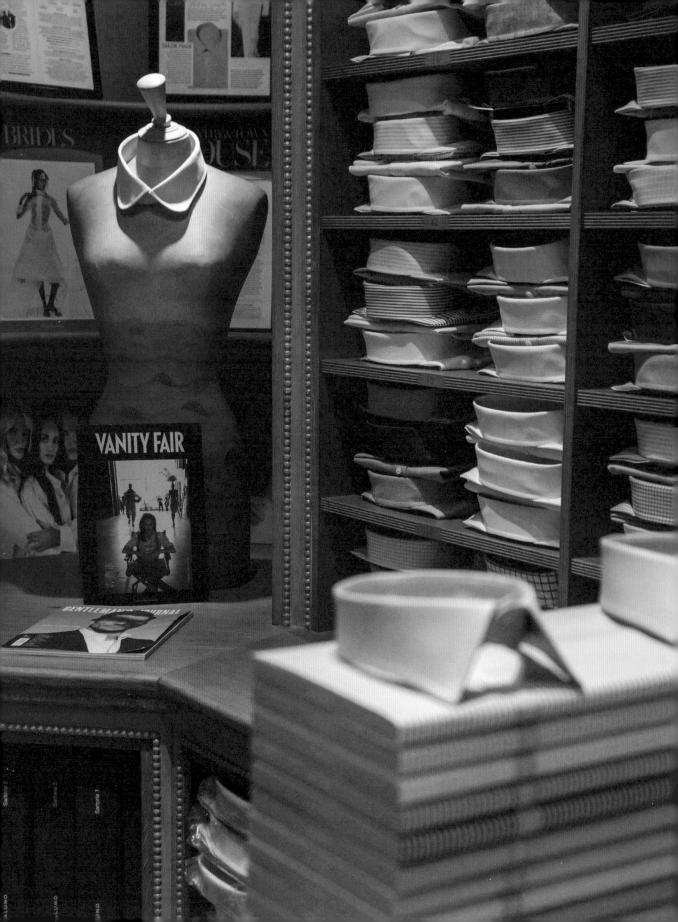

eighteenth-century townhouse in Gloucester, where she has been based for a decade, with a team of thirty, all but three of whom are women. The team was initially assembled from adverts in local newspapers and Emma 'has never looked back'. The factory houses both a shop and a fitting room for local patrons and all of the bespoke cutters are female. 'It is,' she says, 'a pleasure to be able to give young people in Gloucester an entry to this craft.'

Emma is perhaps Jermyn Street's greatest advocate of the traditionally faceless seamstresses who actually make the shirts – most of the other shirtmakers focus on the cutters. 'There's only going to be one cutter to every ten seamstresses,' she explains, 'so I looked to change the focus on training and job creation and improve their image.'

Attending a reception at 10 Downing Street during David Cameron's premiership, Emma was introduced by a government aide to the CEO of Conde Naste, Jonathan Newhouse, with whom she shared her enthusiasm for shining a light on British seamstresses. Newhouse was taken with the idea and agreed to sponsor a Conde Naste Sewing Scholarship at £10,000 per year for five years to encourage underprivileged young people to 'learn a living'. The initiative is completely unique and a testament to Emma's visionary leadership amongst British shirtmakers.

In 2007 Emma heard a Radio 4 programme featuring interviews with soldiers injured in the Afghanistan War. Moved to tears, she decided to help and set up the charity Style for Soldiers, which offers injured servicemen a free bespoke shirt to help them gain confidence as they look to re-enter both civilian life and the job market. She visits Headley Court, the soldiers' rehabilitation centre in Surrey, every two months, talking to the soldiers while measuring them. For amputees, the shirts are adapted with Velcro to make dressing easier. In the forces, dressing smartly is a fundamental attribute and Emma realised that she could help these heroes feel good about themselves. She wasted little time in approaching other brands to help, and to date Marks & Spencer has given over 750 suits, Russell & Bromley over 250 shoes, Burberry 200 trench coats and scarves, Lock & Co. hundreds of hats, London Sock Company socks, Huntsman suits, and Reiss suits and gifts for partners. Charles Dance and David Gandy are both ambassadors for the charity.

Emma has also designed a black ebony walking stick for soldiers who need one, the silver collar of which is engraved with their regiment and initials.

Today the regular Style for Soldiers reunion parties are the core of the charity's focus, bringing injured soldiers and their partners for spectacular lunches and events, including an annual family day at Woburn Safari Park donated by the Duke of Bedford. Prince Charles was guest of honour at the 2016 Christmas party, meeting all of the assembled veterans who talked passionately of what a huge difference Style for Soldiers makes to their rehabilitation process. Prince Charles and the Duchess of Cornwall have since also sponsored the walking sticks.

Emma also knew that for couples an injury in active service means belts being tightened across the board, so when inviting soldiers and their partners to reunion parties the charity sends the partners £100 gift vouchers. The events were recently extended to include 'Art in the Aftermath', an exhibition of art, poetry and film created by former servicemen suffering from post-traumatic stress disorder or brain injuries predominantly as a result of the Afghanistan conflict, as well as paintings and drawings by Harry Parker who was seriously injured by the explosion of a Taliban improvised explosive device.

Emma's work for Style for Soldiers garnered her a much-deserved MBE in the 2015 New Year's Honours List, rightful recognition for a tireless and inspirational advocate for Britain's wounded heroes.

Emma Willis is in many ways the least traditional of the Jermyn Street shirtmakers, which is fundamental to her brand's appeal – the shirts are classic yet modern, almost simple in their elegance, letting the craftsmanship and fabrics speak for themselves. If you're looking for the crispest, coolest shirt on the street, which can hold its own in Paris or Milan, this is probably the shirtmaker for you. In many respects, I can see Emma outlasting many of her long-established counterparts – her unique blend of modernism and appreciation for Jermyn Street heritage is a heady combination and the future of British shirt making is clearly safe in her hands.

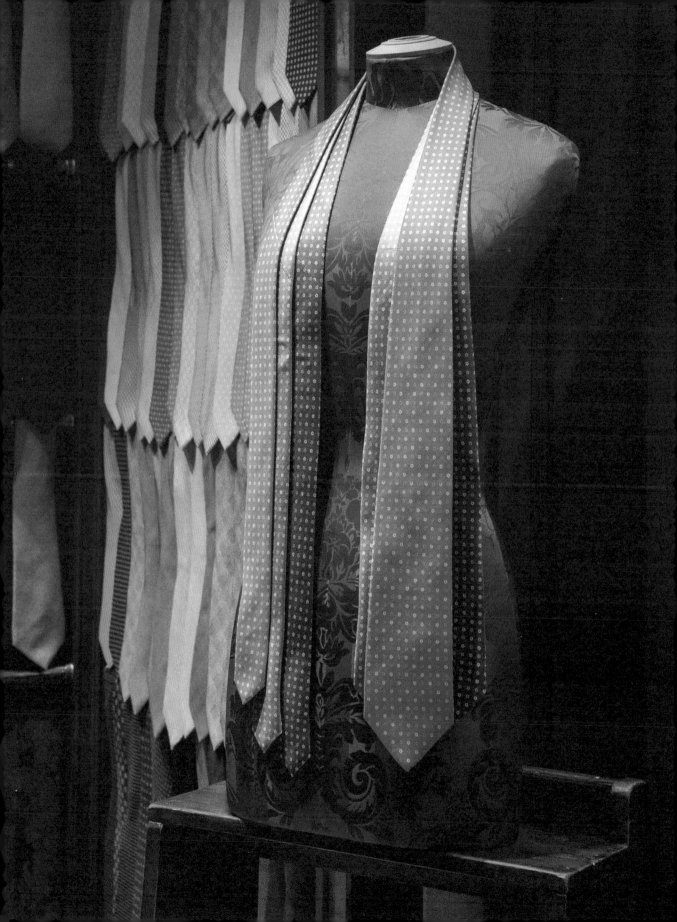

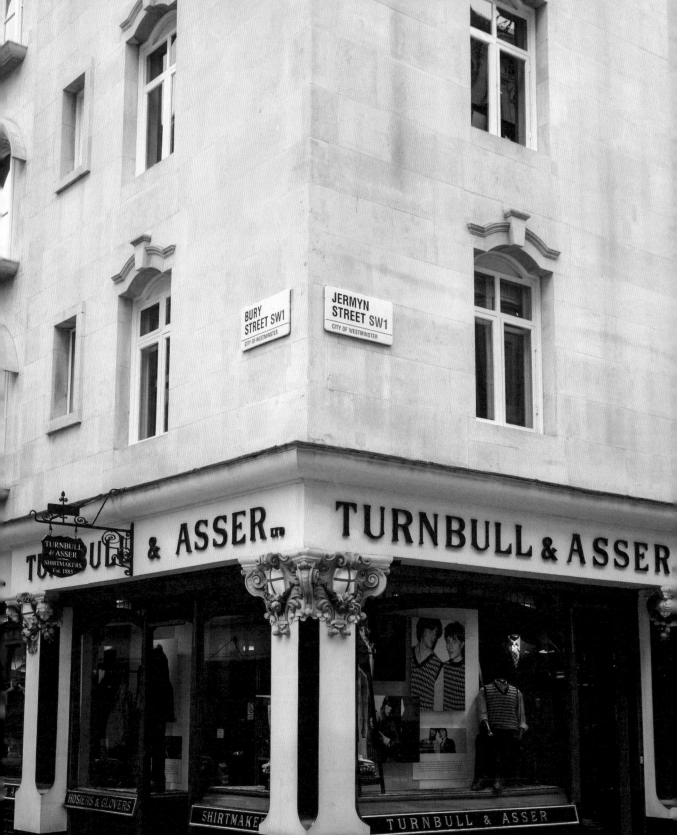

TURNBULL & ASSER

If one brand encapsulates what we think of as a 'Jermyn Street shirt' it must be the quintessential London shirtmaker Turnbull & Asser. A household name for over a century, they are the heart of Jermyn Street and the gold standard by which all other fine shirts and shirtmakers are judged the world over. For many, Turnbull & Asser is *the* shirtmaker and it isn't hard to see why. Turnbull & Asser know their game inside out – walking into their Jermyn Street flagship, shirts are conspicuous by their absence amongst an explosion of beautiful ties and knitwear. The shirts are in the basement, so that customers feel they are going down to something very special, which they certainly are.

Turnbull and Asser's origins can be tracked back to hosier and shirtmaker John Arthur Turnbull and salesman Ernest Asser who met in 1883 and founded a hosiers under the 'John Arthur Turnbull' banner in St James's. The store was rebranded as the more familiar Turnbull & Asser in 1885. Eight years later, they moved premises to the current location of the flagship store, on the corner of Jermyn Street and Bury Street.

Turnbull & Asser – known then as 'the Hunting Hosier' – adopted the symbol of a hunting horn with a 'Q' above it, naming it the Quorn after an old fox hunt in the Nottinghamshire/Leicestershire locale. Perhaps the most famous amongst the branded Quorn items was the Quorn scarf which in its day was as exclusive and desirable as those in Burberry's house check. In 1915 Turnbull & Asser created the 'Quorn trench coat' also known as the active service coat for the British military, a year into the First World War. The remarkable coat boasted a detachable fleece lining to use as a dressing gown at night – while the waterproof coat itself doubled as a sleeping bag.

One of Turnbull & Asser's most famous and distinguished clients was British prime minister Winston Churchill. Churchill's iconic three-piece suits were bespoke by Henry Poole on Savile Row, but his famous white shirts and spotted bow ties came from Turnbull & Asser. During the Blitz, Churchill commissioned Turnbull & Asser to make him a particularly practical addition to his leisurewear wardrobe – in effect, a pinstriped romper suit to be worn over his everyday clothes before entering bomb shelters, the alarm for which gave it its popular name of the 'siren suit'. Churchill's particularly decadent proto-onesie was not

just confined to dark basements either – he once wore it to dinner with President Roosevelt! Churchill went on to have Turnbull & Asser make him variations on the siren suit in velvet and an example in bottle green is still on display in the store.

The 1960s was perhaps the period when Turnbull & Asser broke through the barriers of Jermyn Street and into the general public's consciousness, as it flirted with high fashion and embraced the rapidly changing trends in menswear. The younger generation at the Jermyn Street flagship were Peter Bartindale who designed giant velvet bow ties, cutter Paul Cuss and, most famously, Michael Fish who created increasingly wide neckties which eventually entered the lexicon as 'kipper ties' in his honour. Fish was something of a rebel in his day, entertaining Turbull & Asser clients outside of working hours, and building a social hierarchy within tailoring which blurred the lines between friends and customers for the first time. Fish became a darling of the showbusiness set and left Turnbull & Asser to set up his own shop in Clifford Street, which he revelled in, eventually becoming the curious catalyst for a legendary showbusiness anecdote involving Peter Sellers, Roger Moore, Leslie Bricusse and a substantial bag of cocaine. The story allegedly did not end well for Fish and, not long after, he shut down and went to New York to work for Sulka. Less contentiously, Fish made the iconic ruffled shirts worn by Jon Pertwee in his turn as the third incarnation of Doctor Who.

As formalities softened, so did Turnbull & Asser's collars. There's a story that David Frost and Lord Snowdon had their way into a New York nightclub unceremoniously barred for not wearing ties – their response was that they could not wear ties with their Turnbull & Asser silk turtleneck shirts. Richard Burton was so taken with this flamboyant look that he ordered five such shirts in different colours, then another five matching shirts for Elizabeth Taylor. Perhaps the best-known ambassador for these striking turtleneck silk shirts was actor/director David Hemmings, who adopted it as very much his signature look.

In 1970 Turnbull & Asser's bespoke department – previously in the basement – moved, quite literally, around the corner to the neighbouring building on Bury Street, where it remains to this day. As well as movie stars, the firm has made shirts personally for a number of the most famous international fashion designers including Moscino, Marc Jacobs and Alexander McQueen.

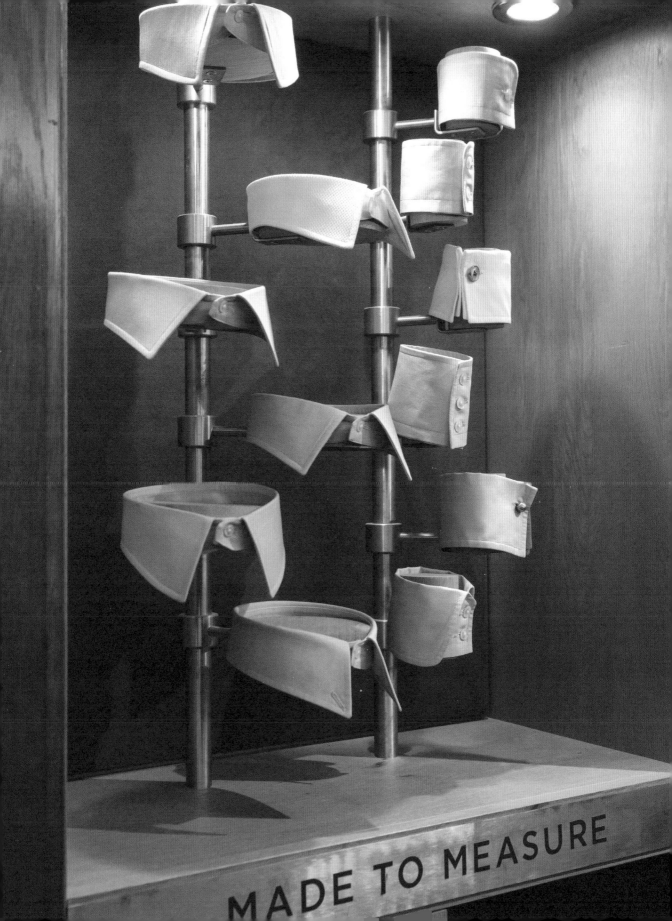

MADE TO MEASURE

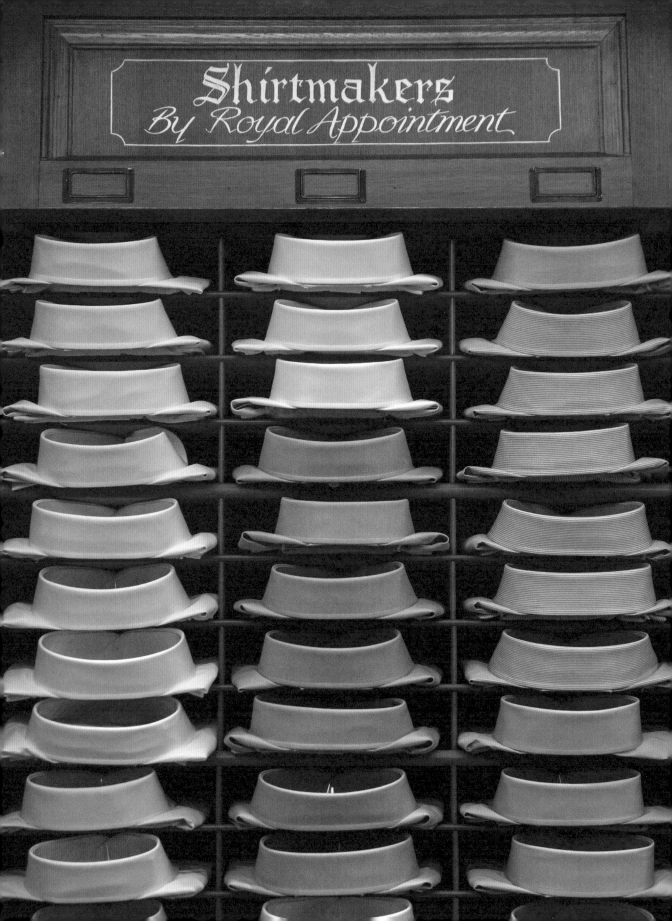

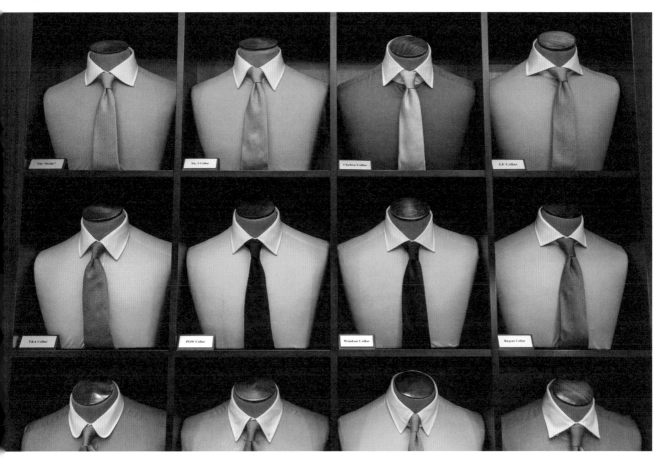

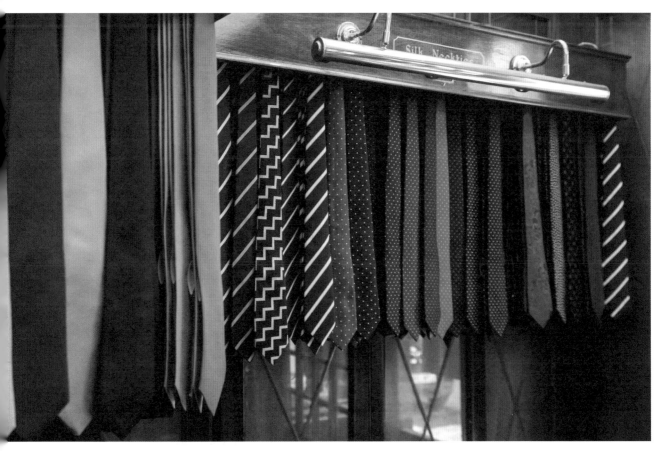

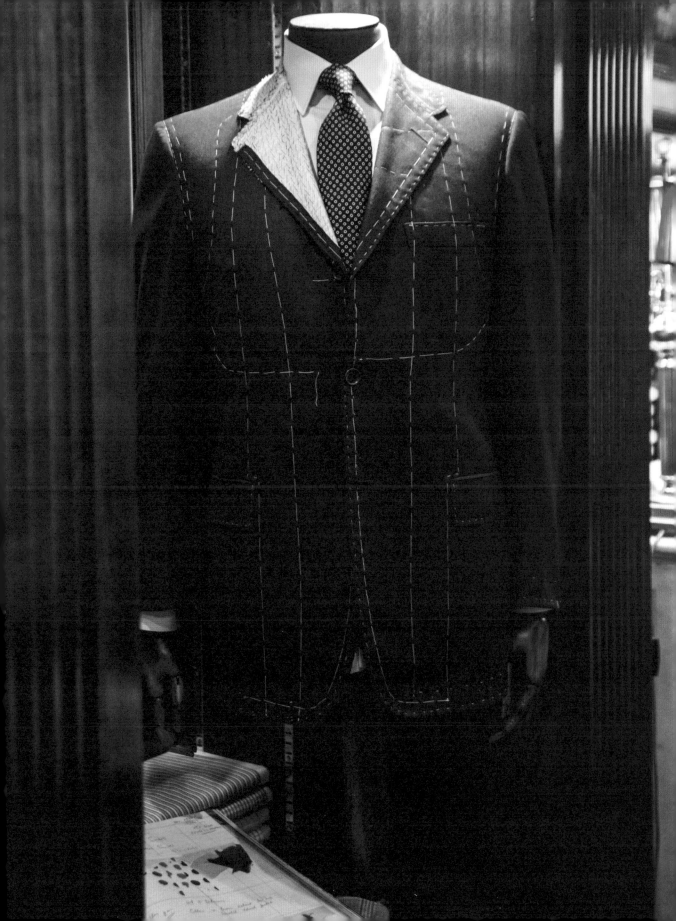

TURNBULL & ASSER ON FILM

More than any other shirtmaker, Turnbull & Asser has brought Jermyn Street style to the big screen. Most famously, of course, director Terrence Young took Sean Connery there to have his shirts made for *Dr No* (and beyond), but Bond is merely the tip of the sartorial iceberg. Young was one of many film directors whose patronage Turnbull & Asser enjoyed, alongside John Frankenheimer, Richard Attenborough and Bond producer Albert R. 'Cubby' Broccoli. Bond creator and bon vivant Ian Fleming was a patron too, and though he never named the literary Bond's shirtmaker, it is fair to assume it would have been Turnbull & Asser.

One of cinema's less conspicuous Bonds, David Niven, was a long-term Turnbull & Asser client and is credited with coming up with the idea for the cocktail cuff there, though the definitive origins of this particular design are sadly lost in the mists of time. Ever the trendsetter, Niven also favoured ties and shirts made in matching fabrics.

Although Roger Moore brought his own shirtmaker, Frank Foster, to his Bond tenure, Turnbull & Asser made at least one shirt for his 007 debut *Live and Let Die*, possibly the spectacular ruffled evening shirt seen in publicity photos but not the film itself. Moore's best friend off screen, Michael Caine, was a customer for many years, wearing Turnbull & Asser in his private life as well as in a number of movies, most notably *The Italian Job* and British gangster classic *Get Carter*. In the 1980s Caine found himself lunching in exclusive Mayfair restaurant Le Caprice when he spotted cutter Paul Cuss and company director Kenneth Williams at a table opposite, prompting him to rise and loudly josh them, 'No wonder the shirts are so expensive.'

As part of their deal with Bond producers Eon Productions, Tom Ford now make Daniel Craig's Bond shirts, but Turnbull & Asser made his iconic 'first' white evening shirt for his superior debut *Casino Royale* as well as most of Pierce Brosnan's shirts during his tenure as 007.

For the action-packed Brosnan films, Turnbull & Asser were making upwards of 100 shirts per movie. To accommodate Daniel Craig's smaller but more robust stature, they created a more fitted shirt (with more accommodating doubles for the action scenes), but perhaps their most memorable creation for Mr Craig was not a shirt – during his

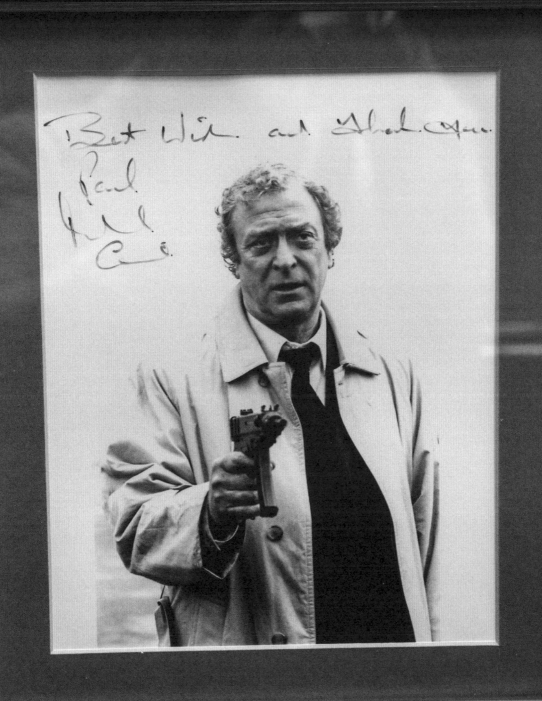

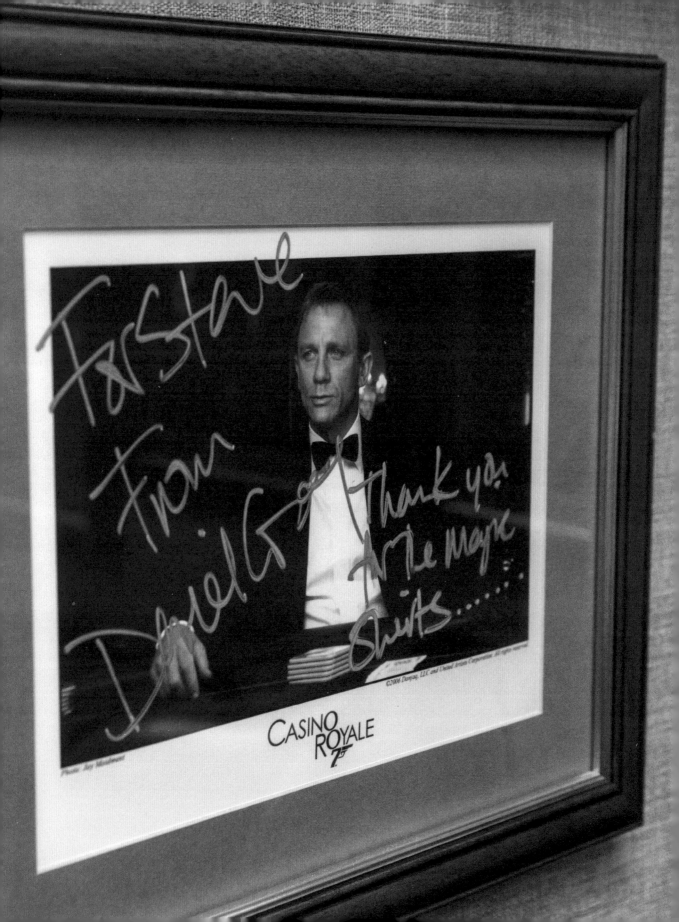

For Steve
From
Daniel Craig Thank you
for the magic
shirts......

CASINO
ROYALE
007

Photo: Jay Maidment

©2006 Danjaq, LLC and United Artists Corporation. All rights reserved.

international publicity tour for *Casino Royale*, the actor broke his arm, so Turnbull & Asser made him a bespoke black arm sling to complement his dinner jacket.

In *The Great Gatsby* (1974), Robert Redford's character stands in front of a wardrobe full of beautiful Turnbull & Asser shirts which he proceeds to fling all over his dressing room, as well as the company's characteristic branded boxes. Legend has it that *Great Gatsby* producer Robert Evans selected Turnbull after lunching in London with actress Candice Bergen, who was wearing one to great effect.

In Oliver Stone's masterpiece *Wall Street* (1987), Michael Douglas played his most memorable role – stockbroker Gordon Gecko with his 'greed is good' mantra and iconic bold power-dressing. Turnbull & Asser made Gecko's shirts, most notably the blue one with white collar and cuffs which was (and remains) one of the most powerful and divisive costumes in film history.

More recently, Turnbull & Asser made many of the shirts (and pyjamas) featured in the quintessential modern menswear classic *Kingsman: The Secret Service*, starring Colin Firth, Taron Egerton and Sir Michael Caine.

Today Turnbull & Asser offer a number of ready-to-wear items inspired by their Hollywood heritage including *Dr No* style shirts (with cocktail cuffs, of course) in white and blue, a *Casino Royale* style evening shirt, a club collar shirt inspired by *The Great Gatsby* and stunning blue shirts with white collars and cuffs in homage to Gordon Gecko. They also sell a number of colourful ties as seen in *The Great Gatsby*, *Tomorrow Never Dies* and *The World Is Not Enough*, as well as the green patterned tie worn by Heath Ledger as The Joker in *The Dark Knight*, though that particular character may be considered somewhat less inspirational to the modern gentleman than James Bond. 'People all over the world are manic about Bond,' opines Turnbull & Asser's Steve Quin. 'It has opened up shirts and ties to a lot of people.'

HRH The Prince of Wales was granted the power to bestow royal warrants in 1980. His first was issued to Turnbull & Asser's head cutter Paul Cuss, before being passed to their retail director – and his son-in-law – Steve Quin upon Cuss's retirement. Quin continues to make Prince Charles's shirts to this day.

Steve Quin is a genial, dapper man with a ready smile and a smooth manner – the archetype of Jermyn Street expertise – and presides over Turnbull & Asser's bespoke department with an air of immaculate calmness. Quin's journey to Turnbull & Asser started in a menswear store in Brixton thirty-five years ago when he heard of an opportunity to join the prestigious firm in the West End. He recalls the tone being set by Hollywood star Kirk Douglas perusing shirts and ties in the background while he was interviewed for his new job. 'Clothes were always a passion,' explains Quin. 'I started working front of house, but I wasn't allowed to actually serve customers for eight or nine months – people took advice on the shop floor much more seriously back then. I remember, once I was allowed to serve customers, one of my first was going on a shoot and needed kitting out for that – that was a real baptism of fire!'

Quin explains why Turnbull & Asser was and is known as the 'Peacock of Jermyn Street': 'It's because of all the colours. We don't go for seasonal colours, we stock them all year round. We own our own tie factory in Sidcup, Kent and the ties are designed to complement our shirts with their colours.'

Apart from the bold, beautiful colours, perhaps the most distinctive hallmark of Turnbull & Asser shirts is their unique three-button cuff, on both bespoke and ready-to-wear shirts. 'They're our trademark,' explains Steve Quin. 'The idea is that fellow customers can recognise each other.' In a concession to the changing face of fashion, Turnbull & Asser's casual shirts are increasingly coming with one button rather than three buttons on the cuffs.

The distinctive Turnbull & Asser collar was designed by the late Doug Hayward, who always wore their shirts (and stocked a range of their ready-to-wear shirts under his own label in his Mount Street emporium) and was, according to Quin, 'a great friend of Turnbull & Asser'. Indeed, they refer to their house collar as the Hayward Collar and a shirt back with two pleats as a Hayward Back.

Today, a Turnbull & Asser shirt is made by hand from at least thirty-four individual pieces of cloth, sewn by a single needle with eighteen to twenty stitches per inch in the company's Gloucester factory, where it passes through the hands of sixteen different artisans during thirty-six separate processes.

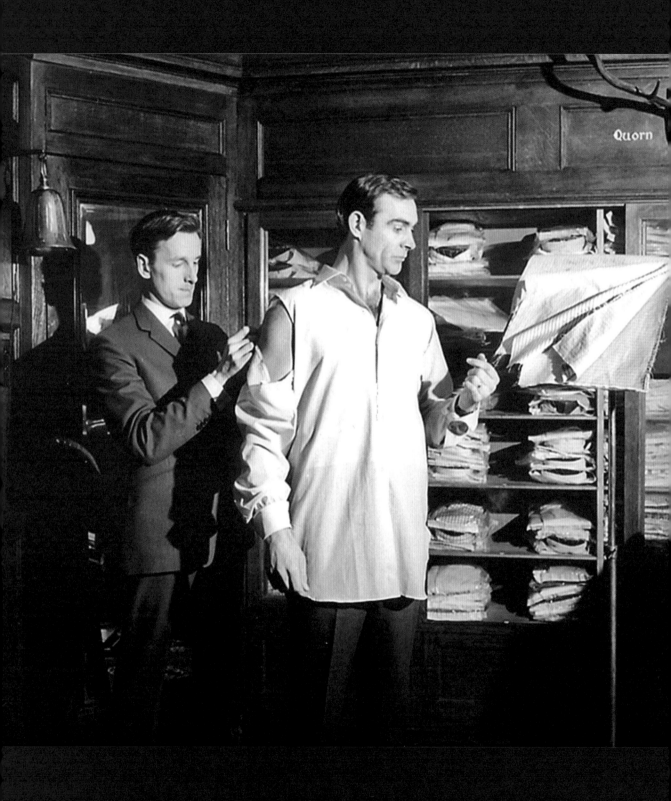

Bespoke shirts have a minimum initial order of four, with a four-week wait for the first finished shirt, which is then worn and washed by the customer to ensure perfect fit before any necessary adjustments are made. Bespoke prices start at £295 per shirt, rising to £450 for Sea Island cotton.

Quin has had more unusual requests from customers than most: 'One chap wanted pockets at the bottom of his shirt to hide money in. Another had his social security number embroidered inside his shirts so his body could be identified in the event of a mishap. We made shirts for the inventor of Pacman, who wanted Pacman embroidered on the collar points!'

In 1986, Ali Fayed, the younger brother of Harrods tycoon Mohamed Al-Fayed, bought Turnbull & Asser from Country Bank (NatWest) and renovated the Jermyn Street flagship. Fayed, along with his sons, still owns the business and in recent years has overseen a move towards expansion, both in terms of retail sites and in what the brand offers.

In 1997, Turnbull & Asser opened its first store in the USA, on East 57th Street in New York. In 2011 it moved to larger premises – an opulent character townhouse, just a few doors down. In 2015 another London store was opened near Claridge's on Davies Street in Mayfair and in 2015 the Big Apple gained a second Turnbull & Asser inside the Oculus of the newly built Westfield World Trade Centre, although this has since closed.

In 2013, the flamboyant Dean Gomilsek-Cole became head of design and gave the brand's ready-to-wear selection perhaps its most audacious overhaul ever. Gone were the classic navy-blue double-breasted blazers long favoured by the royal family, and in their place came a cacophony of fashionable flourishes – shawl collars, unusual button stances and lurid patterns and fabrics. It is fair to say that this new look was not to everyone's taste, but the bespoke shop is, of course, immune to such progressions.

In 2018, Becky French, previously at Ralph Lauren Purple Label and Aquascutum, joined Turnbull & Asser as head of design. In the autumn

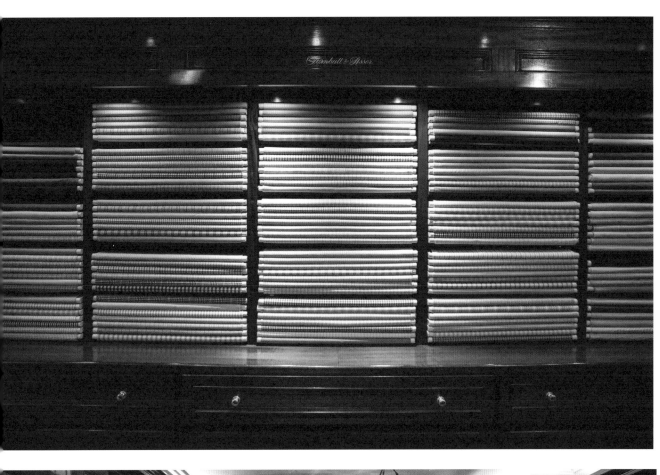

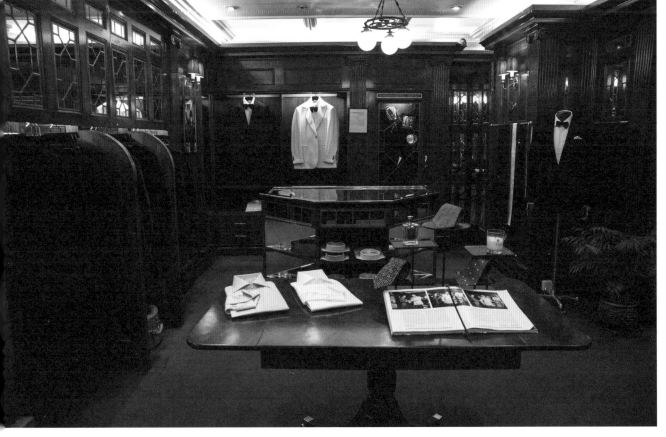

of 2019 she graduated to creative director, making her the first female to take the helm of the menswear legend. In the press release issued to mark her appointment, French said:

> Turnbull & Asser has such a rich history and reputation as the leading luxury British shirtmaker. It is a pleasure to be a part of the evolution of Turnbull & Asser and to further develop the ready-to-wear, Made to Measure and Bespoke shirt lines, along with a full lifestyle collection. I would love more people to know about Turnbull and aspire to own at least one of our shirts, which are made in our workroom in Gloucester. We hope to speak to our existing customers but also invite a new audience to walk in to the doors of our stores in London and New York.

It seems likely that as long as men wear shirts, they will be walking through the legendary doors of Turnbull & Asser.

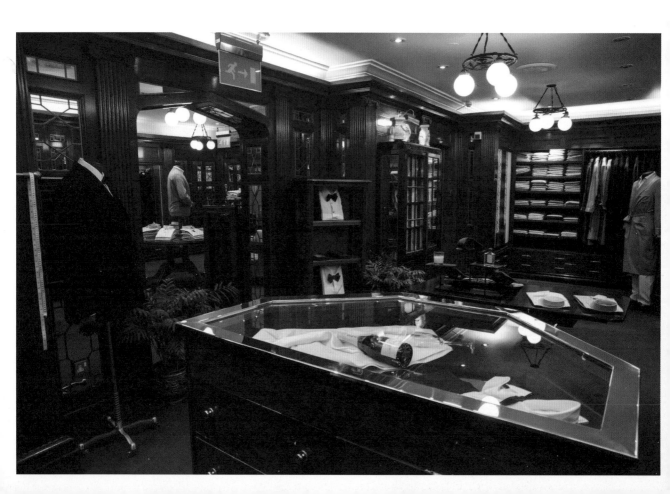

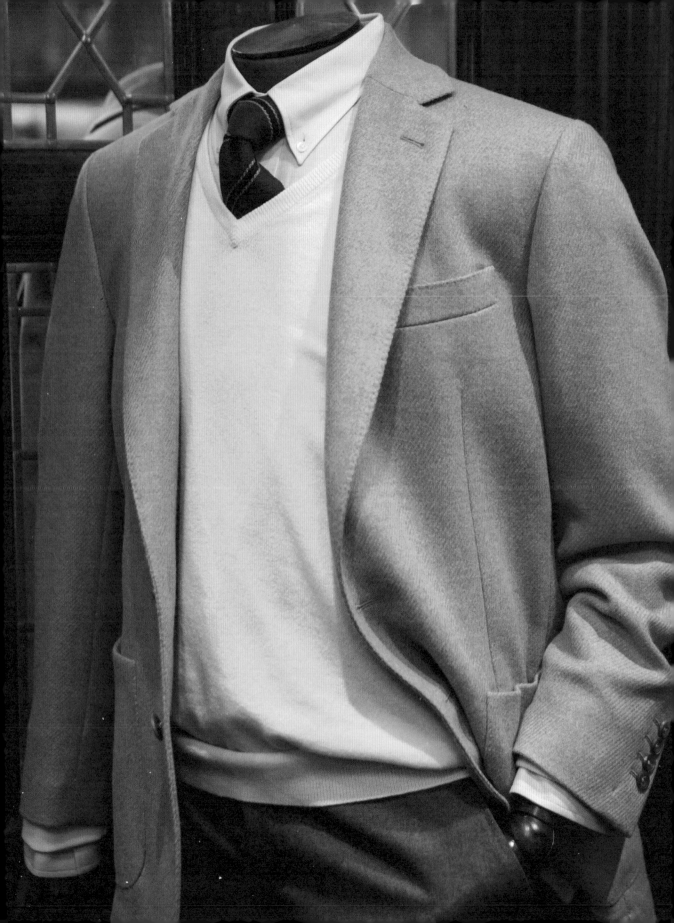

HILDITCH & KEY

HILDITCH & KEY
Shirtmakers since 1899

MYN STREET
NDON

W1

TUR S.

& ASSER LTD

HILDITCH & KEY

There is something uniquely cosmopolitan about Hilditch & Key that makes it stand out from the other shirtmakers with which it shares Jermyn Street. Perhaps it is the fact that it is the only one to have a store in that bastion of fashion Paris, which competes successfully with the most famous of French shirtmakers Charvet. Perhaps it is that it has long had a reputation as being a little more exclusive than some of its competitors, not releasing the names of celebrity clients and appearing to be something of an elite club for shirt wearers. Hilditch & Key is definitely for the discerning shirt fan – the shirts are amongst the more expensive on Jermyn Street, but don't confuse exclusivity with elitism: it is a charming, tasteful store, and shopping there is never less than a joyous experience.

In 1899, Charles F. Hilditch and W. Graham Key, a pair of shirtmakers who had trained together at Harman's on Duke Street, decided to set up their own business. Initially opening on Tottenham Court Road, Hilditch & Key had a different approach to most of their contemporaries, marketing to a distinctly younger (though no less appreciative) audience – university undergraduates. Having somewhat cornered a market, the firm moved to Jermyn Street in the early twentieth century and in 1907 opened their remarkable store in Rue de Rivoli in the heart of the Parisian menswear district (at one point there were three Hilditch & Key stores in the French capital).

Like much of St James's, the original Hilditch & Key store was destroyed in the Blitz, and temporary premises were taken at number 65 Jermyn Street after the war. Eventually the company moved permanently to number 39, with an additional store at number 37 acquired in 1978. By this time, Hilditch & Key was owned by ex-lawyer and banker Michael Booth, a long-time customer of the brand. The opportunity to acquire the business was drawn to Booth's attention by Lord Sterling, whose own shirtmaker (Alex Finch at Harvie & Hudson) tipped him off. Finch initially came in with Booth as a partner but by the 1990s, Booth had full control. Booth would also buy the famous hatter Bates, also on Jermyn Street, but we're getting ahead of ourselves. The shirts were made at a factory in Scotland, which Hilditch & Key owned,

and were considered amongst the best ready-to-wear shirts on Jermyn Street. The shop also stocked a substantial selection of mid-range ready-to-wear tailoring.

Hilditch & Key has embraced the changes to modern retail more than many of its peers. When Steven Miller, the former managing director of Turnbull & Asser, took over Hilditch & Key a few years ago, he overhauled the business completely. The Scottish factory was closed and he brought Jermyn Street legend David Gale over from Turnbull & Asser as pattern cutter. Gale is not in the store every day, but when he is, customers can see him at work making patterns on the shop floor, a unique site in Jermyn Street. Gale is one of the most respected shirtmakers in the world and recruiting him was a typically shrewd move on Miller's part.

Steven Miller is a straight-talking, no-nonsense man who understands the realities of commerce as much as he appreciates fine shirts and the heritage of the brand he has been entrusted with. He is a business leader who wants to lead Hilditch & Key into a bright and sustainable future, rather than resting on its laurels as a Jermyn Street legend. Since he took over, the company has opened six stores in Russia and more in eastern Europe, and he has his eye on expansion into China through licensing agreements. The shirts are stocked in Bloomingdale's in America as well as department stores and menswear shops in Pretoria, Madrid, Athens, Madrid and Dubai. The bespoke shirts are now made in Milan ('70 per cent of high-end Jermyn Street shirts are,' says Miller) and he has done away with suits and jackets, refocusing on smart, luxurious weekend casuals, particularly knitwear (cashmere sweaters run between £345 and £495). Outerwear is restricted to practical raincoats and bomber jackets, in contrast to the covert coats and crombies offered elsewhere on the street.

When Michael Booth bought Bates the hatter, it made sense to consolidate its premises with Hilditch & Key, and the alliance of shirts and hats is a natural one. Steve Miller has overseen this expansion and considers the hat business a 'small but good' one, buoyed by the likes of *Peaky Blinders* setting trends amongst younger crowds.

Ready-to-wear shirts – in both 'classic' and 'contemporary' fits – are priced between £160 and £170 but there are regular, popular sales. 'We see our shirts as a disposable luxury,' notes Miller. 'There's very little

re-collaring. We tell people they are an investment if they look after them, so when they're worn out they buy a new one.'

For its bespoke shirts, Hilditch & Key offers a choice of some 1,150 fabrics. There is an initial order of four shirts starting at £265 each. Once David Gale has made a customer's paper pattern, it is sent to the manufacturing facility where it is digitised into a computer-aided design (CAD) machine for the cutting. The CAD machine allows for pattern manipulation to ensure perfectly matched stripes and checks. Pattern matching, very much a lost art, is something Hilditch & Key are particularly proud of – their focus on details even extends to having a customer's initials engraved on his shirt buttons should monogramming be to his taste. An initial shirt is sent to the customer for wearing and laundering, and the pattern is tweaked before the additional shirts are produced. Today, bespoke accounts for between 20 and 25 per cent of Hilditch & Key's business, a healthy figure in the internet era.

Steve Miller points out that the internet has repurposed shirtmakers' customer bases, replacing word of mouth, but the loyalty the brand engenders – particularly amongst its bespoke customers – is remarkable. The week before I met Miller he'd overseen a long-term customer's first shirt for his son … who was 4 years old. 'We have one customer who spends £40,000 a year on bespoke shirts,' says Miller, and while he is reticent to be drawn on the company's client list, it is known that Hilditch & Key famously made designer Karl Lagerfeld's trademark high-collar shirts, while President Nicolas Sarkozy bought his *chemises* from their Paris store.

Hilditch & Key has a daunting reputation, second perhaps only to Turnbull & Asser, but this Jermyn Street cornerstone's huge, loyal following is testament to the exceptional service and superb shirts its clients enjoy. As with all the very best brands, once they have experienced Hilditch & Key, customers rarely shop for shirts elsewhere. If you are looking for a modern, almost continental bespoke shirt, without the tradition and ceremony often associated with Jermyn Street, then Hilditch & Key is undoubtedly the shirtmaker for you.

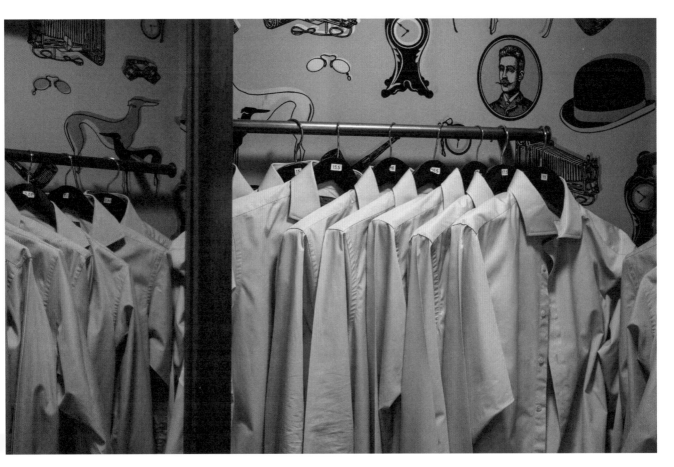

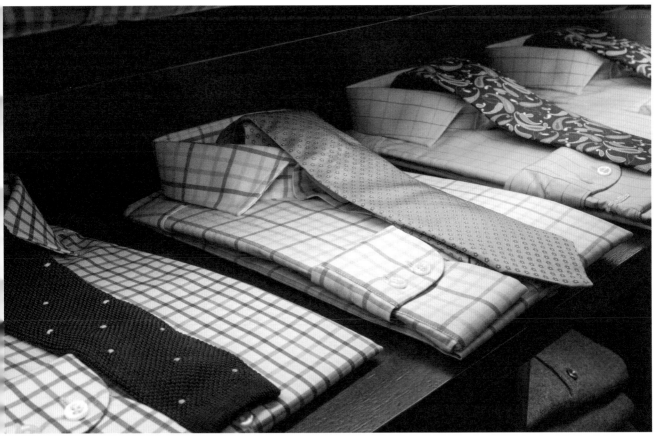

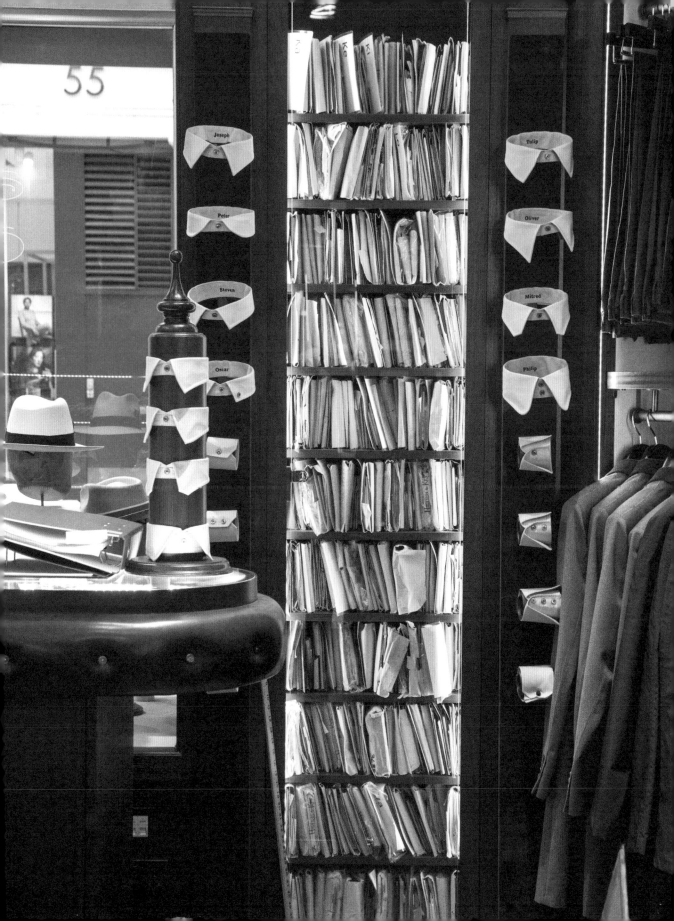

NEW & LINGWOOD

One of the most popular tourist attractions on Jermyn Street is the life-size statue of legendary dandy Beau Brummel, and its location directly in front of the two New & Lingwood stores which flank the entrance of the Piccadilly Arcade could not be more profound, as New & Lingwood is a true mecca for the dandy of today.

New & Lingwood was founded in Eton, Berkshire in 1865 by Samuel Lingwood and Elisabeth New, who went on to marry, becoming the first love story of Jermyn Street. Eton College was – and remains – the pinnacle of the British public school system and New & Lingwood established itself to dress both the masters and the pupils, a tradition which continues to this day, with every boy's uniform still fitted in the Eton branch. Over the years, New & Lingwood has made the distinctive uniform of black tailcoat, striped trousers, waistcoat and shirt with detachable collar for luminaries such as Tom Hiddleston, George Orwell, Ian Fleming, Hugh Laurie, David Cameron, Princes William and Harry and Boris Johnson.

In 1887, the exterior of the shop was painted white to mark Queen Victoria's Golden Jubilee and the result was so striking that when the passing monarch noticed it on Eton High Street, she sent a note to the store commending it for looking 'so pleasant' and expressing her hope that the this new paint job would be permanent.

In 1916, Samuel Lingwood sadly died, leaving his wife to run the business through the challenging period of the First World War and its aftermath. Stretched to breaking point financially, Elisabeth briefly passed the business to the courts, but by the time she died in 1931 both she and the business – which was taken over by a group of investors – were solvent. A colourful figure in her day, Elisabeth – inspired by Queen Victoria – took to sitting on a chair in the window of the Eton shop, encouraging customers to pay her homage.

In 1922, Elisabeth opened her second shop in Jermyn Street, then as now the aspirational base of all selling menswear in Britain. Like many of its neighbours, the store was obliterated in the German bombing during the Second World War, and it reopened at number 53 Jermyn Street in 1946, where it remains today.

Over the years New & Lingwood has absorbed three other businesses – shoemakers Poulsen Skone and Joseph Gane & Co. and bespoke shirtmaker Bowring Arundel. When I first came to Jermyn Street two decades ago, New & Lingwood was predominantly a shoe shop that sold shirts and dressing gowns, but in that time it has completely reinvented itself with one of the strongest brand identities on the street. In 2015, New & Lingwood was acquired by the American private equity house POP Capital, which led to the brand's first American store, arriving on New York's Upper East Side in 2018. The New York store boasts a charming outdoor garden where guests can enjoy J.J. Corry whiskies and Highclere Castle cigars.

New & Lingwood enjoyed a brief foray onto the British high street in the last decade, as House of Fraser department stores stocked a range of their entry-level ready-to-wear offerings.

The two New & Lingwood stores, which face each other at the Jermyn Street entrance of the Piccadilly Arcade, boast perhaps the most eye-catching displays on Jermyn Street – heavy silk dressing gowns emblazoned with skull and crossbones motifs, bright knitwear and trousers, evening capes, outrageous tweeds and beautiful silk pyjamas – so unique is the range that it would be impossible not to identify a New & Lingwood customer from quite a distance. The skull and crossbones theme (originally from an ancient Eton society), which runs through jacket linings, scarves, ties, cricket caps, slippers and socks as well as the gowns, was introduced by former buying director Simon Maloney and continues to form the focus of each season's new collection. New & Lingwood, long one of the most traditional of all the stores on Jermyn Street, is certainly embracing bold modern styles.

Upstairs, however, in the bespoke shirt department, things are reassuringly old-fashioned. Overseen by genial store manager Charles Seaton, this charming oasis is a place where time has stood still. Today, Seaton is the store's shirtmaker too, measuring bespoke customers himself and looking after their every need. Self-effacing and modest, Seaton is a charming, intuitive salesman who really gets to know and understand his customers. For many years, the shirtmaker at New & Lingwood was Sean O'Flynn, who arrived from Huntsman in 1984 and presided over the department for the next two decades before leaving to set up on his own in Sackville Street, where he remains to this day.

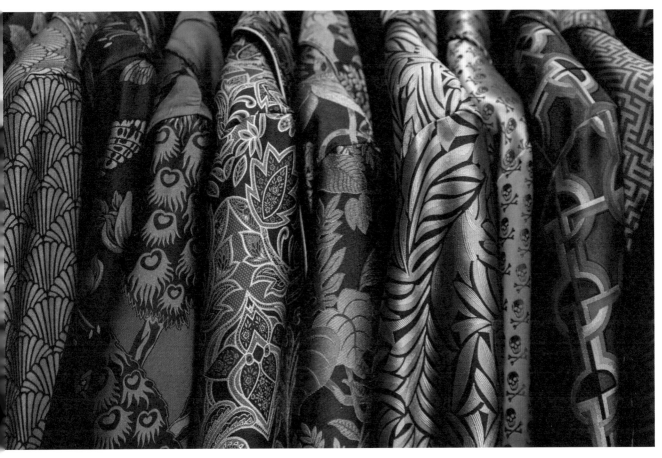

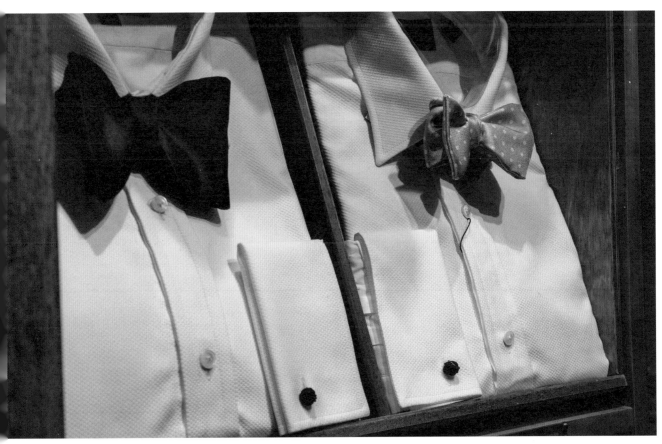

Seaton carefully but confidently balances the past triumphs of New & Lingwood shirt making with the brand's modernity. 'It is a modern take on classic British menswear,' he explains.

'A lot of what I've learned is from looking at the archive,' explains Seaton about his shirts, acknowledging that 'James Bond is always the best gauge of menswear. Shirts should have a clean drape – although the real heyday for luxury shirts was the late 1990s and early 2000s, everything was too big. Now it has gone the other way.'

New & Lingwood's ready-to-wear shirts are excellent value for money, coming in at between £125 and £175 with all the usual styles of collars and cuffs. Their house style 'St James's' collar is a moderate spread, a little softer than many others, for a more relaxed look. They also sell an assortment of neckband (collarless) shirts off the peg.

New & Lingwood offer both made-to-measure and bespoke shirts. For bespoke, the minimum order is four shirts initially, with a lead time of four to eight weeks. The bespoke shirts are handmade in London, while the made-to-measure shirts are produced in the Czech Republic. Bespoke shirts start at £275 while made-to-measure shirts are from £225. Both services are available in the Eton and New York stores as well as in the Jermyn Street flagship.

Shopping in New & Lingwood is one of the most enjoyable experiences Jermyn Street has to offer. From the stunning displays, enchanting atmosphere and sense of history in the store to the charming, knowledgeable staff, there really is nowhere else like it, and its appeal is unique. Now over 150 years old, this venerable brand has truly stood the test of time and, like the statue of Beau Brummel in front of it, it will no doubt cast its shadow over luxury menswear for many years to come.

NEW & LINGWOOD

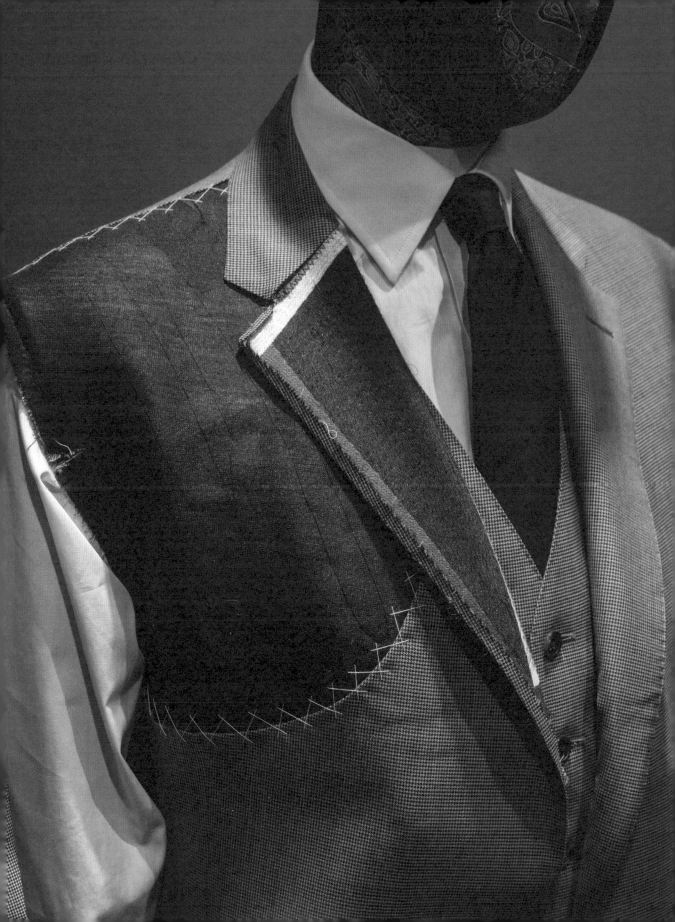

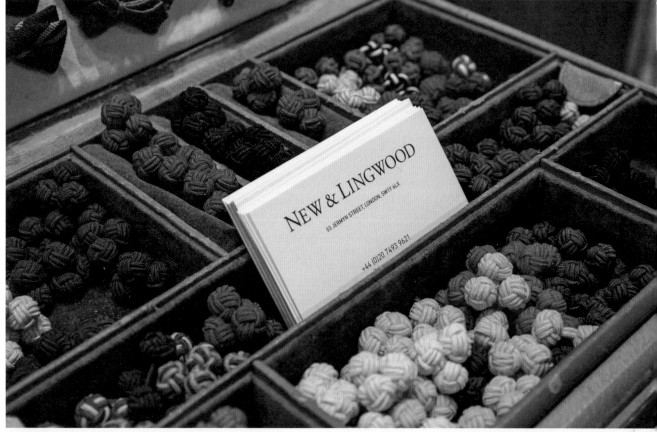

NEW & LINGWOOD

53 JERMYN STREET, LONDON, SW1Y 6LX

+44 (0)20 7493 9621

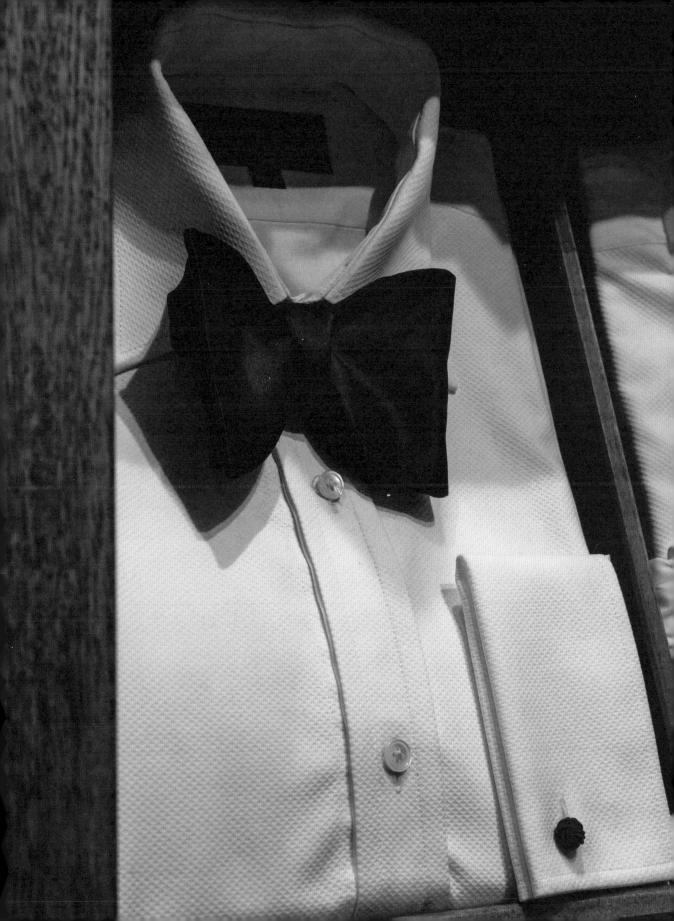

BUDD

The most discreet of the Jermyn Street shirtmakers, Budd occupies small, elegant premises in the Piccadilly end of the Piccadilly Arcade at numbers 1a and 3. The window displays usually focus on silk scarves, dressing gowns and evening wear, and while not without flashes of colour, it is one of the most circumspect shopfronts, but perhaps the most stylish, in the West End. Budd is the Piccadilly Arcade's oldest tenant, having opened in 1910 at number 4. At that time the shop sold only bespoke shirts, so despite the compact premises, the lack of ready-to-wear shirts made the space work.

In the April of 1941, the St James's district was heavily bombed by the Nazis – both Fortnum & Mason and Dunhill were all but destroyed, although Mr Dunhill took to selling his wares from a wheelbarrow on Jermyn Street in defiance of the assault. On 17 April that year, just after 3 a.m., a 2,200lb parachute bomb hit the Piccadilly Arcade at roof height, devastating all but two of the shops within. Budd burned down and there were twenty-three casualties including the famous singer Al Bowlly ('Goodnight, Sweetheart') who lived across the road on Duke Street.

Harold Budd wasted little time regrouping and purchased the leases of the only two surviving shops in the arcade – numbers 1a and 3, where Budd remains today. It would take sixteen years for the arcade to be rebuilt completely.

The economic downturn following the Second World War saw the demand for bespoke shirts, particularly in silk, lessen and Budd adapted by expanding into haberdashery, selling ties, scarves, dressing gowns, handkerchiefs, cravats and pyjamas. The store maintains an excellent selection of accessories today with beautiful soft polka dot silks a particularly elegant look. It also offers a beautiful selection of 'madder silk' ties and every evening wear accessory one could wish for.

In 1983, Budd was bought by Webster Brothers, another British shirtmaker, which was founded in 1847. Their combined history made them arguably London's longest surviving, continuous producer of shirts.

In 2011, Budd was acquired by a consortium led by Irishman Steven Murphy, former owner of Savile Row tailor H. Huntsman.

In March 2019, Budd opened a pop-up shop at 93 Lower Sloane Street in Chelsea which moved to number 16 in Chiltern Street, perhaps the most picturesque street in Marylebone, later that year. Some years ago I lived in Paddington Street, just around the corner, and would walk down Chiltern Street on my way to my office on South Audley Street. Although it had an array of clothes shops, including the iconic Trunk, none of them really catered for my needs and something more classical felt needed. Since the opening of the Chiltern Firehouse, the London outpost of the Chateau Marmont Hotel, Chiltern Street has become one of the most popular in central London and Budd's appearance there demonstrates their shrewd approach to growing their brand.

The Budd store in the Piccadilly Arcade is overseen by manager Andrew Murphy, a dapper fixture of London's menswear scene for over thirty years. A true exponent of old-fashioned service, Murphy is the epitome of Jermyn Street classic charm. Murphy's father worked for tie manufacturer Vavasseur for over fifty years and instilled in him his love of the West End menswear scene. A natural wit, Murphy is known for his off-the-cuff *bon mots*, whether enquiring if a handkerchief is 'for show or blow' or describing Budd's luxurious nightwear as 'cut for men, not boys'.

Budd's ready-to-wear shirts come in a beautiful range of checks, plains and – particularly – stripes, for which they are best known.

The 'Budd stripe' – a simple yet striking design – is a coloured stripe (most often a blue) running parallel to a white satin stripe, both of which are finely edged with black, which is all but invisible to the naked eye but elevates the stripe, giving it a cleaner, sharper look. The Budd stripe was originally woven in silk, in the delightfully named Silk Street in Barbican, but a German incendiary bomb destroyed the warehouse and its stock and the stripe was not revived until the 1980s when British mill Thomas Mason was entrusted with reweaving it in a two-fold 100s cotton poplin. In 2000, to mark the millennium, a new range of Budd stripes was introduced and the cloth has remained a staple ever since, with the cloth still under the Thomas Mason name on the looms at that company's owner, Albini, in Italy. The colour palette is refreshed occasionally, but the Edwardian- and sky-blue stripes remain perennial menswear classics.

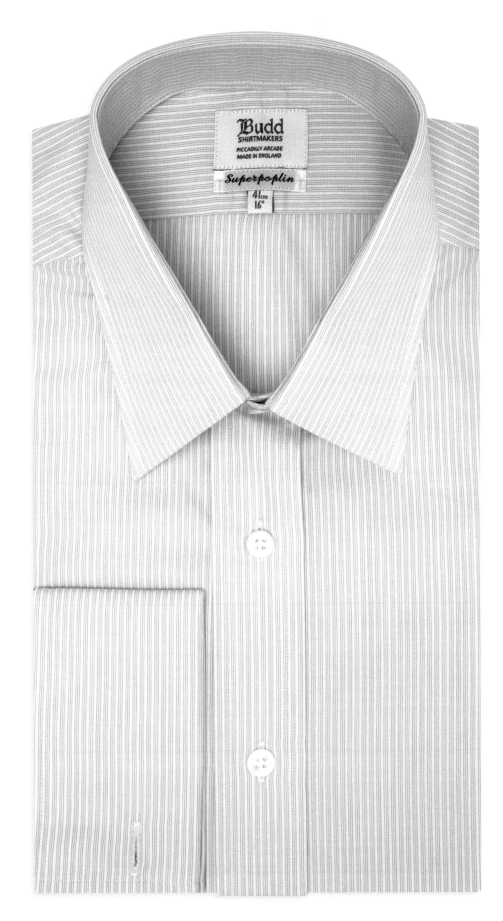

The shirts are now offered in three shapes – classic, tailored and slim fits.

Budd's ready-made shirts feature an average-sized collar and either double cuffs or a single button squared cuff. The standard collar, which hasn't been changed since the 1980s, is forward facing and has a slightly softer look than Turnbull & Asser's. Budd's cutaway collar, known as the 'Bank collar' in a nod to the Webster family, has been a staple of the company's offerings for over forty years. Less severe and more elegant than European cutaway styles, it sits neatly under the lapels of a jacket. There are also button-down and pin collars, and a straight-cut, more formal-looking collar named the 'Washington' due to its popularity with Budd's American customers.

The classic-fit shirts are amongst the best ready-to-wear shirts on Jermyn Street (or anywhere else) and are cut to an exclusive block, which has remained the same since they were first offered in the 1950s. They are formal and striking and start at £185 for plain cotton, rising to £325 for Sea Island cotton.

The tailored-fit shirts tend to be slimmer and more casual, and of course use less fabric and are priced accordingly, starting at £130.

The slim-fit shirts are cut shorter so that they can be worn untucked and are the most casual of all. The sleeves are trimmer too and prices start at £120.

It is, perhaps, a sign of the times that the Chelsea and Chiltern Street pop-up stores only offered the tailored- and slim-fit shirts, in keeping with their less traditional neighbourhoods. Budd owner Steven Webster noted at the time of the Chelsea pop-up opening:

The new pop-up allows Budd to try something new, taking us out of the trusted familiarity of our Jermyn Street premises and into a different part of town. We hope to engage with a new and broader audience, giving them a pure Budd experience and writing a new chapter for the company with the introduction of our new, slim-fit shirts. I have three sons in their twenties and work with young men in their late twenties and thirties. Watching and learning from them, the need for a slim fitting, elegant and high quality shirt has become very apparent. I want Budd to be on their radar.

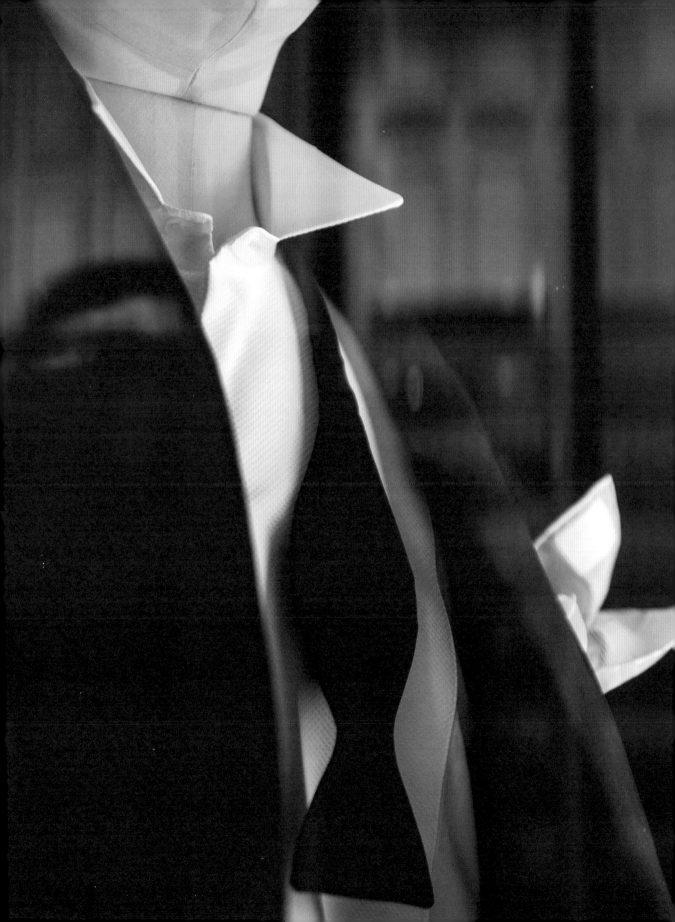

Budd offer a made-to-measure or 'stock special' service as a compromise between ready-to-wear and bespoke, with a choice of six collar styles, sleeve length and six cuffs which can be ordered one at a time. The shirts take two to four weeks to produce and prices start at £225. Monogramming is available.

A Budd bespoke shirt is considered by many to be the very best that Jermyn Street has to offer. Head cutter John Butcher is one of Jermyn Street's longest-standing artisans, having worked at Budd for over fifty years, with a dip in the floor where he stands behind his cutting board to illustrate his longevity. 'My godfather's friend was a rep for David & John Anderson's and got me an interview there, where I did a two-year apprenticeship,' explains Butcher. 'There was a job at Budd as an apprentice and I've been here ever since. It all starts with a pair of shears and I was at an immediate disadvantage – I'm left-handed and all shears are right-handed.' In his five decades cutting shirts, Butcher says his greatest challenge has been producing dress shirts made of pure marcella cotton (usually only part of the shirt is made of this thick fabric): 'it's like wearing a suit of armour,' he opines.

Butcher's colleague Darren Tiernan, Budd's senior cutter, is one of the most engaging men on Jermyn Street. A handsome man with a thick beard and piercing eyes, he celebrated his thirtieth anniversary as a cutter in 2017, and to mark the occasion Budd commissioned an exclusive Alumo check cloth. Darren is one of the most passionate men on Jermyn Street and his enthusiasm for shirt making is infectious. 'It was nice to have thirty years recognised,' recalls Tiernan:

> Decades come and go so it was nice to have it marked with the exclusive cloth. It was also nice that a lot of bespoke and made-to-measure customers commissioned shirts to be made from it to help mark the anniversary. It was based on an old design which I remember cutting a lot when I first started as an apprentice at Bowring Arundel. We cut so many shirts from it as it worked across the board, i.e. with a suit, sports jacket or even jeans.

If Butcher is one of the great traditionalists of Jermyn Street, Tiernan is a forward thinker, taking on more adventurous commissions such as linen safari jackets (safari jackets are notoriously difficult to

make). Tiernan can often be seen sporting a bespoke shirt open neck, demonstrating the product's less buttoned-up appeal: 'I wear open-neck shirts at work purely for comfort. I wear a tie when I'm away seeing customers in the US and abroad, so don't have an aversion to wearing ties.'

Of Budd's continuing appeal, Tiernan notes:

> Budd shirtmakers is still one of the old-school shirtmakers. I think people like the long rich history of the company – the fact that we are in-house cutters and have an on-site cutting room that people can see, also that we have our own workshop in Hampshire, instils a sense of confidence with customers who are looking for traditional and classic shirts.

There is a minimum initial order of four bespoke shirts at Budd, which are made at an exclusive workshop in Andover in Hampshire (where the stock special shirts are also made). The workshop was established

over fifty years ago, originally as part of former Budd owner Webster Brothers, relocating from the company's London premises in 1965.

The first shirt takes eight to ten weeks and standard cotton shirts start at £275.

'Really good-quality material is half the battle with a bespoke shirt,' notes Butcher. 'People feel our fabrics after shopping elsewhere and are immediately converted', and Tiernan agrees. Budd offers over 8,000 fabrics for its bespoke shirts. Both men are great advocates of the exclusive soyella fabric – a silky two-ply cotton from the Swiss mill Alumo which runs to around £465 per shirt (as opposed to £295 for a ready-to-wear shirt in the fabric).

Darren Tiernan explains that the typical Budd bespoke customer has an idea of what they want from the get go:

> Most people come to us for bespoke shirts for work so usually
> I recommend maybe 1–2 white shirts, a nice blue to wear with
> greys and blues and maybe a neat stripe and a small neat check, but
> the beauty of this job is you are usually surprised how adventurous
> people can be with bespoke.

For such an elegant, classic brand, Budd has embraced the changes to the menswear market that technology has brought. It regularly partners with *The Rake* magazine and has without doubt the most detailed website of any shop on Jermyn Street, with an exhaustive blog offering a real insight into the craft and the brand.

Famous Budd wearers have included Bill Nighy, Lord Mountbatten, Sir Evelyn de Rothschild, Eddie Murphy, Jon Hamm, William Dafoe, Kevin Hart, David Beckham and Peter Capaldi. Another *Doctor Who* actor, Matt Smith, wore Budd on screen as the Time Lord, while Hugh Bonneville sported the company's wares in *Downton Abbey*. Recently Daniel Craig paired a Budd evening shirt (along with a black bow tie and white cotton pocket square) with a double-breasted Anderson & Shepherd dinner jacket at the 77th Golden Globe awards, offering a tantalising glimpse of how great a British bespoke Bond could look in the new decade. 'I'd love to have a crack at Bond,' opines Darren Tiernan. 'I'd do it proper old school. Maybe go retro style on one or two of them, Connery/Moore style.'

SHIRTMAKERS

EST. 1910

HARVIE & HUDSON

Of all the shirtmakers on Jermyn Street, Harvie & Hudson feels the most distinctly English. The shop window's veritable explosion of butcher striped shirts, spotted silk scarves, sleek covert coats and pastel lambswool knitwear perfectly encapsulates what it is (and what it is perceived) to be an English gentleman. In the summer, bold linens for both shirtings and jackets capture the spirit of Cowes and Henley. Shopping in Harvie & Hudson – the only family-owned shirtmaker on Jermyn Street – is never anything less than a joy.

The origins of Harvie & Hudson can be traced back to the long-defunct Jermyn Street shirtmaker shop at number 23, where – before the Second World War – George Hardie was the head cutter and Thomas Hudson was the store manager. The enterprising pair decided to start up on their own, but the ambition was sidelined by the war, during which Hudson was drafted to active service in Burma, while Harvie worked as a cutter in a factory making uniforms.

After the war, the friends were reunited and eventually opened the first Harvie & Hudson store at 20 Duke Street (now the car park entrance of the Cavendish Hotel), which was owned by the infamous Rosa Lewis who, keen to encourage new business in hard times, gave it to them at a peppercorn rent. Unfortunately, the opening day was hampered by a substantial flood on the premises, but they soon rebounded and trade in ties and shirts was brisk.

When the Cavendish Hotel closed prior to refurbishment, Harvie & Hudson moved across the road to 41 Duke Street (now the Willow Gallery) where it continued to flourish. In 1964, Harvie & Hudson made its triumphant debut in Jermyn Street across two storeys at number 97. It later opened stores at 77 Jermyn Street and in 1986 on Knightsbridge. In December 2004 it opened a fourth store at 12–13 Lime Street in the City of London, which housed a self-contained barber in conjunction with Taylors of Old Bond Street. The 77 Jermyn Street store became increasingly bespoke focused, with huge rolls of fabric on display, but in 2011, landlord the Crown Estate wanted the property back at the expiration of its lease and Harvie & Hudson took the opportunity to reconsolidate its business into the flagship.

Harvie & Hudson's arrival on Jermyn Street coincided with that decade's 'peacock revolution' and the brand's major contribution to this was the decision to market ready-to-wear shirts made up of bold, striped cloths traditionally reserved for pyjamas. Harvie & Hudson's mantra, amidst a sea of traditional blues and whites, was 'you can have anything you want'.

Each year, Harvie & Hudson commissioned 1,000m each of four bold, striped fabrics from a mill in the north of England which made for very popular limited edition shirts. Before menswear became more minimalist, around 2000, this was one of the brand's great distinguishing features.

When the 77 Jermyn Street store was closed, Harvie & Hudson completely refurbished the flagship store, modernising it substantially but never losing its charmingly olde worlde feel.

Today, a Harvie and a Hudson still own the store, Richard Harvie and Andrew Hudson, and both are regularly in the store, taking orders and guiding customers through their purchases. Richard Harvie is an erudite, sleek man who seems pleasantly surprised that his family business has developed such a cult following amongst the well-heeled. He didn't start out working for the business, instead undergoing a management course at Harrods before joining. Harvie and Hudson are both very much hands on with all aspects of their business, through design and buying to e-commerce and social media.

The Harvie & Hudson store never really feels like it is in London: instead, as you step through the door of 97 Jermyn Street, you feel transported to a grand English country house which just happens to sell a vast array of fine menswear. Amongst the best the store has to offer are the scarves, in wool, silk, cashmere and permutations thereof, corduroy trousers and waistcoats in warm hues of reds and blues. Outside of Cordings of Piccadilly it has perhaps the best selection of ready-to-wear country clothes in London.

Harvie & Hudson's ready-to-wear shirts – distinguished by their racing-green label (shirtmakers' labels are usually white), represent arguably the best value on Jermyn Street, priced at between £80 and £145, and their selection of stripes and checks rivals that of any of their competitors. Although they offer the now expected slimmer fits, their classic shirts are still cut in a traditional style which suits the brand and its customers. If you're going to try one, go for their classic butcher's stripe in white and blue, a distinctive bold choice that's as English as marmalade.

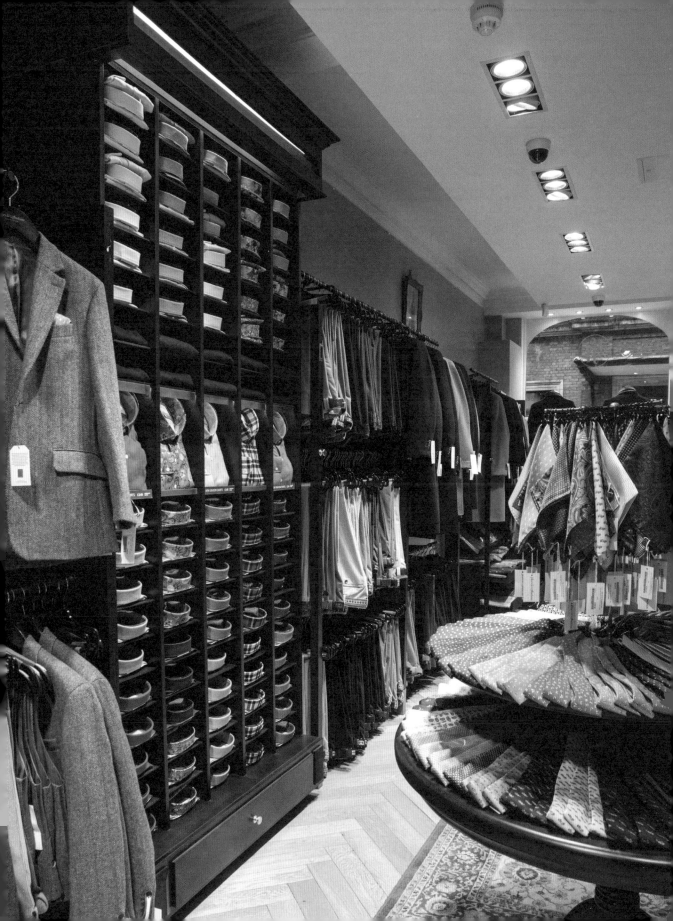

Harvie & Hudson still offer a bespoke shirt service, though today it accounts for only about 10 per cent of the company's business. In line with other shirtmakers, an initial order of four shirts is required, starting at £245 each (thereafter they can be ordered one at a time). The initial shirt takes approximately a month and Harvie & Hudson ask the customer to wear and launder it three times to ensure a precise fit. The service is also offered to American clients through a series of trunk shows. The bespoke shirt department, on a raised dais at the back of the store, is a tranquil oasis away from the rest of the shop and just the place for a delightful bespoke interlude, whether for a first-time customer or a seasoned regular.

Winston Churchill once said 'A gentleman buys his hats at Locks, his shoes at Lobbs, his shirts at Harvie & Hudson, his suits at Huntsman and his cheese at Paxton & Whitfield' and his advice holds just as true now as then: Harvie & Hudson is one of the great, enduring British brands and long may that continue.

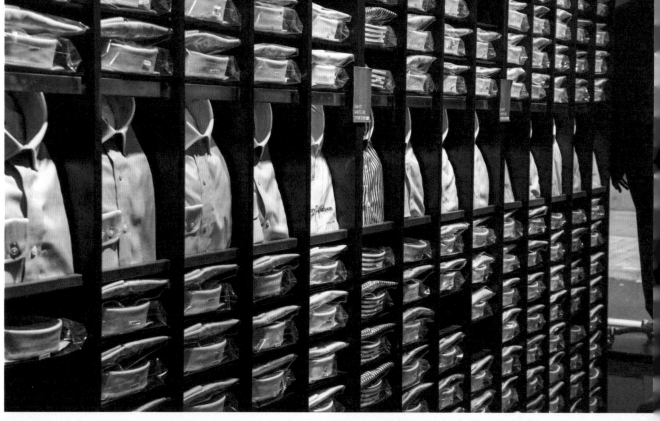

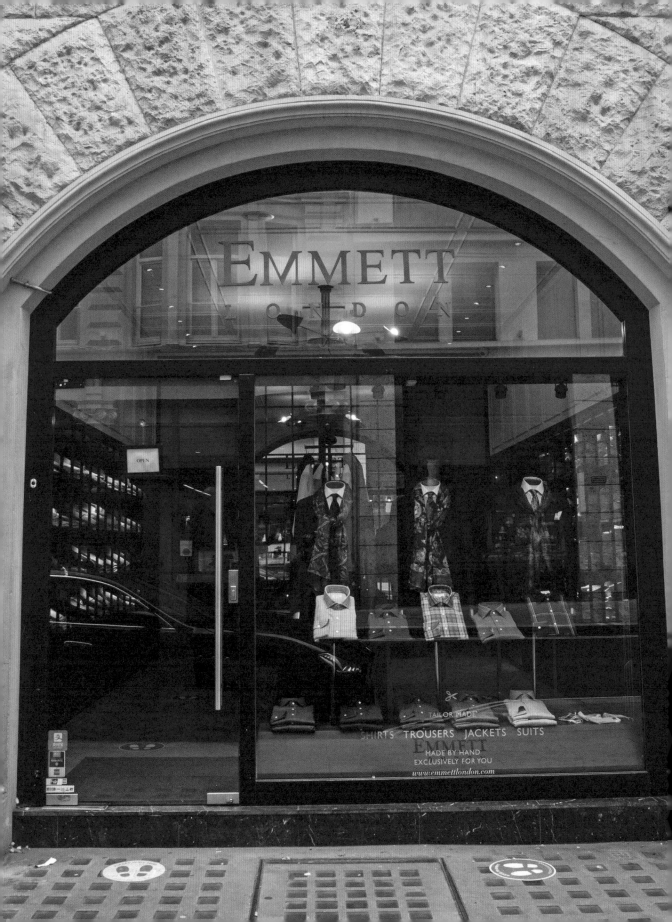

EMMETT

To meet Robert Emmett is to take an instant liking to him – a charming, reserved man who radiates a relaxed energy, which immediately makes his customers feel at ease. Were he not presiding over his shop, right at the Haymarket end of Jermyn Street, this affable, stylish man would be perfectly at home in one of the better members' clubs in the area, holding court at the best table. In many ways, he reminds me of the late Doug Hayward. But despite embodying many of the best qualities of the archetypal English gentleman, Robert Emmett is in fact Australian and here, perhaps, lies the secret of his laid-back bonhomie.

The Emmett family emigrated from Sydney to England when Robert was aged 4. Emmett's father was a doctor who wore tailored shirts for work, and by the age of 14, Robert's hobby was taking them apart to create his own paper patterns and borrowing his mother's sewing machine to make his own shirts, inspired by what he saw in glossy magazines. After training in classical French cuisine at l'École hôtelière de Lausanne in Switzerland, he later took a tailoring course in Geneva and eventually opened his first shop above a garage in Zurich, which he oversaw for a year and a half.

In 1992, backed by a £20,000 loan from his father, Emmett opened his first London store at 92 King's Road, then as now the most fashionable address in Chelsea. This was a bold move on Emmett's part as neither the street nor the district was immediately identifiable with high-end menswear, but the brand and the shirts rapidly gained a cult following, in no small part due to glowing endorsements from the late Adrian 'A.A.' Gill, one of Britain's great dressers, as well as one of the most erudite menswear writers to pick up a pen. 'Adrian was a great client and friend,' says Emmett. Gill, who tragically died in 2016, wrote regularly for *The Times* and *GQ*, and any endorsement by him was taken very seriously in an age largely without Instagram or *The Rake*.

Emmett's decision to open his first store in Chelsea rather than St James's was prudent – 'I thought King's Road was more fun,' he explains, 'and a lot cheaper than Jermyn Street.' In the early days, Emmett was distinguished by bold, colourful shirts largely at odds with

the traditional Jermyn Street aesthetic, but time and tide waits for no man and fifteen years after opening his first store, Emmett opened a second in Jermyn Street.

The Jermyn Street store, opposite the theatre and flanked by the excellent steak restaurant Rowley's, has a unique atmosphere amongst the shirtmakers of the area: it is a little less formal than the rest and neatly represents the *sprezzatura* inherent in the brand. I would say there is no better place in the UK to start your collection of off-duty shirts off the peg than here.

Today, Emmett shirts are perhaps the most stylishly relaxed on Jermyn Street and many have less rigid collars and patterns than those offered by other makers. Emmett shirts are not made in England – 'I wish there were English makers, but there aren't,' opines Robert – instead coming from Italy, Turkey and Poland. The shirts made in Poland are, he says, the finest he offers: 'It's wrong that people see a label that says "Made in China" or "Made in Poland" and automatically assume it is inferior.' Emmett offers both a bespoke and made-to-measure service. There is no minimum order and the turnaround time for a bespoke shirt is five weeks.

Shirts off the rack cost between £145 and £195. All are distinguished by a distinctive contrasting fabric inside the cuffs, a flourish which has become a trademark. The button cuff shirts have an attractive rounded barrel cuff and are fastened with one button. The collars are typically a moderate spread or cutaway.

Above its cosy shop, Emmett has a magnificent bespoke salon in what was once a grand first-floor Jermyn Street apartment, where it offers suits and separates as well as shirts. Robert Emmett oversees this part of the business himself while his two sons run the shops in Jermyn Street and King's Road.

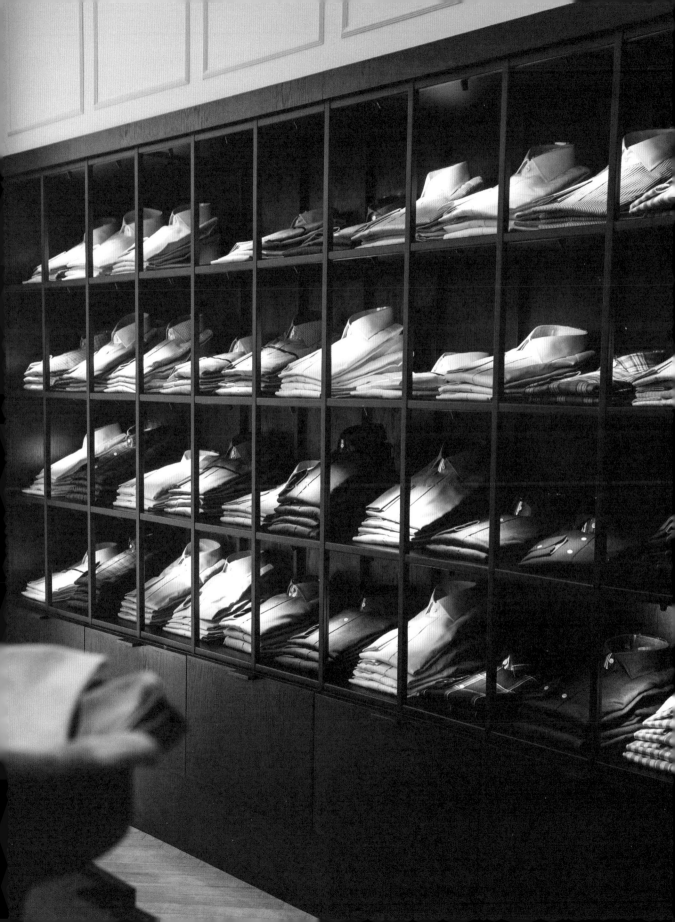

STEPHEN LACHTER

Stephen Lachter is the archetypal English gentleman – a warm, gracious man with an infectious smile, for whom nothing is too much trouble. He's also an exceptional shirtmaker with a client list that has been the envy of the world for decades. He began his career in retail working for suit shop Hepworth (which later became Next), alternating floor walking there by day with aspirations of becoming a stand-up comedian at night. Hepworth was a flourishing business producing made-to-measure and ready-to-wear suits, and Hardy Amies was the first designer to have a licensing deal with them. Although Lachter was earning more from stand-up, he was disappointed when he was let go by Hepworth after three years, and joined a menswear recruitment agency to look for his next role. Not long after, he found himself at Turnbull & Asser, from which he'd purchased his dinner shirts for his act, being interviewed by Tony Carlisle – it was a success, but Carlisle, who Lachter notes 'enjoyed a long lunch', forgot to actually send the offer letter, leaving him hanging for weeks. Eventually, Lachter was pointed towards Hawes & Curtis, which at the time Turnbull & Asser owned, and given a job as a salesman in their Burlington Gardens store (the site is now occupied by Salvatore Ferragamo) in 1976. 'This opened up a new life to me,' recalls Lachter, 'and I loved it. I actually got to talk to the customers, in fact I was encouraged to build relationships with them. Within four days of me starting, the Duke of Kent walked in off the street. It was another world.' It was here at Hawes & Curtis that he met his present colleagues, John Kent and Terry Haste.

At Hawes & Curtis, Stephen learned to fit and cut shirts under legendary cutter Roy Woodhead and began building up a list of clients which spanned from Hollywood royalty to British aristocracy. He was introduced to Frank Sinatra by tailor Cyril Castle. Sinatra in turn introduced him to Cary Grant. 'It was just a nice place to be,' opines Lachter today.

Another of his shirt customers at Hawes & Curtis was South African entrepreneur Roy Bishko, who founded Tie Rack in 1981. 'Roy asked if I'd like to be their buyer … for an astronomical salary,' chuckles Lachter. 'I accepted, of course, and within six months they made me a director.

I learned about business very quickly – it was what you might call a baptism of fire!' Tie Rack, of course, was a high-street fixture for many years – at one point the business had 330 stores in twenty-four countries.

Buying, however, was not where Lachter's heart lay – he wanted to get back to the business of bespoke. 'I'd had enough of Tie Rack and made a few quid so it was time to try something new.' He had met tailor John Kent – who was a royal warrant holder as the Duke of Edinburgh's tailor – when he was a cutter at Hawes & Curtis. Kent mentioned that he was considering striking out on his own as a bespoke tailor and suggested they set up shop together; thus the Kent and Lachter union was born. Initially they were both by appointment only, travelling to meet clients, but as the business started to grow, their friend Henry Rose offered them a space at his 8 Kingly Street premises. 'It wasn't anything plush,' recalls Lachter:

It was a bit spit and sawdust really but we had a base. It was above the Miranda Club and Bob, the club's manager, would send customers up for suits and shirts. He was immaculate. John and I introduced ourselves to each other's clients too, of course.

A year later, a basement space became available from the tailor James & James at 11 Old Burlington Street, and Lachter, Kent and Rose moved there – it became their first shop and their home for the next five years. Both Kent and Lachter had showbusiness clients and increasingly turned their attention to making costumes for film and television. In addition to making all the costumes for the series *Howard's Way*, Lachter made Clint Eastwood's silk pyjamas and dressing gown for the film *White Hunter, Black Heart*. Other customers included Sir Ralph Richardson, Tommy Nutter and Stewart Granger, whose patronage he shared with Frank Foster. 'In those days we never did any advertising,' says Lachter, 'it was all word of mouth. People used to like us – we all had a passion for the trade.'

In time, the business grew to the point where bigger premises were required and a shop presented itself at 8 Stafford Street – a tailor named Terry Hammond was looking to retire. Lachter and friends spent some £10,000 revamping the shop. 'It was around this time that the business really took off,' Lachter asserts. He made the shirts for Ralph Fiennes'

ill-fated turn as John Steed in the abominable *Avengers* movie, which were probably the film's highlight.

At this time, Stephen and his friend Emma Willis both used the same 'production' or factory to make up their shirt orders, and when that business found itself in financial difficulties they clubbed together and bought it in order that they could carry on without any break in their output. Eventually Emma opened up in Jermyn Street and Lachter took over the production business completely, making branded shirts for many third-party shops ('half the West End,' notes Lachter with a smile).

Lachter's next move was to buy another shirt business:

> Katy Stephens was one of the great unknown shirtmakers, working out of Archer Street in Soho. She was Douglas Fairbanks Jnr's favourite shirtmaker. And Raymond Burr's. Huge Hollywood stars. Around 1992 she asked me to buy her business. It was very different to mine – all her patterns were cut out of newspaper! But we made a deal and I bought a lot of great cloth and a lot of great customers. She had some really big spenders – one guy ordered eighty shirts each year! She was a real character.

When the Stafford Street lease came up for renewal, Kent and Lachter decided to continue their association elsewhere, while Henry Rose moved on. Nick Granger owned the legendary Savile Row tailors Norton & Sons and in 1994 asked them if they'd like to go in with him there. Lachter describes the premises at 16 Savile Row as 'like an old country house', but he flourished there, having all their shirt customers as well as his own for a percentage of the rent. Eventually, however, fate was to play two unexpected hands. 'Nick sold Norton's to Patrick Grant,' explains Lachter. 'Patrick had very different ideas to us about how it should be run – he wanted to modernise it all … but he needed the rent. He didn't come from a tailoring background.' Grant – best known as one of the judges on the television series *The Great British Sewing Bee* – led a successful rejuvenation of Norton's, having sold his house to purchase the business, which continues to flourish under his leadership.

The second blow dealt by fate was that John Kent became very ill and had to leave the business, leaving Lachter stranded and unhappy in

Norton's. 'It wasn't what we wanted,' says Lachter, 'and of course I had to look after John's customers, including the royal ones.'

Terry Haste, a brilliant cutter and arguably the best tailor in Britain today, originally met Lachter in 1976 at Hawes & Curtis, and was head cutter at Tommy Nutter when he introduced Tommy to Lachter, who became his shirtmaker in the 1980s. Haste had just left his role as managing director of another Savile Row institution, Huntsman. He approached Lachter about joining him to take on Kent's client list. They began seeing clients at the premises of cloth merchants Holland & Sherry on Savile Row and – much to their delight – by 2010 John Kent was well enough to return to work and the trio formalised their business as Kent, Haste and Lachter.

After two years with a short lease at premises previously occupied by Denman & Goddard on New Burlington Street ('it was a great deal but we had to kit it out … and it was infested with moths underneath all the tweed on the walls … and carpet beetles under the carpet! It took six weeks for Rentokil to sort that out!') the firm moved to its current home in Sackville Street. Lachter owns and runs the shirt side of the business, and Kent and Haste, the tailoring side.

The Sackville Street premises are a delight to visit, and the non-stop banter between the three old friends is nothing short of hilarious. They are warm, welcoming and make the bespoke experience a great deal of fun. 'Terry is younger and more enterprising than us,' explains Lachter. 'He knew Nick Foulkes and through Nick got me an article in *GQ* magazine … which finally got me a little of the credibility back with my son after Kanye West came into Norton's some years ago and I didn't recognise him!'

Lachter's house style is the epitome of refined conservatism: 'I tend to stick to a modern, semi-fitted silhouette. I don't like the skimpy shirts – unfortunately there tends to be a very fine line between skimpy and tight! Over the years it has become a very refined, fashion-conscious business.'

There are no ready-to-wear or made-to-measure shirts, only bespoke. Lachter likes an initial order of four shirts with the process taking approximately two months, including a fitting. Thereafter, shirts are, of course, quicker. Prices start at £265, which is excellent value for money.

Stephen Lachter would be a great first shirtmaker for anyone and his long, loyal client list speaks volumes about how happy his customers are.

His gentle disposition and eagerness to please, as well as his passion for his trade, immediately dispel any nerves a customer might have, and his anecdotes are as legendary as his shirts.

PINK SHIRTMAKER (AKA THOMAS PINK)

Pink, Pink Shirtmaker, Thomas Pink … however you know the brand, you know it, and it is generally associated with the excesses of the 1980s – City high rollers wearing braces and gold day-dates partying all day and working all night. And while it is true that Pink sits more comfortably with Armani and Burberry than with true shirt-making artisans, it has long vied with Turnbull & Asser as the most famous name on Jermyn Street.

Thomas Pink was founded in Chelsea in 1984 by the Mullen brothers, James, Peter and John, whose father was a shirt manufacturer in Dublin. They chose the bold name 'Pink' partly to stand apart from the traditional blues and whites of other British shirtmakers, but also after an eighteenth-century London tailor who specialised in red hunting coats (known as 'pinks'). Pink focused on heavily marketing itself as an aspirational brand, a strategy which paid dividends. In 1989, Pink came to Jermyn Street, neatly splitting the street into what is known as the 'bespoke' (St James's) and 'sale' (Haymarket) ends. It has always sat somewhat curiously between the two, but in its heyday attracted celebrity customers from Hugh Grant to Elle Macpherson. Further stores opened in Dublin and New York, and today there are twenty around the world.

In 1999, the Mullen Brothers sold their majority share in the business to French luxury goods juggernaut Moet Hennessy-Louis Vuitton SA ('LVMH'), adding it to their portfolio along with Fendi, Dior, Hublot, Donna Karan, Tag Heuer and Kenzo, which continues to own it to this day. LVMH paid a staggering €48 million for this 70 per cent and snapped up the remaining 30 per cent in 2003. Peter Mullen later turned around the fortunes of another great institution, leading a consortium to rescue Wellington boot firm Hunter in 2012.

Unfortunately, Pink's awkward position between the cheaper Jermyn Street brands and the true shirtmakers has not stood the test of time and unlike many of its true luxury LVHM stablemates it has not weathered

the retail storm, reporting an operating loss of £23 million in 2019. In April 2019, the brand had repositioned itself as a high-end luxury brand under the name Pink Shirtmaker but it still falls between two stools, having neither the quality of Turnbull & Asser or Charvet nor the true high-end fashion credentials of Angelo Galasso.

Pink's ready-to-wear shirts are priced at between £110 and £185, come in muted checks and stripes, and are largely 100 per cent cotton. A range of limited edition (thirty per piece) 'patchwork' shirts made from surplus fabrics to help reduce waste is one of the more unusual options offered.

Pink's 'bespoke' line, run by Richard Gibson (of Smyth & Gibson, an Irish shirtmaker whose ready-to-wear shirts were offered by Selfridges for some years) from Vauxhall, is in fact made-to-measure. Although twenty-four measurements are taken to create a pattern, there is a choice of over 400 fabrics (most of the Jermyn Street shirtmakers offer upwards of 1,000), seven collars and just three cuffs. There is an initial set-up fee of £100 to cover the creation of the pattern and fitting, and the shirts are then 'honestly priced' according to fabrics chosen. There is no minimum order.

Thomas Pink shirts are not like any other on Jermyn Street because they are a fashion item rather than a piece of tailoring. Nowhere else on the street will you find a shirt that is 17 per cent polyamide for £130, but the heritage these shirts tap into is not one of hand making and paper patterns; it is one of status and prestige. The Pink name is known all around the world, but it is essentially a fashion label that just happens to have its flagship on Jermyn Street. Pink is not, of course, without its fans, and shirts, like everything else, are a matter of personal choice, but Pink is not the place for the Jermyn Street experience.

T.M. LEWIN

T.M. Lewin is, without a doubt, the most divisive shop on Jermyn Street. Its incredibly low prices, perpetual sales, aggressive marketing and plethora of stores make it the antithesis of the traditional Jermyn Street ethos, but on the other hand it has opened the doors at entry level for those who wish to dress well and enjoy clothes but who do not have the budget to indulge themselves further down the street.

Thomas Mayes Lewin opened his first shirt shop in Panton Street (just off Leicester Square) in 1898, relocating to Jermyn Street five years later. Lewin's shirts popularised the modern idea of a shirt that buttons down the front – previously they had largely been pulled on over the head like a T-shirt. It was known at the time as a 'coat shirt'.

In 1979, the business was bought from the Lewin family by brothers Tony and Chris McKenna. Chris McKenna died in a car crash in 1989 and his brother of a heart attack four years later, and their family sold Lewin's in 2006 in a management buyout backed by the Bank of Scotland for an estimated £25 million.

In 1993, T.M. Lewin changed its business model, offering shirts by mail order for the first time. It also moved its production from Essex to the Continent. Seven years later it began marketing discounted promotions through mail shots and in 2005 launched what was to become its core offering – four shirts for £100. Fifteen years later, when we are used to these promotions and accept them for what they are, it is hard to remember how revolutionary this was, or to underestimate the impact it had on the shirt business. Around this time, T.M. Lewin branched out beyond shirts, offering a full (and affordable) wardrobe for men.

For the man in a hurry, even the smallest T.M. Lewin store (there are tiny, almost kiosk-like ones in some railway stations) has enough clothing to fill an overnight bag. They all stock suits, ties, accessories, outerware and even shoes.

In recent years, T.M. Lewin has sold a capsule collection of its shirts through high-street department store Debenhams, which at around £30 per shirt represents the best-value shirt easily available outside of London. It has also shrewdly partnered with the Law Society to offer young lawyers substantial discounts on even sale merchandise.

Today, T.M. Lewin has sixty-five stores around the world and estimates that it has sold over 30 million shirts in the UK. The shirts are what they are – modern styles, predominantly slim fit and a world away from a traditional handmade British shirt, but nobody can really argue with the price. If you're young or on a budget, there are far worse places to buy your shirts, but best stick to the 100 per cent cotton offerings in a regular fitting. You'll find the pricing allows you to build a wardrobe and you'll enjoy it so much that you'll hopefully soon start looking further

down Jermyn Street towards the traditional shirtmakers – and that can only be a good thing.

HAWES & CURTIS

Like T.M. Lewin and Charles Tyrwhitt, Hawes & Curtis is today a discount-driven multi-buy affordable shirt and tailoring brand, but its heritage is decidedly different.

In February 1913, Ralph Hawes and George Frederick Curtis opened their first store at number 24 in the Piccadilly Arcade, offering tailoring and shirt making for the great and the good. Amongst their early customers was Lord Mountbatten, who remained a patron for most of his life. Perhaps their most famous client, however, was the Duke of Windsor (or the Prince of Wales as he was prior to his abdication), who bought lounge suits, blazers, flannel trousers and linen shirts there, bestowing a royal warrant upon 'Hawes & Curtis Hosiers' on 5 December 1922. The duke, of course, is credited with inspiring the 'Windsor knot' style for ties and Hawes & Curtis made both the ties (with a thicker than usual interlining to bulk them out) and the spread collar on his shirts to accommodate them.

By 1934 Hawes & Curtis was one of the true Jermyn Street success stories, having acquired seven shops on and around the street and boasting 12,000 regular customers. Four years later, King George VI conferred another royal warrant on the firm, which lasted throughout his reign. Another decade on, Hawes & Curtis received a third royal warrant from the king, a tremendous endorsement of just how successful and popular the stores were. Around this time they also designed and made the shirt and tie Queen Elizabeth II wore during the Second World War, while her husband became a client the following decade, awarding them a fourth royal warrant until 1985. It may seem difficult to believe now, but Hawes & Curtis was, in its heyday, every bit as prestigious as Turnbull & Asser. Unfortunately, it was not enough. Between the 1960s and 1990s the brand – which for some time was actually owned by Turnbull & Asser – had mixed fortunes and never adapted to the changes facing the retail industry as well as its competitors.

At the start of the new millennium, Hawes & Curtis was in trouble – £500,000 in debt and with no new stock, it was on the brink of administration. In 2002 entrepreneur Touker Suleyman and his brother bought the Hawes & Curtis business for just £1 (and took on all the debt) and set about rebuilding it as a modern retail operation.

Today, Hawes & Curtis's business is booming and it has over twenty shops in the UK as well as online sites catering to America, Australia and Germany. The shirts are very similar to those offered by T.M. Lewin and there is very little to choose between them – both represent excellent value for money. The styles are, again, modern and fitted with a huge range of casuals in all sorts of extravagant patterns. The 'stretch' and 'extra slim fit' offerings are probably best avoided. On the Hawes & Curtis website the shirts start at as little as £17.95: undoubtedly the cheapest shirt on Jermyn Street. Hawes & Curtis also offer a substantial range of tailoring and accessories, with wool and cashmere overcoats starting at £129, £99 suits and trousers from £25. They also have a ladies' range.

Cheap and cheerful mass-produced shirts are now the order of the day at what was once one of the leading shirtmakers on Jermyn Street. The constant sales and heavy promotion are at odds with the heritage of British shirt making, but for those starting out on their Jermyn Street journey Hawes & Curtis offer the opportunity to build a wardrobe of classic pieces for minimal outlay and their heavy marketing helps keep classic style in the public eye. Touker Suleyman is a great advocate for the British high street and must be admired for breathing life into one of the great British clothing brands, snatching it back from obscurity with such success.

CHARLES TYRWHITT

Like Pink, Charles Tyrwhitt (pronounced 'Tirrit' for the avoidance of doubt) is a product of the 1980s and is very much a budget fashion brand rather than a shirtmaker. Founded as a mail-order company by entrepreneurial Nicholas Charles Tyrwhitt Wheeler while he was still a Geography undergraduate at Bristol University in 1986, the company's catalogue-driven marketing and low prices soon found favour amongst

HAWES & CURTIS

Luxury Suits
From £249

businessmen, and in 1997 it opened its first retail store on Jermyn Street. 'From the beginning, my ambition was to create the "best shirt business in the world",' explains Nick Wheeler. 'It became increasingly obvious that I could never call myself that unless I had a store on *the* street. Jermyn Street is the shirt street. It is a special place for all shirtmakers and I needed to be there.'

Similar to T.M. Lewin and Hawes & Curtis, Tyrwhitt soon expanded its high-street operation with some forty stores in the UK and thirteen in the USA, including in New York, Washington DC and Chicago. Recently, Tyrwhitt has begun offering a made-to-measure shirt service, distinguishing it from its competitors.

The ready-to-wear shirts, which are usually under £20 (but in some cases as much as £45 for Egyptian cotton) when purchased in quantities of four or more, are more distinctive than those offered by T.M. Lewin or Hawes & Curtis, with bold, bright checks predominating. They are slightly more relaxed too with smaller, softer collars the order of the day. Tyrwhitt also offers a wide selection of ties (£30 for two), suits (from £125), shoes (from £65) and coats (around £140 for wool and cashmere), but largely avoids casual clothing. Of the three lower-priced shirt shops on Jermyn Street, Tyrwhitt has a particularly loyal customer base – affectionately christened Tyrwhiteers by the brand – with the likes of Lord Sugar and David Cameron being known to wear the company's shirts. 'Making a shirt is not rocket science,' says Nick Wheeler:

But getting a shirt right takes a lot of time. Men come in different shapes and sizes and every man wants something different from his shirt. Some like heavy fabric, some like fine fabric. Some like non-iron, some like to iron. Some sweat, some don't. Some have sensitive skin, some don't. It is important to get the perfect shirt – or as perfect as possible – for each customer. We use great materials – fabrics, linings, threads, and buttons – but we also work very hard on offering the right amount of choice in the right number of fits to ensure that the shirt is a great fit and, most important of all, makes our customers feel a million dollars.

Charles Tyrwhitt has also offered a range of shirts (and ties) inspired by the classic Prince of Wales check patterns in aid of the Prince's Trust, with £5 donated to that very worthy cause for each item sold from the collection.

Like those offered by their competitors T.M. Lewin and Hawes & Curtis, Charles Tyrwhitt shirts are perfectly good for everyday business wear but are a world away from the luxury of true handmade Jermyn Street shirts. That said, you could buy four shirts from each of these brands for about the same price as one bespoke shirt elsewhere, and if you need to build up a wardrobe, you can certainly fill in the basics here.

Nick Wheeler, who is married to Chrissie Rucker, the founder and owner of The White Company, remains a great ambassador for his brand and it is hard not to admire the entrepreneurial spirit that repaid his initial investment of £99 on 500 leaflets and £199 on an Amstrad word processor with the global clothing brand he owns today.

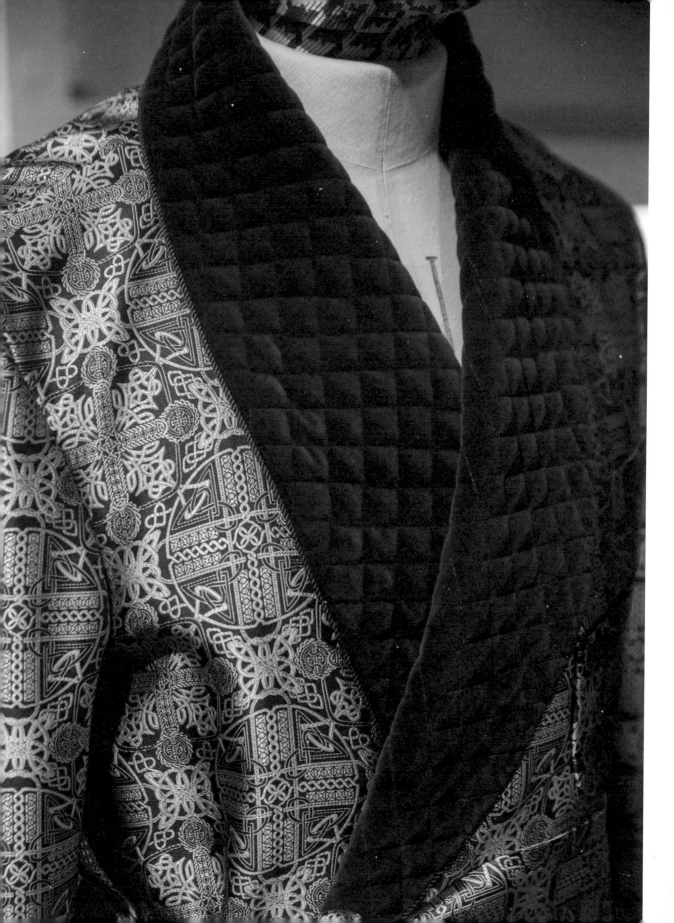

AND WHILE YOU'RE ON JERMYN STREET

J ermyn Street remains a cornucopia of shopping, grooming and dining beyond fine men's shirts. If you are planning a day there shopping, the following are certainly worth a visit.

DAVIDOFF OF LONDON

Located on the corner of St James's Street and Jermyn Street since 1980, this delightful cigar shop is amongst the best in the world (indeed, according to *Forbes Magazine* it is 'the best cigar shop in the world') and is still overseen by charming proprietor Edward Sahakian. Many of the shop's customers, who have included everyone from Arnold Schwarzenegger to Sir Christopher Lee, can be seen smoking their latest purchase outside Franco's restaurant opposite.

FRANCO'S

Opening in 1945, Franco's was one of the first Italian restaurants in England and ran successfully as a traditional trattoria for many years. Twenty years ago it was still very much the same – a small, informal affair with red gingham tablecloths and wine bottles racked across all

the walls. Today, it has been completely refurbed and is perhaps the most modern restaurant on Jermyn Street. The food is excellent and the ambience is lively, but aim for a table upstairs: the basement has much less atmosphere. Also be aware that an audio version of *The Wind in the Willows* is played in the toilets, leading to any number of confused customers thinking they have had a conversation with a talking toad. Once you know what's going on, it is quite delightful.

WILTON'S

A Jermyn Street fixture since 1984, Wilton's can trace its origins back to an oyster stall near Haymarket belonging to George William Wilton in 1742, and today oysters are still at the heart of its menu. One of the best traditional seafood restaurants in London, Wilton's is a bon vivant's idea of heaven, with immaculate service, beautiful, classical surroundings and a sumptuous menu that delights politicians and film stars in equal measure. A true delight. Jackets and ties are no longer a requirement for male diners, but you'll be disappointed in yourself if you wear neither.

ALFRED DUNHILL

One of the great British designer success stories, Alfred Dunhill has had its flagship at 48 Jermyn Street since 1906. The shop sells a wide selection of high-end luxury tailoring and luggage as well as accessories, writing instruments, fragrances and shoes. The leather goods – for which it is justly famous – are particularly spectacular with prices to match. Dunhill sells a range of formal cotton shirts retailing at between £250 and £425 as well as made-to-measure and bespoke options. Luxurious as these are, they do not typically represent good value for money.

ROWLEY'S

At the Haymarket end of Jermyn Street, on the original site of Wall's butchers, is Rowley's, one of the most agreeable steak restaurants in London. An unpretentious, no-nonsense approach to traditional fare – the fillet steak with unlimited chips is a masterpiece – combined with an excellent wine list, reasonable prices and gregarious, attentive staff have made this excellent restaurant a delight for the best part of four decades. This is the place to take your kids to eat if you're making a family visit to Jermyn Street (and why not start them young?). It may not be as grand as Wilton's or as buzzy as 45, but it remains a true delight and the perfect end to a day on Jermyn Street or, come to mention it, any other street.

EDWARD GREEN

Edward Green has been one of Britain's most prestigious shoemakers since 1890, with Mr Green's motto of 'excellence without compromise' being every bit as applicable to the company's shoes today. The shoes, which are particularly popular with American customers, are still made in Northampton and there is a store in Paris as well as several in London. Unlike some of the other Jermyn Street shoemakers, Edward Green offers a customisation service (similar to made-to-measure in shirt terms) but no bespoke option. The ready-to-wear shoes are reassuringly expensive, from £475 to north of £1,000, but the quality is absolutely assured.

CROCKETT & JONES

One of the most famous English shoemakers, Crockett & Jones is also one of the best value, offering fine Goodyear-welted shoes, produced in Northampton, from a number of delightful shops on Jermyn Street and in the surrounding area. The main collection, every one a bona fide classic, is very reasonably priced at between £400 and £500. The more exclusive

Hand Grade collection starts at around £100 more and uses higher-quality materials, including some particularly striking reptile skins (at around £4,500). Crockett & Jones also offer special order and bespoke services. The shoes are as good as those offered anywhere else in the world and have become the benchmark by which British shoes are measured.

FORTNUM & MASON

Perhaps the most famous shop in Britain, Fortnum & Mason is, after nearly 300 years, without a doubt the ultimate department store. Often referred to with the accurate but nonetheless flattering appellation 'the Queen's Grocers', it's easy to see why it would be everyone's first choice of shopping destination. The world-famous food hall is brimming with everything you could ever wish to eat or drink, while the upper floors stock a variety of homewares, fragrances and clothing. A shopping trip

to Fortnum & Mason is as intrinsically British an experience as one can have, and in between shopping there is the excellent tea room and the magnificent restaurant, 45 Jermyn Street. In the face of declining fortunes for high-street shops and department stores in particular, former CEO Ewan Venters led Fortnum & Mason into a new age of glorious success, representing all that is great about Britain.

45 JERMYN STREET

Once simply the restaurant of Fortnum & Mason, 45 Jermyn Street has rapidly become one of the key culinary destinations in the capital. Every bit as good as one of the Ivy restaurants, it has a superb, diverse menu curated by the brilliant Jamie Shears and a delightfully sophisticated atmosphere. The staff are as immaculate as you would expect from a Fortnum & Mason venture, and although the restaurant is exclusive, it is never anything less than welcoming. A very welcome addition to Jermyn Street and a must visit both for foodies and for those just looking for an excellent drink at the end of the day.

PAXTON & WHITFIELD

About halfway down Jermyn Street it is not unusual for a first-time visitor's nose to be assaulted by the aroma of particularly strong cheese, which seems distinctly at odds amongst the shoes and shirts in which the street specialises. But walk a little further and you will find the source of this pungent smell: Paxton & Whitfield, which since 1797 has been England's leading cheesemonger. A joyously old-fashioned shop selling the very finest selection of cheese (as well as hams, biscuits, chutneys and port), Paxton & Whitfield really is worth a detour from the menswear – your taste buds will thank you later.

JOHN LOBB

The most prestigious (and expensive) of the Jermyn Street shoe shops, John Lobb is owned by Hermes and so is also the most fashion forward. Around the corner on St James's Street is – confusingly – another John Lobb which is independently owned by the Lobb family and offers only bespoke shoes. The Jermyn Street store's ready-to-wear collection has been offered since 1982. The shoes are designed and made by hand in Lobb's Northampton workshop. A pair of Lobbs here will cost you about £1,000, and while there can be no doubt of the quality, they are at the high end of prices for ready-to-wear shoes.

FOSTER

A delightful bespoke shoemaker, Foster & Son has been creating the finest footwear since 1840, as well as a range of briefcases, luggage and belts. There is a limited but excellent range of Northampton-produced ready-to-wear shoes, priced similarly to Lobb's, but the true joy of Foster bespoke shoes is that they are actually made in a workshop on the Jermyn Street premises, something no other shoemaker on the street can boast. A true classic.

BENSON & CLEGG

Located between New & Lingwood and Budd in the middle of the Piccadilly Arcade, Benson & Clegg is a delightful, compact men's accessories shop which also offers off-the-peg, made-to-measure and bespoke tailoring. They stock a vast selection of cufflinks, braces, blazer buttons and ties: indeed, perhaps the largest selection of regimental ties in the UK. They supplied the Royal Navy reppe tie worn by Roger Moore in *Live and Let Die*, and have a James Bond-inspired range of ties and accessories which are as good as those found anywhere else on Jermyn Street.

ABOUT THE AUTHOR

Jonathan Sothcott is a prolific, award-winning British film producer whose successes have included *Nemesis*, the *We Still Kill the Old Way* series and *Vendetta*. After spells as a film journalist and documentary maker, at 24 he became the youngest television executive in the UK. Since then he has produced dozens of movies which have been seen all over the world, selling millions of copies on DVD. Away from movies he has written for *GQ* and books about Danny Dyer and Christopher Lee. He is married to actress Jeanine Nerissa Sothcott.